D1498252

L'Eternel Féminin

From
Renoir
to
Picasso

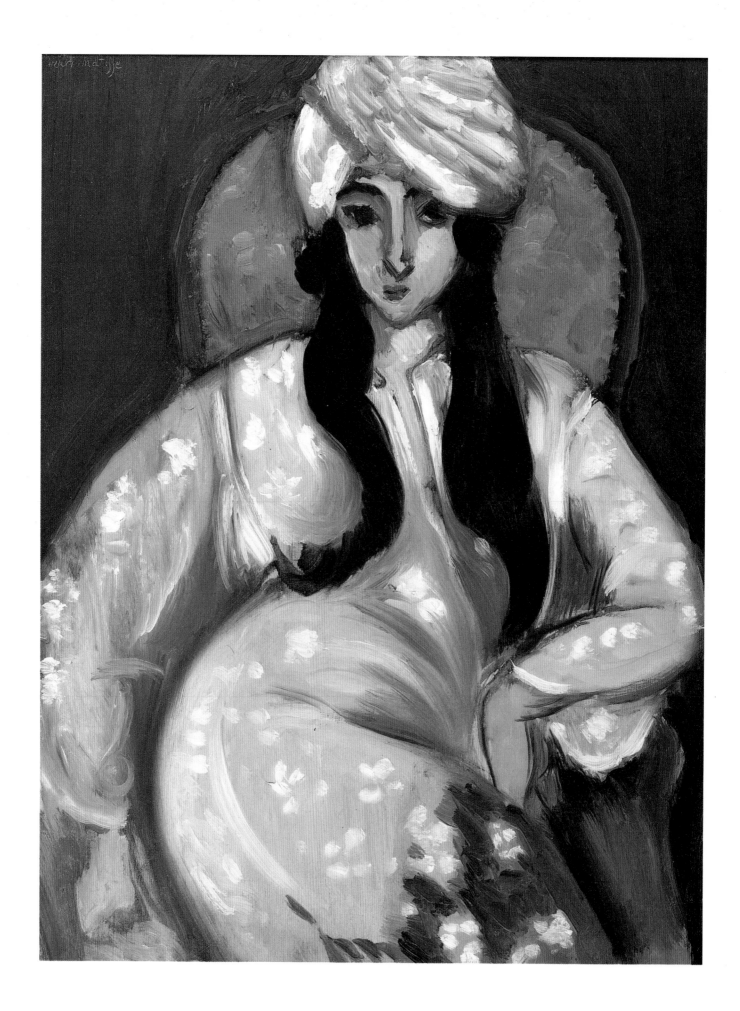

Roland Doschka

L'Eternel Féminin

From
Renoir
to
Picasso

With essays by
Roland Doschka,
Eckhard Hollmann,
Barbara Palmbach, and
Ursula Straatmann

Prestel
Munich · New York

This book was published to accompany the exhibition
Das Ewig Weibliche — L'Eternel Féminin
From Renoir to Picasso
at the Stadthalle Balingen from
June 15 to September 15, 1996

Front cover: Pablo Picasso, *Seated Nude* (detail), plate 45
Back cover: Pierre Bonnard, *Marthe Dressing*, plate 19
Spine: Kees van Dongen, *Portrait of Guus on a Red Ground* (detail), see p. 38
Frontispiece: Henri Matisse, *The White Turban (Lorette)*, plate 21

Library of Congress Cataloging-in-Publication Data
Doschka, Roland.
[Ewig Weibliche. English]
L'Eternel Féminin : from Renoir to Picasso / Roland Doschka :
contributions by Roland Doschka ... [et al.].
Translated from the German.
ISBN 3-7913-1730-X (alk. paper)
1. Women in art-Exhibitions. I. Title.
N7629.2.G3B35313 1996
704.9'424'07443473--dc20 96-38387

Photo Credits:
The Bridgeman Art Library, London, facing plate 59;
Atelier Hugel, Villingen-Schwenningen, plate 42;
Art & Photo, Clichy, plate 10; Florence Cuming, London, plate 71;
Studio Fink, Holzgerlingen, plates 40, 52;
facing plates 54, 56, 58, 59, 62, 66; facing plates 68, 68; 78
Interfoto-Pressebild-Agentur, Munich, facing plate 58;
The National Gallery, London, plate 73;
R.M.N.; Paris, facing plate 62;
Philipp Schönborn, Munich, plate 48

Prestel-Verlag, Mandlstrasse 26, 80802 Munich, Germany
Tel. (+49-89) 381709-0
Fax (+49-89) 381709-35
and 16 West 22nd Street, New York, NY 10010, USA
Tel. (212) 627-8199
Fax (212) 627-9866

Prestel books are available worldwide.
Please contact your nearest bookseller or write to
either of the above addresses for information
concerning your local distributor

Translated from the German by Nicholas Levis, Berlin
Edited by Kirk Marlow, London

Color lithography by Fotolito Longo, Frangart
Printed by Gerstmayer, Weingarten
Bound by Dollinger, Metzingen

Printed in Germany

ISBN 3-7913-1730-X (English edition)
ISBN 3-7913-1749-0 (German edition)

Printed on acid-free paper

Contents

The Eternal Female – L' Eternel Féminin 8

Pierre-Auguste Renoir 17

Edgar Degas 19

Paul Cézanne 21

Paul Gauguin 23

Pierre Bonnard 26

Henri Matisse 30

Kees van Dongen 35

Amedeo Modigliani 40

Marc Chagall 45

Fernand Léger 48

Joan Miró 50

Pablo Picasso, Painter of the Human 52

Plates

Pierre-Auguste Renoir · The Eternal Female · *Plates 1 to 8*

Edgar Degas · Love is Here, Painting is There · *Plates 9 to 10*

Paul Cézanne · The Metamorphosis of Eros into Color · *Plate 11*

Paul Gauguin · Painting against the Corruption of Civilization · *Plate 12*

Pierre Bonnard · The Painter of Stylish Women · *Plates 13 to 20*

Henri Matisse · Luxe, calme et volupté · *Plates 21 to 23*

Kees van Dongen · From Madonna to Cosmopolitan Woman · *Plates 24 to 29*

Amedeo Modigliani · Eros and Melancholy in Classical Form · *Plates 30 to 31*

Marc Chagall · The Sacred Song of Painting · *Plates 32 to 39*

Fernand Léger · "L'Eternel Féminin" as "Contraste des Formes" · *Plates 40 to 43*

Joan Miró · The Eternal Female as Cosmic Principle · *Plate 44*

Pablo Picasso · Painter, Muse, and Model · *Plates 45 to 51*

Picasso as Draftsman · *Plates 52 to 79*

Biographies 219

For Angela Rosengart

Foreword and Acknowledgments

Examining the concept of L'Eternel Féminin in its relation to the visual arts and literature was a major challenge.

After its enthusiastic reception in France, Goethe's metaphor developed into an essential component of European culture. Today many interpretations are connected with "L'Eternel Féminin": Woman as mother, lover, companion, and bride; as femme enfant, femme virginale, femme fragile, femme fatale, and femme natale. Indeed, the chain of associations ranges from the protective mother-figure to the companionable partner to the hotly desired lover to the destructive femme fatale.

I encountered positive reactions throughout the preparation of this many-faceted exhibition. Without the constructive cooperation of so many, this project certainly could have never been realized.

My heartfelt thanks are to due to all friends, colleagues and co-workers, as well as to Prestel-Verlag for their careful supervision of the catalogue. Thanks are due above all to the lenders, for without their generous participation this ambitious exhibition would have never been realized. The large number of works from collections across the world impressively underlines the unique character of this exhibition.

My special thanks are due to: Heinz Berggruen; Hans Brandau; Brooks Museum of Art, Memphis, Tennessee; Tima de Chaudun; Melanie Clore; Sotheby's, London; The Dixon Gallery and Gardens, Memphis, Tennessee; Françoise Dumont; Galerie Cazeau, Paris; Galerie Sassi, Paris – New York; Galerie Thomas, Munich; Galerie Utermann, Dortmund; Waddington Galleries, London; Philippe Garcia; Spencer Hays; Klaus Hegewisch; Warren Hopkins; Paul and Ellen Josefowitz; Samuel Josefowitz; Horst Kleiner; Uli Klingler; Francis Lombrail; Henri Loyrette; Caroline Mathieu; Hector Magotte; Méret Meyer; Michael and Valerie Milkovich; Musée d'Art Moderne, Liège; Musée d'Art Moderne et d'Archéologie, Besançon; Musée d'Orsay, Paris; Museum of Fine Arts, St. Petersburg, Florida; Angela Nevill; Helena Newman, Sotheby's, London; Lionel Prejger; Noelle Rathier; Marc Restellini; Dana Ruben Rogers; Pace Wildenstein, New York; Angela Rosengart; Dietmar Sauer; Jürgen Schwarzer; Horst Siedle; Esperanza Sobrino; Acquavella Galleries, New York; Helga and Sepp Sohler; Walter Springer; Michel Strauss; Sotheby's, London; Soulier-François; Sylvia Weber; Reinhold Würth; Walther Zügel.

Roland Doschka

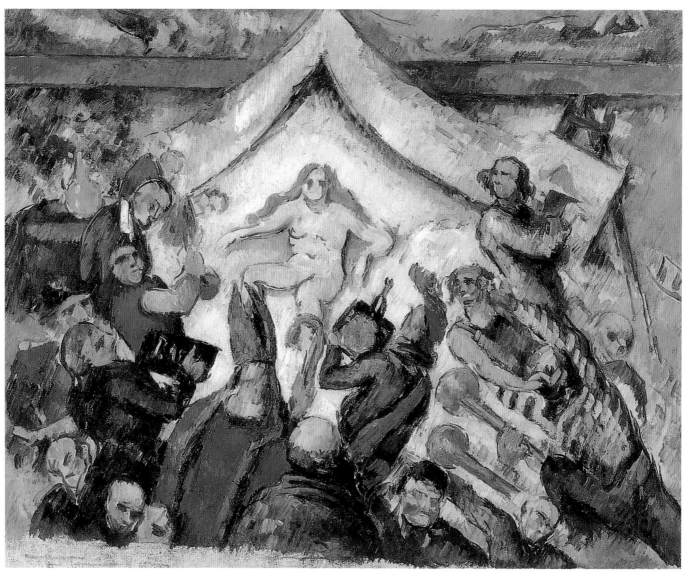

Paul Cézanne, *L'Eternel féminin*, 1875, oil on canvas, J. Paul Getty Museum, Malibu, California

The Eternal Female – L'Eternel Féminin

Two Words and a Multitude of Interpretations:
Remarks on Goethe's Adage and its Reception
in French Art and Literature

Certainly no other sentence of Goethe's has drawn more intensive or persistent interest from commentators and interpreters than the German poet's well-known phrase "the eternal female leads us on high" with which he ends the second part of his "Faust" by means of a "Chorus Mysticus."

This passage has been open to endless and varied interpretations – some scholarly and others overblown – ranging from "the Virgin's divinely forgiving love" to "the purest expression of *amor intellectualis Dei*" or "the epitome of all helpful forces," or seeing the image as either "the Ideal Female" or "the great Mother of Nature." The "Eternal Female," so it seems, is difficult to comprehend, but yet it seduces the imagination – most especially the powerful imagination of man – in its pursuit of profound trains of thought.[1]

With wise foresight Goethe remarked, in a conversation with J. P. Eckermann on May 6, 1827, that "The Germans are such astonishing people! With all their profound thoughts and ideas, that they search for everywhere and keep to themselves, they make life more difficult than it need be. Ah, at last, please be so daring as to surrender yourselves to impressions, allow yourselves to be amused, allow yourselves to be touched, to be exalted . . . They come and ask me what idea I am trying to embody in my Faust. As if I myself knew and could express it!"[2]

"L'Eternel Féminin," conjectures one of the earliest French commentators, "is, in its incomprehensible entirety, a very German phrase, and in principle it means nothing more than the idealization of the feminine as opposed to the masculine. It is a kind of ennobled symbol for attraction between the sexes."[3] So it was undoubtedly the melodious sound of the phrase, at one time translated into French, rather than any deep meaning it might have, that made "L'Eternel Féminin" a stock expression of the French language. To this day French literati, musicians, and visual artists use the phrase "L'Eternel Féminin" in as many different contexts as possible, without ever feeling the need to restrict it to a precise definition. We shall thus follow the advice of the Viennese philosopher of language, Ludwig Wittgenstein (1889–1951), according to whom the meaning of a word is deduced from its use.

Just a few years after the publication of Goethe's "Faust," the first French translation appeared. "Faust" was met with an immediate and intense response, especially in Paris, and it stimulated much discussion among literary circles and salons of the time. One of the first visual artists to read it was the Romantic painter Eugène Delacroix (1798–1863), who in 1825–28 published a series of lithographs based on the German work (see illus. p. 10). Delacroix received the

All transient things
Are but a parable;
The Inaccessible
Here becomes actuality;
Here the ineffable
Is achieved;
The Eternal Female
Leads us on high.

JOHANN WOLFANG VON GOETHE
Faust II, Chorus Mysticus

decisive inspiration for the design of this series from a theatrical production of "Faust" staged in London in 1825. Apparently, the gloomy and grotesque impressions arising from this particular performance shaped Delacroix's interpretations of "Faust" even more lastingly than did his reading of Goethe's own text.

In 1828, the Parisian art publisher Charles Motte issued a French translation of Goethe's "Faust," accompanied by 17 illustrations and a portrait of the author by Delacroix. Delacroix, who had had a humanist education, was also inspired by the writings of Shakespeare, Dante, and Lord Byron, among others, but he felt himself exceptionally attracted to, and challenged by, the theme of "Faust."

When Goethe himself saw two of Delacroix's lithographs for "Faust" in 1826, he remarked, in a discussion with Eckermann, on November 28, 1826: "Here I must confess that I had not been so completely convinced – M. Delacroix is a man of great talent, who has found in 'Faust' his proper nourishment. The French criticize his wildness, but here it suits him well." And in 1827 Goethe wrote, in *Kunst und Altertum:* "That is why he [Delacroix] is the right man to immerse himself in 'Faust,' in order to likely bring forth images that no one else could have possibly conceived." Here Goethe rightly deduces what is essential and modern in Delacroix's art. For Delacroix does not merely illustrate subject-matter; he goes beyond this by transmitting the mood and tension of a scene into a graphic style. Graphic stroke and visual technique themselves become the vehicles of expression, and, as Charles Baudelaire (1821–1867) expressed it, "imagination vaults over the subject."

Because of the sensation caused by the arrival of Wagnerian opera in France, Goethe's phrase again became popular and was made known to an even wider audience. The "Eternal Female" was again an issue of artistic discourse, especially as a result of the performance of *Tannhäuser* in Paris in 1861. The opera deals with the polarity of two female types: Saint versus Venus. Tannhäuser, the very prototype of the modern artist, finds his inspiration in Venus and wins a singing contest at the cost of enormous suffering, but in the process becomes a despised outsider. He can only be redeemed through the self-sacrifice of a loving woman – through the "Eternal Female." The opera caused a scandal, not only because of "Germanic" violations of the traditions of French *Grand Opéra*, but, more importantly, because of allusions to the power of Eros, which Wagner had discovered as the driving force behind artistic creativity. Therein lay the explosive force in Wagner's opera. That which was indignantly rejected by the bourgeoisie was enthusiastically received by young writers, musicians, and artists.

Eugène Delacroix, *Faust Visiting Gretchen in the Dungeon*, lithograph

in Baudelaire's poetry: "Diverses figures de femmes paraissent au fond des poésies de Baudelaire, les unes voilées, les autres demi-nues, mais sans qu'on puisse leur attribuer un nom. Ce sont plutôt des types que des personnes. Elles representent l'Eternel féminin, et l'amour que le poète exprime pour elles est l'amour, et non pas un amour."

Baudelaire's "Les Fleurs du Mal" appeared as a revelation, especially for young artists and writers of the Second Empire who felt helpless faced with the constraints of convention and the Academy, and who suffered under hypocritical ideals long ago congealed into clichés. They saw in this work the confirmation of their own yearnings for freedom.

Among them were two high-school boys who had made each other's acquaintance in 1853, at the Collège Bourbon in Aix-en-Provence: Paul Cézanne (1839–1906), the son of a banker, and Emile Zola (1840–1902), the son of a hydraulic engineer. Among the writers whose works the two young rebels respected and practically devoured were Victor Hugo (1802–1885), Alfred de Musset (1810–1857), Alphonse de Lamartine (1790–1869), and Gustave Flaubert (1821–1880) – whose novel *La Tentation de Saint Antoine* especially fas-

Wagner's operas became sources of inspiration for painters such as Henri Fantin-Latour (1836–1904) and Odilon Redon (1840–1916), and for the Symbolist writers Stéphane Mallarmé (1842–1898), Paul Verlaine (1844–1896), and Joris-Karl Huysmans (1848–1907).

Thus the "Eternal Female," in all her enigmatic facets, became the central theme of the second half of the nineteenth century. It was especially Baudelaire, who had taken up Wagner's cause in his heroic polemic of 1861 ("Richard Wagner et *Tannhäuser* à Paris"), who proposed the idea of deliverance through the "Eternal Female" in "Les Fleurs du Mal," his volume of poetry published in 1855 and confiscated just three weeks later:

> J'implore ta pitié, Toi, l'unique que j'aime,
> Du fond du gouffre obscur où mon coeur est tombé.
> C'est un univers morne à l'horizon plombé,
> Où nagent dans la nuit l'horreur et le blasphème.[4]

> O my sole love, I pray thee pity me
> From out this dark gulf where my poor heart lies
> A barren world hemmed in by leaden skies
> Where horror flies at night, and blasphemy.

Baudelaire, the *poète maudit*, played through every facet of Woman in his writings, from corrupting vampire to figure of mythical exaltation. The manner in which he expresses himself varies from rapturous, lyrical phrasing to a tone of gruff, gutter vulgarity. With his air of dandyism and his noncommittal rootlessness, Baudelaire expressed a cynically hostile contempt for Woman while at the same time mystifying "the female" by elevating her to a vague, idealized type.

Théophile Gautier (1811–1872), to whom Baudelaire dedicated "Les Fleurs du Mal," wrote about the fascination of the female

Paul Cézanne, *The Feast (The Orgy)*, 1864–68, oil on canvas, private collection

Paul Cézanne
Afternoon in Naples
(Rum Punch), 1875–77
oil on canvas
Australian National Gallery,
Canberra

cinated Cézanne. Baudelaire's "Fleurs," however, seems to have been a kind of bible for the two youths, and both recited passages from it by heart – even at secret meetings by night on the banks of the Arc River.

It was no wonder that the "Eternal Female" was at this time already among the central themes for both Cézanne and Zola. Most of all, the shy, self-doubting Cézanne, who suffered from conflict with his tyrannical father, projected his existential fears and erotic desires upon the "Eternal Female." That is apparent not only in his early paintings, but also in a poem addressed to his trusted friend Zola, written on the reverse of a drawing:

Oh, je jure sur mon âme
Que je n'avais jamais vu de si belle femme.
Cheveux blonds, yeux brillants d'un feu fascinateur
Qui, dans moins d'un instant, subjuguèrent mon coeur.
Je me jette à ses pieds; pied mignon, admirable
Jambe ronde; enhardi; d'une lèvre coupable,
Je dépose un baiser sur son sein palpitant;
Mais le froid de la mort me saisit à l'instant,
La femme dans mes bras, la femme au teint de rose
Disparaît tout à coup et se métamorphose
En un pale cadavre aux contours angouleux:
Ses os s'entrechoquaient, ses yeux éteints sont creux….

Oh, I swear on my soul
Never did I see a beautiful woman

With blond locks and sparkling eyes
Who in an instant so beguiled my heart.
To her feet I throw myself down,
And on my knees with guilty mouth
Plant daring kiss on palpitating breast;
But the cold of death seizes me right then,
The woman in my arms, woman all tinted roses
Disappears, and all at once metamorphoses,
To a pale cadaver with angled contours,
With rattling bones and lifeless eyes.[5]

Cézanne's early paintings are full of eroticism and violence, as if the painter wished to visually exorcise his nightmares and to free himself from his torments and unfulfilled passions.

Even his titles betray this: *The Feast (The Orgy)* (1864–68) (illus. p. 10); *The Abduction* (1867), given to Zola as a present; *The Temptation of St. Anthony* (1867–69); *The Murder* (1867–70); *The Strangled Woman* (1870–72). Some art historians believe that Cézanne himself is recognizable in these works as either actor or voyeur.

In 1877 Cézanne finally completed a picture entitled *L'Eternel féminin* (illus. p. 8), which has since been the subject of many studies and interpretations. On a canopied bed, Cézanne depicts an essentially faceless woman in a grotesque, seductive pose. The bed is surrounded by a group of staring men, recognizable as representatives of various classes and professions. Among them, a clergyman stands out from the group because of his miter. There are also two trumpeters, two genre

Edouard Manet, *Nana*, 1877, oil on canvas, Hamburger Kunsthalle

figures who quarrel with each other, a judge wearing black robes, and a man with a sack of money who is interpreted by some as Cézanne's father, the parvenu who rose from hatmaker to banker. Finally, there is a painter at an easel, unmistakably Cézanne, taking his own place in the "dance around the golden calf." Here the "Eternal Female" becomes a symbol for the seduction by Woman, who has the whole world of men at her feet. By no means does Cézanne, who appears twice in the painting, exclude himself.

The same topos, also revolving around a blond woman, can be found in *Nana*, Emile Zola's celebrated and scandalous novel. In this ninth volume of the "Rougon-Macquart" cycle, written from 1877 to 1880, the young protagonist of the title, a "Venus blonde," secures a place for herself in the corrupt Parisian society of the Second Empire. With "toute puissance de son

sexe" – the magic seductive force of her body – she achieves power over government ministers, aristocrats, civil servants, and journalists.

However, as she is finally forced to recognize, this society will always consider her a courtesan without virtue, a woman who will be given no chance for real recognition. In the end she realizes that the hypocritical depravity of the upper classes is even more reprehensible to her than is her own naive and undisguised corruption born of want.[6] In writing this book, Zola knew that he had taken on an issue that would meet with strong reactions. As well as his egotistical goal of boosting the novel's circulation and distribution through a good scandal that would get all of Paris talking, Zola's intention, as he wrote twenty years after the novel's publication, was "... to show a prostitute, the very best, like a couple of thousand others in Paris, and thus protest against the many Marion Delormes, against *les dames aux camélias*, the Marcos and Musettes, against these ornamental snares of vice, whom I believe to be a danger to our customs and to exercise disastrous influence on the imaginations of our girls."[7] "Preserving the purity" of "L'Eternel Féminin" and delivering her from the clutches of vice is thus the apparent motive for Zola's moral involvement. Despite his naturalistic and meticulous studies of detail and society, he seems to have forgotten, at least in retrospect, that the cause of the almost epidemic spread of prostitution in the nineteenth century lay not in "the female" herself, but in a society shaped essentially by men.

Edouard Manet's well-known oil painting *Nana* (illus. p. 12) was rejected by the Salon jury in 1877. The verdict of this institution determined an artist's status in the Parisian art world. The jury deplored the painting as an "outrage à la morale," and Manet ended up showing it in the window of a store on the Boulevard des Capucines. The Parisian public saw in it a visual rendering of a scene from Zola's novel, and this resulted in a controversy that matched the reception of the novel: a *succès de scandale*. People overlooked the fact that Manet's picture was actually painted before the novel was published. Manet would only have been

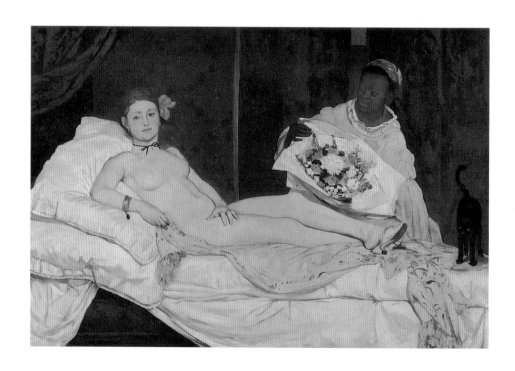

Edouard Manet, *Olympia*, 1863
oil on canvas, Musée d'Orsay, Paris

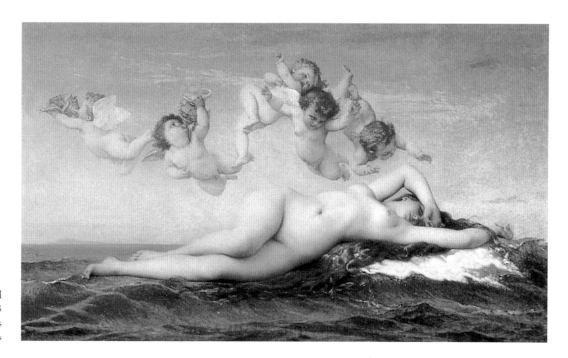

Alexandre Cabanel
The Birth of Venus, ca. 1863
oil on canvas
Musée d'Orsay, Paris

able to take his title, at most, from the previous novel in the cycle, *L'Assommoir*, which deals with Nana's childhood. That Henriette Hauser, a well-known Parisian prostitute, had posed for Nana only served to add to the general indignation. A gentlemen, who in keeping with the new pictorial aesthetics has been partly cut off at the right edge of the painting, and whose dress and pose unmistakably identify him as someone of "higher status," observes the courtesan as she powders herself in front of a round floor-mirror. She gazes, confidently and without shyness, at the viewer, who is on the same level as the elegant man. In the same way as the reclining figure in Manet's *Olympia* of 1863 (illus. p. 12), Nana looks down at the male viewers to whom these paintings are addressed, while the gaze of man is captured and "led on high" by the "Eternal Female." Against the devoted passivity of the usual Salon nudes, in which "L'Eternel Féminin" has been congealed into mythological cliché for the satisfaction of male voyeurs, Manet presents a modern woman, one well aware of her power. Only in a society determined by prudery and prostitution, such as that of the Second Empire, could Manet's pictures of women have caused such a shock. The reaction was not only among men: Empress Eugénie, the wife of Napoleon III, was indignant when she viewed Manet's *Le Déjeuner sur l'herbe*, and supposedly attempted to pierce it with her parasol.

Paintings of nude women, as the Salon of 1863 so amply demonstrated, were accepted and even welcomed, but only when they appeared in mythological disguise. The foremost erotic mythological image was that of Venus, the goddess of love, whose appearance in Salon paintings outstripped those of the bathing Dianas, cavorting nymphs, and Psyches sunning themselves. Reviewing the Salon in the *Moniteur universel*, Théophile Gautier wrote: "On pourrait, si l'on voudrait, désigner d'un nom particulier le Salon de 1863, l'appeler le Salon des Vénus."

The sensation of the Salon of that year was Alexandre Cabanel's *The Birth of Vénus* (illus. p. 13). Emperor Napoleon III bought the pic-

ture for the incredible sum of 50,000 francs, so that he might hang it in the royal bedroom. The painting represents the literal incarnation of the bourgeois "Eternel Féminin" and symbolizes the double standards prevalent in Second Empire society. The title and subject-matter give it an aura of the idealistic or academic, and place it in an art-historical tradition that extends from Jean-Auguste-Dominique Ingres's *Venus Anadyomene* (1848) back through Raphael's *Triumph of Galatea* (1513) all the way to Botticelli's *The Birth of Vénus* (ca. 1485–86) in the Galleria degli Uffizi, Florence.

With her studied gaze, at the same time naive and lascivious, and with her seemingly unobserved studio model's figure stretched out on the crest of a wave as though on a sofa, Cabanel's Venus satisfies fully the curiosity of a voyeur. Male fantasy is nonetheless brought back to its senses by means of numerous pictorial devices indicating that the goddess of love is not of flesh and blood, but rather a divine character placed in the higher sphere of an academic, bourgeois mythology. This is shown by the sculptural smoothness of her body and the marmoreal coolness of her sanitized and hairless skin. The nude form hides its commercialized voyeurism behind a mask of obsolete ideals long bereft of meaning. Zola remarked mockingly on this in "Nos Peintres au Champ-de-Mars," his review of the exhibition: "La déese, noyée dans un fleuve de lait, a l'air d'une délicieuse lorette, non pas en chair et en os — cela serait indécent — mais en une sorte de pâte d'amande blanche et rose."[8]

Cabanel was by no means the only artist to succeed in bringing this voyeurism down to its common denominator. Many Salon painters made energetic use of the new pictorial formula. Nevertheless, it was Cabanel's Venus that was the sensation of the Salon, and it was discussed throughout Paris.

Every "peintre pompier," as the Salon painters were later to be derisively called, understood that the Venus motif allowed a seamless combination of commercialized sexuality and bourgeois aesthetics —

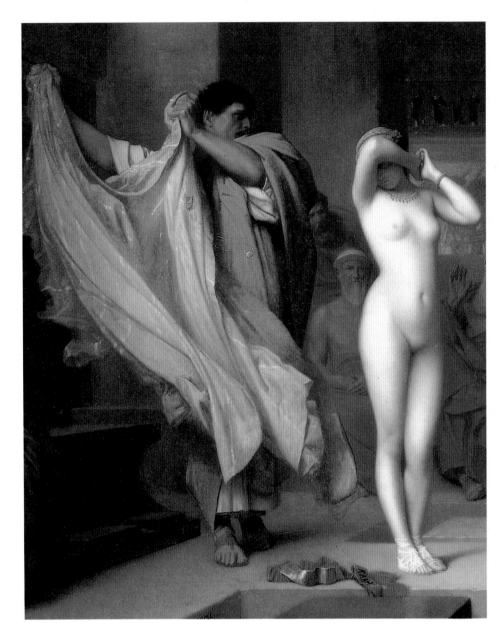

just the right mix of the real and the ideal. Therein lay a practical guarantee of success. Young painters began to take up the patent recipe. Much in the manner of Cabanel's Venus, Paul Baudry's female in *The Pearl and the Wave* also extends her body the length of a wave, while Amaury-Duval's *Goddess of Love* offers her attractions to the (male) observer from an upright position.

No other painting from the Second Empire epitomizes the half-exhibitionistic, half-voyeuristic fascination with this particular "Eternel Féminin" as well as does *Phryne before the Judges* (1861) (illus. p. 14), a much-admired painting by Jean-Léon Gérôme. Gérôme, who was one of the most influential and highest-paid painters of his time, was both a professor at the Ecole des Beaux-Arts and a member of the Salon jury. Thus, for young painters he filled a dual function, setting both the prevailing standards of taste and promoting high ideals.

According to the story, Phryne, who was the model for the most important sculptors of Classical Athens including Praxiteles and Apelles, had been accused of blasphemy because the artists had used her as the model for a statue of Aphrodite. Gérôme's painting depicts the dramatic climax, when Phryne's defender tears off her garment in order to convince the judges of her divine beauty. She covers her eyes in an attempt to avoid the gazes of the judges – who are represented as alternately lecherous, astounded, shocked, or admiring – while at the same time turning her naked body toward the viewer.

In a biting critique of the painting, Zola expressed his amusement by calling it a "ragout for lecherous old men, whose arousal provides entertainment for a blasé public." It is reasonably safe to assume that Zola visited this particular Salon with his friend Cézanne, and that the two spoke about the picture. Thus, Cézanne's painting *L'Eternel féminin* (illus. p. 8) might be understood as a sort of satirical commentary on Gérôme's picture.

Honoré Daumier (1808–1879), whose caricatures in the periodicals *Le Charivari* and *La Caricature* are a sort of X-ray picture of the

Second Empire, and to whom we also owe detailed commentaries on the daily events of his time, made a few sketches of the Salon of 1865, which he employed for his lithographs. In a witty and biting manner they show the dilemma between the "Eternal Female" who has been rigidified into an antiquated ideal, and the banality of everyday reality. Daumier's accompanying commentary describes the lecherous reactions of the male audience, as well as the cool, ironic remarks of the women.

The men, armed with a magnifying glass, rush up to the pictures with voracious looks and justify their curiosity with feigned interest in painterly qualities: "Eh! bien en regardant ce tableau de près on finit par y découvrir des qualités, on voit que la couleur est bonne." [Ah, if you look at this picture from up close, you'll discover its real qualities, you can see that the color is good.] The women, visibly intimidated by the pictures, turn away: "Cette année encore des Vénus … toujours des Vénus! S'il y avait des femmes faites comme ça!" [Venuses again this year … always Venuses … as if women like that really did exist!]

With Richard Wagner and Friedrich Nietzsche having prepared the way, the writings of Sigmund Freud (1856–1939) were also rapidly disseminated in France. The connection between sexuality and death, between Eros and Thanatos, thus became a central topos of art and literature. It was the Symbolists particularly who waged a battle against an arrogant positivism, and who saw therein a chance to rebel against the bourgeois, materialist view of art. As early as 1874, Gustave Flaubert had made the synthesis of Eros and Death an issue in his novel *La Tentation de Saint Antoine*. In the book, the Saint's powers of imagination, exhausted through long asceticism, are regenerated through the appearances of the Queen of Sheba, a sphinx, and other mythological seductresses. Only with help from the sign of the Cross can St. Anthony, beset by the temptation of a corrupt "Eternal Female," find the good life of virtue and prayer once more.

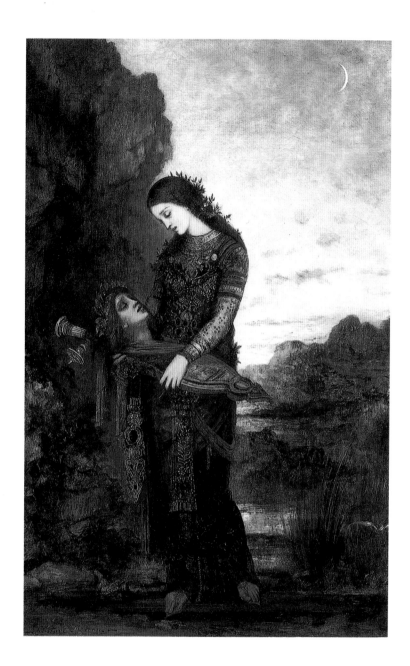

The Symbolist painters and poets mostly drew the prototypes for their *femmes fatales* from biblical female figures, such as Judith, Delilah, or Salomé. But mythological personifications, such as the Sphinx, Helen, Messalina, or Circe, also entice men toward destruction with their dangerously seductive sensuousness. Gustave Moreau's *Thracian Girl Carrying the Head of Orpheus* (illus. p. 15), which attracted much attention at the Salon of 1866 and was purchased by the State for 8,000 francs, engendered a whole series of paintings in which the "Eternal Female" drew the man not "on high," but down, into death.

Moreau's unusual variation on the traditional myth of Orpheus forced him to provide the Salon public with an explanation of his picture in the catalogue. Orpheus, who created music that enchants humans as well as animals, suffers a horrible death. The frenzied women of Thrace, whose love he has rebuked, tear him to pieces and throw his lyre and his head into the river. Moreau does not show the bloody deed itself, but instead depicts a moment of erotic contemplation. Sobered from her bloodlust, forlorn and still in love, a Thracian girl strikes a melancholy pose and gazes sadly at Orpheus's decapitated head, which she has placed on his lyre and holds in her arms.

Beginning with Moreau's series of "Salomé" paintings in oils (1874–76), the novella *Herodias* (1877) by Flaubert, and the novel *A rebours* (1884) by Huysmans – which contains surely the most significant description in literature of any oil painting by Moreau – this particular New Testament story develops into a popular theme in the visual arts that extends well into the twentieth century.

Moreau's oeuvre reads like an ancestral line of the *femme fatale*. Apart from Salomé, he painted pictures whose main characters are the Sphinx, Leda, Helen, Galatea, Delilah, Circe, and Mary Magdalene. In these works the "Eternal Female" becomes both nightmare image and alluring obsession.

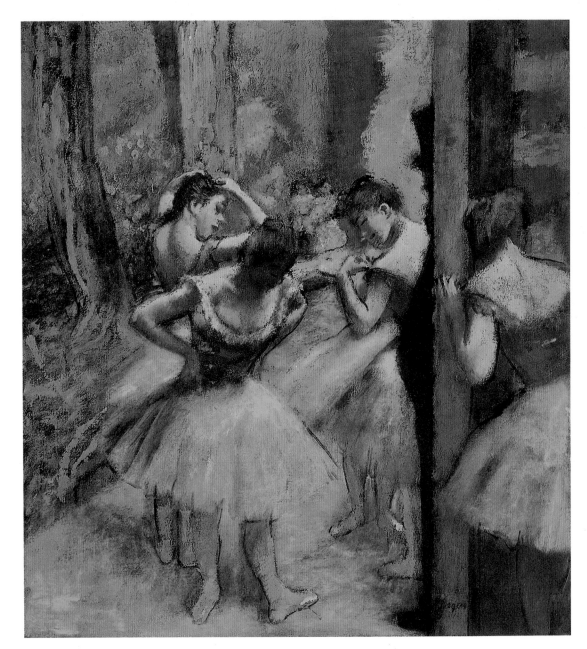

Edgar Degas
Dancers, Pink and Green
ca. 1890
oil on canvas
Metropolitan Museum
of Art, New York

The work of the Modernist painters remains shaped by the nineteenth century's diffuse picture of Woman in all her enigmatic facets. This is especially so with Cézanne, who sublimated his conflicts with the "Eternel Féminin" in his painting.[9] It also applies to Edgar Degas (1834–1917), whose paintings of women rarely indicate emotional involvement, or even recognition (see illus. p. 16). It is not until the work of Pablo Picasso (1881–1973) and Fernand Léger (1881–1955) that there is a transition to an emancipated picture of Woman. In Picasso's case, this was perhaps also the result of his acquaintance with such strong women as Gertrude Stein.

Roland Doschka

1 Michael Neumann: *Das Ewig-Weibliche in Goethes "Faust"* (Heidelberg, 1985)
2 Johann Wolfgang von Goethe: *Werke*, Hamburger Ausgabe, p. 447
3 *Grand Larousse encyclopédique* (Paris, 1982), p. 201
4 Charles Baudelaire: "De profundis clamavi": *Les Fleurs du Mal* (Paris, 1857); translation by Sir John Squires, in *Charles Baudelaire: Flowers of Evil, translated into English by various hands* (London, 1940), p. 53
5 Marie Louise Krumrine: *Paul Cézanne: Die Badenden* (Basel, 1989), p. 50
6 A. Landoux and Henri Mitterand: *Les Rougon-Macquart* (Paris, 1961–64)
7 Ibid., p. 1686
8 Henri Mitterand, ed.: *Oeuvres complètes*, xii (Paris, 1982), p. 852
9 Marie Louise Krumrine: *Paul Cézanne: Die Badenden* (Basel, 1989)

Pierre-Auguste Renoir

Pierre-Auguste Renoir, born in Limoges in 1841 the son of a tailor, is considered a painter of Woman *par excellence*. Nearly half of his oeuvre, comprising about 7,000 works, has the female as its subject. Renoir's idea of the "Eternal Female" has its roots in the lighthearted and sensuously cheerful painting of the Rococo. In fact, Renoir spent the first four years of his artistic life transferring Rococo motifs – *fêtes galantes*, rustic scenes, portraits of Marie Antoinette – on to plates, cups, and saucers. During his apprenticeship as a painter of porcelain, which he began in 1854 at the age of thirteen, he showed an increasing interest in the paintings in the Musée du Louvre, Paris. Among the pictures there that he admired and copied, his favorites included works by Antoine Watteau (1684–1721), Jean-Honoré Fragonard (1732–1806), and François Boucher (1703–1770). Boucher's *Diana at her Bath* (1742) became for Renoir a sort of icon of the female. In the studio of the Salon painter Charles Gleyre (1806–1874), Renoir had his first opportunity to paint the nude figure. During this time, he became acquainted with fellow artists Frédéric Bazille (1841–1871), Alfred Sisley (1839–1899), and Claude Monet (1840–1926). Under their influence he distanced himself from the academic painting of his time, and began to paint *en plein air* in the forest of Fontainebleau. Renoir was no revolutionary. So as not to excessively provoke the official taste of the Belle Epoque, he populated his wooded landscapes with nudes in mythological disguises.

Like many of his peers, he never truly broke with tradition. His paintings of society – bourgeois dances, swimming and boating parties at "La Grenouillère," picnics in the park – all resonate with the joyous Rococo atmosphere he so dearly cherished, and to which he often keyed his color palette. In 1874, Renoir and his fellow painters Monet, Sisley, Edgar Degas (1834–1917), Paul Cézanne (1839–1906), Camille Pissarro (1831–1903), and Berthe Morisot (1841–1895) exhibited 166 pictures for the first time in a privately organized show at the studio of the photographer Nadar (1820–1910). The exhibition met with a scandalous reception. The term "Impressionist" – intended as a deprecation – was taken from the title of one of Monet's paintings and applied by a critic to the group as a whole. Renoir took part in three of the Impressionists' eight group exhibitions.

Renoir did not become a landscape painter like his friend Monet. "Nature leads the artist into solitude. But I wish to remain among people," he said. For Renoir, the female model represented both the eternal and the everyday. It was in her he found his inspiration. "He always found relief in female voices. He demanded that his servants sing, laugh, work noisily. The more childish, the more nonsensical their little ditties were, the more they delighted him," his son Jean Renoir (1894–1979) reported.

Renoir painted his girls and women dancing, playing the piano, in the landscape, by the water's edge, and with children. In their natural beauty and their soft, pulsating forms, they all seem to have come from the great harmonious family of "L'Eternel Féminin."

He required that the flesh of his models be capable of absorbing and reflecting light. His goal was to achieve an effect of sensuous color, having as a youth studied and admired the flesh tones of the female figures in the paintings of Peter Paul Rubens (1577–1640). His variations on the sensuous female nude can be seen in examples of his work spanning thirty years: from *Nude, Rear View*, a delicate pastel of 1879 (plate 1), to the *Bather* of 1882 (plate 3) and 1883 (plate 4), up to *Reclining Nude, Rear View* of 1909 (plate 8) – the last inspired by Diego Velázquez (1599–1660) and now in the Musée d'Orsay, Paris.

By the early 1880s, as he confessed to his friend and art dealer Ambroise Vollard (1865–1939), Renoir felt that he could go no further with the Impressionist method and its tendency to an increasing dissolution of the form, and he sometimes felt as though he could neither paint nor draw. To escape this dilemma, he turned to a classical style of painting. Following in the footsteps of Jean-Auguste-Dominique Ingres (1780–1867), he traveled to Italy and admired the frescoes of Pompeii, and the wall-paintings of Raphael (1483–1520) at the Vatican and the Villa Farnesina in Rome. On this journey he painted *Italian Woman with Tambourine* (plate 2), a work that shows his joyful response to folk customs.

The years that followed were marked by his suffering from an insidious rheumatism. During this time Renoir sought inspiration from painters on whose works he increasingly modeled his own: Camille Corot (1796–1875), Titian (ca. 1487/90–1576), Giorgione (ca. 1476/8–1510), Velázquez, and Rubens. A Mediterranean light still entered his paintings regardless, and he dealt with the age-old issue of the ideal beauty of the human body so intrinsic to the Arcadian landscape. After Renoir moved to Cagnes-sur-Mer, near Nice, in 1907,

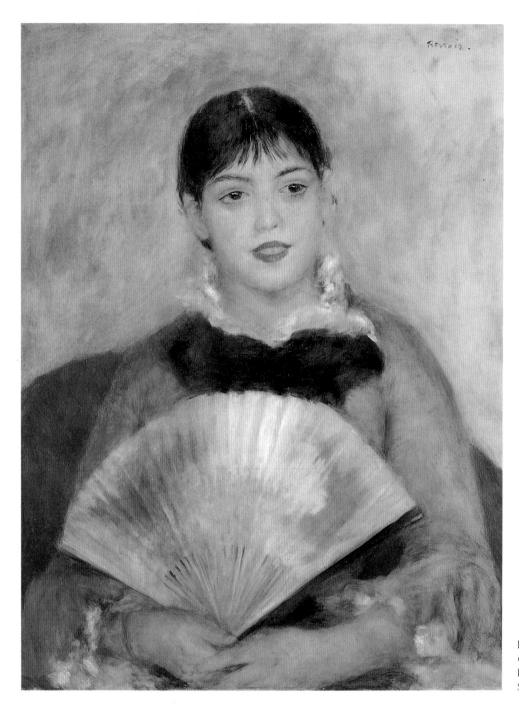

Pierre-Auguste Renoir
Girl with a Fan, ca. 1880
Hermitage Museum,
St. Petersburg

to settle down in the midst of an olive grove, he rendered his nudes in ever more archaic forms, to the point where they become almost like idols. Form moves away from the natural and becomes monumental. The nudes metamorphose into earth and fertility goddesses, and lose individuality. The faces of his housemaids, children, and models all become archetypes. In this way Renoir created his pictorial symbol of the female, which has become as unmistakable as the faces of Raphael's Madonnas or the youthful beauties of Boucher's paintings.

"He invented the Parisienne," Vollard once remarked. Julius Meier-Graefe, who wrote one of the first biographies of Renoir (1911), fittingly described the sensuous effect of Renoir's erotic and delicate blending of color: "When thinking of Renoir, a window opens up to the outside. It flies open, and one sees roses, rosy children, fruits; densely packed, smiling vegetation...and suddenly one is right in the midst of the vortex of juice and flesh and warmth, squeezed between flowers and girls' breasts, and a man has become a funny animal."

Edgar Degas

No painter is as strongly associated with the world of ballet as Edgar Degas (1834–1917). Studies of dancers and delicate sheer tutus are among his most enduring works (see illus. p. 20). His is an oeuvre based on a traditional teaching that extends back to Jean-Auguste-Dominique Ingres (1780–1867) and that holds an undeniably important position in the annals of modern art.

When he was not working in his studio, Degas – the ultimate Parisian *haut bourgeois* – could invariably be found artistically recording the activities he saw at such places of refined entertainment as the opera house, the ballet, or the racetrack, or perhaps enjoying a popular singer's performance at a café-concert. Much like Edouard Manet (1832–1883) or Charles Baudelaire (1821–1867), he cultivated his role as *flâneur*, as an attentive stroller on the boulevards of the capital. But whereas an artist such as Manet gladly took part in society life and by no means avoided partaking in the sensuous pleasures offered to him, Degas assumed an air of detachment, and was thus all the more sharp-eyed as an observer of urban events. And the depiction of the human figure was the central theme of his art.

He did, however, paint a few pure portraits – of relatives and close acquaintances – but he was usually not interested in a psychological penetration of his fellow human beings. More important to him were pointed and sarcastic portrayals of people in certain situations, or the capturing of the human body in motion (plate 9). A close examination of his ballet pictures reveals that they by no means record the individual characteristics of a dancer or her companions, and even less so their momentary psychic situations. And the alluringly dainty tutu is also just an occasional impressionistic addition, not in itself the main reason for painting. What Degas actually represents are momentary recordings of motion, and of sequences of movement being played through by entire groups of figures. Because their nearly uniform outward appearance depersonalizes the ballet dancers, the sequence of their movements can be divided among several figures with great effect, such as in Degas's multiple representations of single figures. While chronophotography may matter-of-factly show successive stages of movement, however, Degas experimented with every form of artistic arrangement to create a seemingly uncoordinated, loose collection of female figures and to envelope them in soft pastel. The effect can be

seen in pastels such as *Dancers* (plate 10) of 1902, which was done during his years of increasing blindness. Here each figure appears preoccupied with her own movements, but each is also an anonymous part of a unified group. The artist himself becomes the imagined ballet master.

Beginning about 1872, Degas took up the theme of dancers. Next to his many variations on female nudes at their toilet, dancers became his leitmotif, and indeed depictions of them account for more than half of his output. With Degas, the dancer became the embodiment of the "Eternal Female." He remained unmarried all his life and had a difficult relationship with women, but he devoted his whole attention to precisely that "suspect" being, Woman. It is overly obvious that the less threatening feminine aspect of the "gamine," of the adolescent, especially fascinated Degas – and not just the artist himself. The dressing rooms of ballet girls, even the backstage area of the old Paris Opéra, were a popular "hunting preserve" for well-to-do men, something that prompted a lively, mocking commentary from Eugène Chapus in "Le Sport à Paris": "Despite the measures that were destined to thin out the crowds of visitors backstage at the Opéra, this has at most only succeeded in eliminating a few feature-writers, also some authors and composers. There is no room for professional curiosity. But, if only you are a financier, a stockbroker, a rich foreigner, a diplomat, an embassy attaché, a man of the world in high repute; if only you have influence in powerful places ... if only you are something like the uncle of a dancer, or her *protector* ... then the portals become open to you. Many serious men normally involved in important business deals, financiers whom one imagines in their clubs smoking and playing whist, many diplomats whom one believes circulating in high society ... are there, in the evening, finding fantastic shelter amidst the hubbub behind the scenes of the Opéra."[1]

Admittedly, Degas always maintained discretion and loathed every form of pushiness, and even sarcastically commented upon the presence of these men everywhere in his paintings, representing them as black silhouettes. Nonetheless, his image of Woman is sharply revealed when one considers how extensive were his dealings, as an artist from the privileged upper classes, not only with the ballet girls, but also with the laundresses, the ironing-women, the popular singers, and, finally, the prostitutes. It corresponded to his archconservative attitude

It is safe to assume that the women who served Degas as models for the female nude at her toilet also belonged to such circles, for they were far more comfortable with their nakedness than certainly any society women would have been. Degas strove to capture the animal-like movements of the female body, "the cat licking itself." If at the time he was rebuked for the "ugliness" of his nudes, and for ignoring the voyeuristic public's desire for voluptuous sensuousness, it is today much more his view of Woman as such — as it was during the entire nineteenth century — that alienates. And in the end Degas's perspective on the female nude — washing or drying herself, combing her hair or having it combed — is by no means less voyeuristic simply because he de-emphasizes any directly sensual, erotic aspects. But even if the idea of the "Eternal Female" does not lose its bitter flavor with Degas, and despite all the contradictions, because of his unsparing manner of observation he did indeed create a radically new image of Woman.

Since Degas was financially independent and never needed to cater to the tastes of a buyer, his search for true-to-life representation bore unmistakable witness to a certain reality of female life; one need only look at *The Little Fourteen-year-old Dancer*, a painting of the young dancer Marie van Goethem done at the beginning of the 1880s. In her rather aloof grace and the whole of her emaciated frame, she is a manifestation of the kind of "anemic specimens in deplorable health ... worn out through an early devotion to this work ... real dancers with springs of steel and knees of iron,"[2] remarked upon by Joris-Karl Huysmans. But their "plebeian coarseness and poverty"[3] was actually celebrated by Degas, among others. Increasingly threatened by blindness in his old age, he turned into a misanthropic grouch, but still wrote gushingly about "his dancers": "even when settled in a golden palace, let her, who by ancestry and soul descended from Montmartre, never forget her street-bred race" ("Montmartre a donné l'esprit et les aïeux... garde, au palais d'or, la race de sa rue.")[4]

Ursula Straatmann

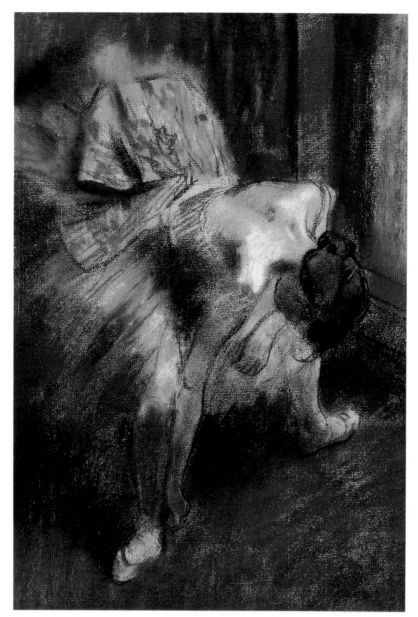

Edgar Degas, *Woman with a Green Tutu*, 1880–85, pastel on paper, private collection, London

— which also included a marked anti-Semitism — that a woman was a priori second-class, and all the more so if she had a lowly social standing. In Degas's day, a girl who was part of the world of the ballet was usually from the lower classes, and she quite often had to give up her school education in the hope of fulfilling her family's desire for upward social mobility. Sometimes a few of them rose to become celebrated prima ballerinas, but others turned to occasional prostitution in order to make a living. No less victimized were laundresses and ironing-women, who flocked in droves from the provinces to the capital, and were forced to subsist on the lowest of wages. All the types of lower-class women that Degas depicted in his work were meant as synonyms for sexual availability; by no means did that apply only to the plump "ladies" waiting for clients in bordellos, whom Degas in his monotypes captured in their full disillusionment.

1 Eugène Chapus, in Robert L. Herbert: *Impressionismus. Paris: Gesellschaft und Kunst* (Stuttgart, 1989), p. 126 [translation of *Impressionism: Art, Leisure and Parisian Society* (New Haven, 1988)]
2 Joris-Karl Huysmans, ibid., p. 149
3 Ibid.
4 Ibid., p. 150, and *Die Degas Portraits* (exhibition catalogue, Kunsthaus Zürich and Kunsthalle Tübingen, 1994–95), p. 55

Paul Cézanne

In the work of Paul Cézanne (1839–1906), the ideas and fantasies revolving around "L'Eternel Féminin" converge upon the "Bathers" – a theme running like a leitmotif through the artist's work. The motif allows understanding of a remarkable process of development: one born in doubt and protest and culminating in the transformation of the world in color. The theme of the bathers exemplifies how in Cézanne's work gender conflicts in the nineteenth century dissolve into a modern, yet timeless, Arcadia, in which color and form themselves become the means through which Eros is expressed.

Cézanne's motif was part of a great tradition that had its origins in the pastorals and rural idylls of the sixteenth-century Venetian masters. The theme of nudes in the midst of Arcadian settings has its roots in the works of Giorgione (ca. 1476/8–1510), Titian (ca. 1487/90–1576), and Palma Vecchio (ca. 1480–1528), all of whom depicted figure and landscape, nude and nature in a harmonious union, intending to celebrate a reconciliation of man and nature. But this was only a dream world, and the young Cézanne held up to it the unsparing mirror of his own inner reality shaped by unfulfilled passions and the verse of Charles Baudelaire. Seized by an obsessive ferocity, he would take his palette knives and spatulas and attack his canvases, which were filled with images of seduction and abduction, rape and murder. It took until the 1870s before Cézanne was able to rid himself of these images, largely under the influence of Camille Pissarro (1831–1903), who became a kind of father figure. At that time Cézanne began to recall his happy childhood – when he, Emile Zola (1840–1902), and Baptistin Baille wandered through the landscape around Aix-en-Provence, climbing hills, swimming, and, beneath the cool shade of a tree, declaiming the words of Victor Hugo, Alphonse Lamartine, Alfred de Musset or, over and again, Baudelaire's "Les Fleurs du mal." To the end of his life, Cézanne would often become nostalgic for the idyllic days of his youth, and would gratefully remember the "feelings that the fine sun of Provence awakened in us." Many years later, Zola wrote in his novel L'Oeuvre: "In their unthinking boyish worship of trees and hills and streams, and in the boundless joy of being alone and free, they found an escape from the matter-of-fact world, and instinctively let themselves be drawn to the bosom of Nature." Thus it can be safely assumed that Cézanne's images of bathers invariably resonate with

memories of his youth, of his experiences, and of the picturesque Arc, the tiny river that flows through the valley of Aix.

The Bathers of ca. 1870 (plate 11) represents an extraordinary stage in the development of the theme. It is the first painting to show bathing figures against a landscape in which can be recognized Cézanne's "holy mountain," the Montagne Saint-Victoire. The painting was done at the time of the Franco-Prussian War, when he felt it necessary to withdraw to L'Estaque, a small fishing port near Marseille not far from Aix-en-Provence, his hometown. In L'Estaque he lived with Hortense Fiquet, the mistress whose existence he was able to keep secret from his unsympathetic father for fourteen years (see illus. p. 22). The charade went on until his father, who was still opening his forty-four-year-old son's letters, finally learned of Hortense's existence – and the existence of their son Paul – and called him to account.

This early painting of bathers is still very much rendered in violent brushstrokes inspired by Eugène Delacroix (1798–1863). Dramatic contrasts of light and dark draw the figures out of the mysterious darkness of the river landscape. Counterbalancing them, an imposing cloud formation gathers over the peak of Montagne Saint-Victoire. The four female bathers are rendered in poses taken from Cézanne's stock repertoire, as Mary Louise Krumrine has proved in her careful examination of the theme of the bathers, until now the most comprehensive.[1] The composition is defined at the right edge by a reclining figure that is modeled on one in Titian's *Bacchanal*. To the left, a standing figure attempts to avoid the viewer's gaze with a gesture of modesty, while a seated woman raises her arm above her head, offering herself to viewers as a seductress. In the background, another female figure runs toward a male figure who has been hiding behind a tree in order to spy on the bathers. A tree closes off the left side of the picture in a Baroque manner. One can safely assume that the male figure is the artist himself, who has intruded into the Arcadian setting of his native region in southern France like a Pan observing bathing nymphs. The painting has a narrative quality in which Cézanne shows the dramatic climax of the story. Like the popular theme of Actaeon surprising Diana at her bath, here too the moment is depicted in which the bathers discover the male observer. For his shameless conduct Actaeon had to pay with his life. For Cézanne, confrontation with the

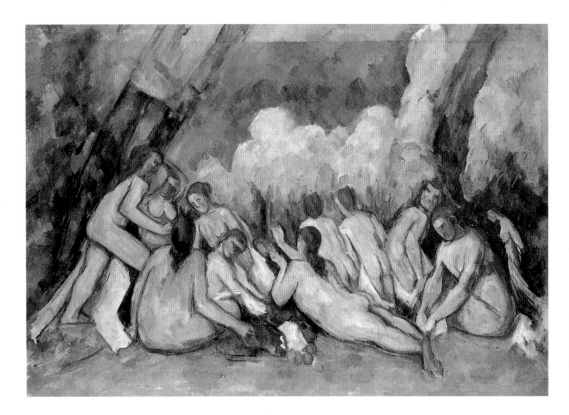

Paul Cézanne
The Large Bathers
1895–1904
oil on canvas
National Gallery,
London

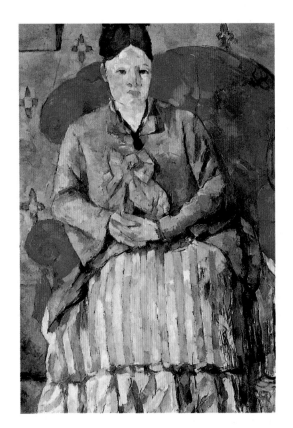

Paul Cézanne
Madame Cézanne in a Red Armchair, 1877–78
oil on canvas
Museum of Fine Arts, Boston
Bequest of Robert Treat Paine

naked female was at the very least heavily charged with fear and doubt. In his later years he avoided the live model altogether, and based his compositions exclusively on sketches and designs from his younger days.

As a result, his paintings lost their narrative character, and the theme of the opposition of the sexes was no longer important for him. It was the paintings themselves that became Arcadia: a crystalline Arcadia of color and form, a "harmony parallel to nature," where the idea of the "Eternal Female" ultimately gave way to an interest in the play of colorful contrasts (see illus. p. 22).

1. Mary Louise Krumrine: *Paul Cézanne: Die Badenden* (Basel, 1989), p. 251

Paul Gauguin

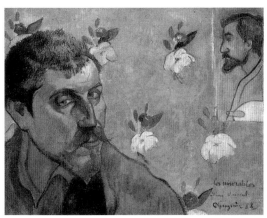

Paintings of women play an unusually dominant role in the work of Paul Gauguin (1848–1903). None of his painter friends took as great an interest in the subject. As early as 1879, when he was still living as a respectable bourgeois and just beginning to play the dilettante in the area of the visual arts, he sculpted an idealized, traditionally classical marble bust of his wife Mette. At this time Gauguin still followed the traditional rules of art, just as he willingly subordinated himself to the constraints of bourgeois existence and played his roles of stockbroker and head of a family without signs of distress. Only years later, after separating from his wife – she returned with their children to Denmark – did the manner of Gauguin's portrayal of women also change. By throwing off his bourgeois existence like an old coat of which he had become weary, he also gained the freedom to break with conventional academic forms in his art. Gauguin's subsequent contact with the Impressionists was also only an episode, however, and it took until the end of the 1880s, following his fateful encounter in 1888 with Vincent van Gogh (1853–1890) in Arles, for him to discover, in his paintings done in Brittany, his own revolutionary and personal style. He heightened his color to an explosive intensity and enclosed figures and objects in dark outlines, in order to separate and give structure to his glowing areas of light.

Where do his female figures fit into this new pictorial world? Formally, they take on no special status; they are treated exactly like everything else he depicts. But what sort of women are these, anyway, who now appear in his work? These peasant women are rapt and ardent, and full of concentration and devotion, but they lack any kind of feminine aura – there is no Eros, no power of attraction. *La Belle Angèle* is a wonderfully painted picture in which the subject contradicts all ideals of beauty. Constrained by her traditional costume and old-fashioned headdress, she gazes out at viewers from beneath lashless lids, reserved and indifferent. The narrow, oval space in which she lives (and thinks) separates her from a temptingly mysterious world – one of strange gods and exotic vegetation that she will never encounter.

Gauguin saw the Breton peasant woman as, at best, the victim of a narrow-minded, intolerant caste system. But for bourgeois women he harbored only contempt, seeing in them dependent creatures of a corrupt society, not even worthy of depiction. The much-celebrated "Eternel Féminin" was for him at that time nonexistent – he was not able to find it anywhere in a civilization he simply considered inhuman. His personal relationships with women were also shaped by these ideas, his contacts with the female sex essentially limited to occasional visits to brothels. The sudden seething passion for Madeleine Bernard, many years younger and the sister of the artist Emile Bernard (1868–1941), remained unconsummated. Gauguin naturally attributed this entirely to societal prejudice. Bernard spoke out against the liaison ("I fear he is destroying her…"), and Madeleine finally made up her own mind to reject a man almost twenty years her elder. None of this concerned Gauguin, for he knew too well what was happening: bourgeois Europe was in its death throes, and all of its principal players – women included – were trapped in the inflexible rules of a civilization gone barren.

A picture like *La Belle Angèle*, however, showed that Gauguin maintained his faith in a better, unspoiled world. He could not find it in his surroundings; it existed somewhere beyond his, and beyond the subject of the painting's, immediate environment. In a letter of 1889 to Emile Bernard, he expressed his desire: "The Occident has arrived at its nowhere, and all who wish to follow Hercules might, like Antaeus, gather new power in those fields from which one returns all the stronger after a year or two."[1]

Gauguin determined to find this untouched and better world, to seek it out somewhere beyond the borders of Europe. He dreamt of an "atelier aux tropiques," where he would work together with his friends, and he did his best to awaken their interest in his plans. He depicted the tropical countries he intended to visit in the most attractive manner possible. But neither Bernard, nor Charles Laval (1862–1894), nor Jacob Meyer de Haan (1852–1895) were convinced.

Gauguin was left entirely to his own devices, but he became even more determined to leave Europe. The decisive influence was his reading of the novel *Le Mariage de Loti* by Julian Viaud (1850–1923), which made him focus his attentions upon Tahiti as the object of his journey. The story describes how a young sailor receives the nickname "Loti" while in Tahiti, lives among the Maori, and in the end marries an enchanting thirteen-year-old girl. The plot is obviously quite similar to Gauguin's own subsequent reports of his real and fabricated experiences in the South Seas, of which he wrote in his book *Noa Noa* (1893). In it, an encounter between his young Tahitian companion

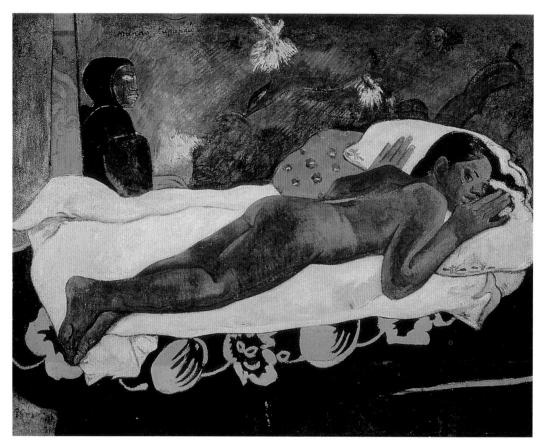

Paul Gauguin, *Spirit of the Dead Watching (Manao tupapau)*, 1892, oil on canvas, Albright-Knox Art Gallery, Buffalo, New York

Teha'amana and an older French lady is turned into a parable: "At Taravao, I returned the horse to the gendarme. His wife, a French-woman, said to me, not maliciously, but tactlessly: 'What! You bring back with you such a hussy?' And with her angry eyes she undressed the composed girl, who met this insulting examination with complete indifference. On the one side a fresh blossoming, faith and nature; on the other the season of barenesss, law, and artifice. Two races were face to face, and I was ashamed of mine. It hurt me to see it so petty and intolerant, so uncomprehending. I turned quickly to feel again the warmth and the joy coming from the glamor of the other, from this living gold which I already loved – I can remember it exactly."[2]

Of his life with Teha'amana Gauguin writes: "Then a life filled to the full with happiness began. Happiness and work rose up together with the sun, radiant like it. The gold of Tehura's face [as Gauguin calls Teha'amana in his book] flooded the interior of our hut and the land-scape round about with joy and light. … How good it was in the morn-ing to seek refreshment in the nearest brook, as did, I imagine, the first man and the first woman in Paradise. … By the daily telling of her life she leads me, more surely than it could have been done by any other, to a full understanding of her race. The Tahitian Noa Noa [in the exact written form 'no' ano' a,' the word means 'scent' or 'pleasant-smelling, fragrant'] fills me up. I am no longer conscious of days and hours, of good and evil. I only know that all is good, because all is beautiful. And Tehura never disturbs me when I work or when I dream. Instinctively she is then silent. She knows perfectly when she can speak without

disturbing me. We talk of Europe and of Tahiti, and of God and of the gods. I instruct her. She in turn instructs me.…"[3]

Gauguin had found the truth and the reality of the "Eternal Female," and from that moment rendered homage to it in more than two hundred colorful and luminous paintings, creating ever new and intensive variations. In the process he succeeded in felicitously syn-thesizing aspects of Western art history and iconography with the heightened colors and exotic forms he discovered in the South Pacific, while still subordinating all elements to his purposeful form. An excellent example is the painting *The Delicious Earth (Te nave nave fenua)* (illus. p. 25). Here Teha'amana is undoubtedly being portrayed as Eve in Paradise, in the "hortus deliciarum" or "Garden of Delights" that was first described in the twelfth-century illuminated Alsatian manu-script of the same name. The manuscript had served as the model for thousands of similar pictures of Paradise in Western art, and gave the name to the whole genre.

In Gauguin's version, however, instead of the serpent, a black lizard sits in the Tree of Knowledge over Teha'amana's right shoulder. The Polynesian Eve is not plucking an apple, but a visionary flower that looks like a peacock feather. Her composed form, her nearly statuesque body, fills almost the entire right side of the painting, dominating the composition. Minutely detailed, strongly colored forms surround her in ornamental wealth and splendor. But Gauguin is not merely creating a decorative and at the same time suggestive picture. He is also re-claiming for painting the literary element that the Impressionists had

banished from their work. Without ever falling into the anecdotal or the coincidental, and entirely with the pictorial means of his own invention, Gauguin "narrates" his opinions and stories, conveys to the viewer his desires and ideas, and in the end paints his image of the world, of a yearning for a reconciliation between civilization and nature, and between culture and the "primitive." But in the real world this state does not occur. It is left to Gauguin's pictures to mediate an idea of it to Europeans.

In 1893 Gauguin attempted, with the sixty or so paintings he had up to this time produced in the South Pacific, to achieve recognition in France, and to gain the status of a celebrated artist. This effort met with failure, and he returned to Polynesia for good. In a passionate struggle with Church and State, and living under increasingly impoverished conditions, he held to the ideal image of Woman that he had gained, although he had by now given up any hope of ever finding recognition for his paintings. In a letter of April 1896 to his friend Daniel de Monfreid (1856–1929), he writes: "I have just finished a picture I × I.30, which I consider to be better than anything I have done before. A naked Queen rests upon a green rug, a maid plucks fruit, two aged men discuss science near the great tree, a beach background…. I believe as far as color is concerned I have never made anything of greater or more ponderous resonance. The trees blossom, the dog guards, the doves coo. Why should I send the picture to them, they already have so many of mine, and they aren't being sold and only provoke a great outcry. This will cause an even greater outcry!"[4]

But soon after Gauguin's death the "outcry" turned into a general admiration. In 1906, 227 of his works were exhibited in Paris, and the painter's name was discussed everywhere. His pictures of women fascinate the art public: although their bodies are beautiful, their almost cubic volume precludes any "sentimentality." Their skins have a sensuous, subdued gloss, although color rigorously obeys strict rules of composition. These women never smile; nonetheless, they radiate serene composure. For all their idealization and typification, they possess convincing honesty and touching humanity. Their message, then as now, remains: "Soyez mysterieux, soyez amoureuses."

Eckhard Hollmann

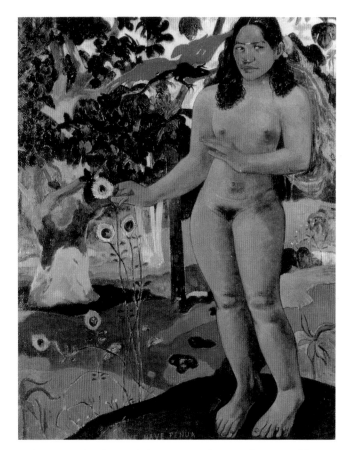

Paul Gauguin, *The Delicious Earth (Te nave nave fenua)*, 1892, oil on canvas, Ōhara Museum of Art, Kurashiki, Japan

1 Henri Perruchot: *Gauguin: Eine Biographie* (Munich, 1991), p. 209
2 Paul Gauguin: *Noa Noa*, ed. Jean Loize (Munich, 1969), p. 42
3 Ibid. p. 44
4 Paul Gauguin: *Briefe an Daniel Monfreid*, ed. Kuno Mittelstädt (Berlin, 1962), p. 34

Pierre Bonnard

Pierre Bonnard was born on October 3, 1867, in Fontenay-aux-Roses, a suburb of Paris. After finishing high school in Paris at the Lycée Louis-le-Grand in 1885, he resolved to study law at the Sorbonne. Three years later, however, he switched to the study of art at the Ecole des Beaux-Arts and the Académie Julian in Paris. The latter, a private art school, was also attended by Maurice Denis (1870–1943), Edouard Vuillard (1868–1940), Paul Ranson 1861–1909), and Paul Sérusier (1864–1927). Together with these artists, Bonnard founded the group the Nabis in 1888. The name derives from the Hebrew word "Nebi'im," meaning

"the prophets" or "the enlightened," and clearly suggests the group's objective: to develop a new aesthetic and to break free from the constraints of academic painting. They hoped to liberate art, especially painting, from the imitation of nature and to free it from the illusionistic, naturalist techniques taught at art academies. Instead of viewing nature "objectively" and factually, the Nabis tried to work from personal experience in an immediate and emotionally charged way. They hoped to translate experience directly into painting without regard for visible reality. Their efforts necessitated a new view of art, the beginnings of which were already visible in the paintings of Paul Gauguin (1848–1903). Denis, who was the theorist of the group, first definitively formulated the underlying idea in his famous statement of 1890: "Remember that a picture, before being a war-horse, a female nude or some anecdote, is essentially a flat surface covered with colors assembled in a certain order."[1]

This basic but yet revolutionary perception opened new avenues of pictorial expression. The subject of a picture – visible reality – declined in importance relative to artistic idea. The pictorial motif could be rendered in decorative and flat forms, and colors could be arranged according to aesthetic criteria. Henceforth, visible and invisible alike – not only the represented object, but also the artist's feelings and fantasy – were to determine composition, without regard for faithful reproduction of objects.

Bonnard realized the new objective most completely in his paintings, where subjectively felt themes are rendered in rich, splendid color. As were other Nabis, he was filled with admiration for Gauguin. The simplified forms in Gauguin's pictures corresponded to Bonnard's own artistic concept – moreso once he had acquired an interest in East Asian art, specifically Japanese wood-cuts. An admiration for Japanese

graphic art reinforced his understanding of the decorative qualities of pictures, his emphasis on surface color in simplified outlines, his ornamental design principles, and his predilection for linear arabesques. All this prompted his painting colleagues to nickname him the "Nabi très japonard."

At the end of the nineteenth century, Bonnard was still heavily indebted to the flat linear style of the Nabis, and he still had a preference for all things Japanese. But after 1900 his oils become increasingly softer and more painterly in interpretation. He began to introduce plastic and spatial elements into his work, and the subdued and softened light of his early period gives way to a rich range of luminous and bright colors. His frequent periods of residency in the south of France no doubt exercised a decisive influence on his choice of colors. Greens, turquoises, violets, and delicate yellows alternate to create a wonderful variety in his paintings. He integrated figures ever more thoroughly into a finely differentiated fabric of color that extends over an entire canvas, enveloping it with an atmosphere of intimacy.

After 1910, his application of paint appears more and more Impressionist. He stippled colors into small vibrating spots, similar to Claude Monet (1840–1926). But the character of Bonnard's painting is otherwise completely different; unlike Monet, he was not concerned with capturing momentary, shifting effects of light. Instead, he was convinced that color alone could be the primary means of expression, with no need for further emphasis or shaping. He wanted to reproduce light, form, and character exclusively through color.[2] Bonnard had an acute feeling for the application of color, and he employed hue and tone with great discretion and sensitivity, regardless of whether he was painting the skin of a piece of fruit, the surface of an article of furniture, or the flesh of a woman.

Instead of description, Bonnard employed suggestion. This was his way of making a felt reality, while also allowing enough room for the observer to exercise his imagination. He composed paintings from memories of color experiences, with no intention of imitating reality; instead, he conveyed the emotions felt during these moments of sensation.

With Baudelaire in mind, Maurice Denis described Bonnard as a painter "de la vie moderne" – one who did not search for mythological or religious themes, but who instead found his subject-matter in his immediate environment, the Parisian bourgeois milieu: society

women, glimpses of fleeting faces in crowds, crowded boulevards, a lady with a little dog captured in the anonymity of the big city, or intimate, homey interior scenes (see illus. p. 29).

People were his most important subjects, especially women. He invariably depicted women who were very contemporary in their aspect, and always in emphatically fashionable dress. After 1900, he increasingly concentrated on bourgeois interiors, and he frequently depicted women bathing or dressing. The beguiling aspect of his art is thus not to be found in the variety of his motifs, but rather in their limited number. He painted endless variations and reworkings of the themes he knew best. The many paintings of Marie ("Marthe") Boursin, whom he met in 1893 and who soon became the center of his life and art, show this clearly. Marthe became his model and, in 1925, his wife.

Bonnard's early concern for the female is already apparent in his urban scenes. Women are often momentarily portrayed as part of the life of everyday Paris. His painting of 1894, *The Flower Shop* (plate 13), depicts two elegant Parisiennes in fashionable dress wearing large hats, who pause in front of the window of a flower shop. Their forms are silhouetted, flat, and unmodelled, in the typical Nabi style. The decorative, stippled pattern of their clothing corresponds to that of the flowers on display. The slim female forms melt into the colors of their surroundings. Rendering the Woman is secondary to concerns of stylization and the decorative play of forms and hues. Garments acquire a certain pictorial independence; compositional techniques of flatness and ornamentalization have higher priority than does the portrayal of the women as particular individuals.

Time and time again, the streets of Paris and their constantly moving crowds of people inspired Bonnard to painterly renditions of individual urban experience. The avenue de Clichy and place Clichy were his favorite motifs. In the early 1890s he shared a studio with Edouard Vuillard at rue Pigalle 28, not far from place Clichy, and it was at this time that the area began to serve as inspiration for many of his paintings. One of the most brilliant pictures in his series of fleeting Parisian scenes is *Place Clichy* (plate 17), painted in 1906–07. Such instantaneous renderings show that the artist was searching for topical subjects as a way to thematize coincidence and ephemerality. This idea had been put forth by Baudelaire, in his essay "Le Peintre de la vie moderne," as a metaphor describing the very substance of modernity and modern urban life.[3] According to Baudelaire, modernity was fittingly embodied in dress *à la mode*. The only other alternative for the artist would be a deliberate disguise that would be so obviously different from contemporary dress.[4] Bonnard's *Place Clichy* seems to reflect Baudelaire's version of modernity, intensified through a conscious emphasis on the pedestrians' fashionable and contemporary clothing.

The overly crowded square is shown as the setting for the new urban life-style of the bourgeois Parisian. Finely textured and muted nuances of gray are used to stress the bright, atmospheric, diffuse light so characteristic of Paris in the winter. Bonnard chose a palette of relatively dark colors to render the busy, scurrying Parisiennes in the foreground and middle ground, creating a stimulating contrast to the unfocused, calm backdrop of the elegant Parisian buildings, painted in a bright palette.

Despite the carriages, horse-driven omnibuses, bicyclists, and playing dogs, the main focus is on the variety of female types. The feminine aspect is made immediate in the form of a Parisienne who steps out of the crowd toward the viewer, almost as if wanting to initiate a dialogue; this lends an element of tension and directness to the painting. Self-confidently working her way through masses of people on the densely crowded square, she momentarily captures the artist's attention. Her presence is accentuated through her clothing, a well-fitting short jacket in warm browns and reds, which is in strong contrast to the dark grays worn by the other female figures. Bonnard's paintings of Paris at the turn of the century are filled with animated women of this type.

Bonnard was a master at portraying womens' faces in extreme close-up in a crowd. Their features seem bathed in light, stressing the fleeting and ephemeral nature of each female form captured only for an instant. Time seems to stand still, and figures become frozen in movement. The resulting impression is of a moment in which the stationary figure in the foreground contrasts with the activity and gaily colored movement behind it. The figures are cut off by the edge of the canvas, and the view is tightly framed, suggesting the fragmentary character of an Oriental woodcut. Such pictorial fragments demand to be considered as indications of an all-encompassing whole, of all the colorful and multitudinous activities that take place in the metropolis of Paris. Through superimpositions and the cutting off of figures, reality is shown only in fragments, simultaneously arousing curiosity and intimacy. Viewers feel as if they are drawn into the flow of events and are actually encountering the woman, or they feel as if they are sitting at the table in *Café in the Woods* (plate 14) of 1896, where subtle harmonies of pale yellow and the glowing red lanterns reinforce the inviting atmosphere of the evening café scene. Here, as in other works, Bonnard depicted the Woman in a rather restrained fashion. Only her feathered hat, skillfully rendered in tones of beige and gray, and her red lips, reveal a muted sensuousness and the mysterious attraction of the "Eternal Female."

The exceptional aspect of Bonnard's work is undoubtedly his ability to merge the figure and its surroundings in a harmonic synthesis, and this finds its expression most of all in his sensuous and secretive female nudes, another of his favorite themes. The color of the figure tends to dissolve into her environment, creating a single whole. This idea was continually pursued with pronounced sensuality and devotion. Bonnard's women do not represent particular personalities, but they appear as symbols and embodiments of femininity, exuding a harmonious intimacy in their aura of delicate colors.

The portrayal of the nude culminated in a series of pictures that resulted from Bonnard's relationship with Marthe. Her daily toilet, and his general familiarity with her womanliness, were inexhaustible sources of visual inspiration. Her body is always shown in its youthful beauty and its sensuousness, even in the smallest details. Marthe constantly presented Bonnard with new possibilities for picture-making. Despite his emotional and personal connection, he always treated her with a certain detachment. For him, she embodied less an individual personality than she did a particular type of woman. Bonnard assuredly brought great feeling to his depictions of nude women, but, with a few exceptions, he did not paint erotic mood studies intended to arouse.

He inclined much more toward an intimate and restrained image of the female.

Bonnard's women are rarely consciously posed. Instead, he painted many fascinating pictures of women in everyday situations: washing themselves, drying themselves, combing their hair, or observing themselves in mirrors. He observed his models at close range without actually becoming a voyeur. In their unconventionally natural poses, his nudes recall Edgar Degas (1834–1917), whose paintings of women at their toilet were nearly all exhibited in Paris between 1900 and 1910. The visual excitement in Bonnard's paintings comes mainly from the painterly attraction of the naked body, and the shimmering colors of the bathroom. These scenes are always set in the interior of a bourgeois home, in a place of security and domestic contentment.

Bonnard's series of female nudes run as a leitmotif throughout his work. However, his earliest two paintings of nudes to have become well known are exceptional in that they depict females in a seductive and directly erotic manner: "Indolence" (plate 15) of ca. 1899, and *Man and Woman*, painted in 1900. In these works, sensuousness – that of the *fin-de-siècle femme fatale* – is made perfectly obvious, quite unlike the later nudes. That, as well as a confident lasciviousness – the woman in "Indolence" unashamedly displays her nudity to contemporary viewers – makes the picture most unusual. Consciously establishing eye contact, this woman challenges viewers to look at her with the same frankness with which she displays herself on the bed-sheets in front of them. In all of Bonnard's work, these are the only two paintings that express themselves so uniquely and daringly. Later nudes have a new, entirely different feeling to them – one that is already apparent in *Woman with Black Stockings* or *The Shoe* (plate 16), a painting of 1900. In a room flooded with sunlight, a young girl sits at her dressing table, completely uninhibited and immersed in herself. Her half-naked, pale, gleaming body contrasts with her black stockings, a theme that artists at the turn of the century often played variations on. As well as depicting the erotic allure of exposed skin and provocative garments, the painting conveys an atmosphere of intimacy and warmth. The soft, velvety, and rather subdued watery light in the pictures of earlier nudes has here given way to a brighter, clearer, more ethereal palette. Quite unlike the nude in "Indolence," the figure in this painting seems incidentally perceived, unaware of either artist or viewer.

In the years that followed, Bonnard treated his nudes more and more exclusively as studies in color. Soft, finely gradated, and in bright hues, they take on the character of delicately modelled sculptures. By the time the development is complete, the emotion of his pictures is essentially carried by the colors in which he renders female forms.

In the period after 1900 and up to the end of the First World War, Bonnard preferred to paint nudes who are bent forward or standing upright; later he also painted women reclining in bathtubs. Whether or not it is apparent that he tried to render them with an objective eye, the women in these later paintings radiate a calm, composed sensuousness, with no desire whatsoever to arouse an observer.

Displayed publicly in this exhibition for the first time since it was shown at Bernheim-Jeune in Paris in 1913 (the year in which it was painted), *Crouching Woman* or *Nude at the Tub* (plate 18) may certainly be counted among the most extravagant and expressive works of art arising out of Bonnard's interest in nudes. This painting is unique merely because of the extraordinary pose. Crouching, without a trace of self-consciousness, fully engrossed in her routine of bathing, the delicate and yet powerful figure kneels before a washbasin, her posture boyishly natural. The model is surely his lifelong companion Marthe, whose characteristically slim figure is unmistakable.

The painting elicits a feeling of calmness and intimacy characteristic of Bonnard's nudes by means of an appropriate range of color, strongly simplified formal language, and the model's self-involvement. The kneeling woman's face is hidden from the viewer, a peculiar pose that the artist favored when he painted nudes.

In a particular group of nude studies, a bright glow surrounds the female figure, intensifying the overall color saturation. In *Pink Nude with Shadowed Head* of 1919, the colors of Marthe's body are related to those of the background, as if the figure were framed by the variegated wall and its areas ranging from yellow to violet. This is a singular painting of Bonnard's because of its simple composition, consisting only of verticals and horizontals and totally without toilet items and wallpaper patterns. It foreshadows the nudes that the artist would paint in the 1920s and 1930s. Essentially nothing other than a depiction of a female body surrounded by soft colors, the painting concentrates on the essentials: the nude figure, undisturbed, is allowed to extend itself, familiarly and languidly, through the entire space of the canvas.

Bonnard reduced his formal vocabulary to a minimum once again that same year in *Marthe Dressing* (plate 19), again devoting himself exclusively to a nude female form and a shimmering, splendid array of color. A conscious effort at compositional clarity is very much in evidence. The body forms a central axis, acting as a vertical counterpoint to the horizontal and oval forms. Flooded with light, the figure takes on its own illumination, powerfully radiating an envelope of tones. Iridescent violets and greens submerge the whole interior into a diffuse atmosphere of color. The painting seduces the viewer through its interplay of colors: the gently iridescent areas of wall, the powerful orange of the bathtub, and the incarnation of Marthe radiating golden-yellow, her face in subdued light and with light shadows, obviously evoking a mood similar to that of *Pink Nude with Shadowed Head*.

In Bonnard's work, the female figure and the space around it are harmoniously and intimately interlocked. The artist does not show nudes in isolation. Posture, gesture, and clothing are firmly bound up with the constituent color of each detail, as is the whole body within the form and the pervading coloration of the picture. The colors create the emotional framework. By defining the body and the space around it, they reinforce, in a manner quite typical of Bonnard, the relationship between Woman and interior, or Woman and street scene.

With deliberation and sensitivity, Bonnard combined everyday scenes with a seemingly coincidental uniqueness, creating an aesthetic order transcending the banality of the subject, and turning it into something original. He painted an intimate still-life of the body, but one that concedes to woman only a limited measure of freedom or individuality of expression and personality. Bonnard's image of Woman is nonetheless gripping. With their sensitive tensions, their discreet qualities, and their lingering tranquillity, his colors make the

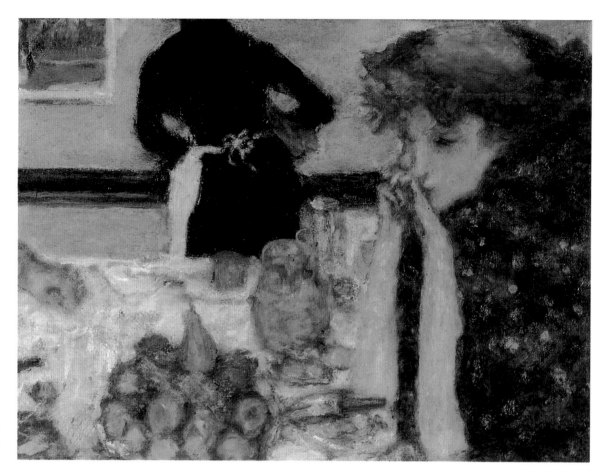

Pierre Bonnard
Luncheon
ca. 1899
oil on canvas
private collection

most reticent images come alive with expression. As a colorist and painter, in his refined feeling for hue and lack of emphasis on individuality or personal details, Bonnard evoked the pure sensuousness and seduction of the "Eternal Female."

Barbara Palmbach

1 Maurice Denis: *Théories, 1890–1910. Du Symbolisme et de Gauguin vers un nouvel ordre classique* (Paris, Rouart et Watelin, 1912), p. 1: "Se rappeler qu'un tableau – avant d'être un cheval de bataille, une femme nue, ou une quelconque anecdote – est essentiellement une surface plane recouverte de couleurs en un certain ordre assemblées."

2 "J'avais compris que la couleur pouvait comme ici exprimer toutes choses sans besoin de relièf ou de modelé. Il m'apparut qu'il était possible de traduire lumière, formes et caractère rien qu'avec la couleur, sans faire appel aux valeurs." Pierre Bonnard to Gaston Diehl, *Comoedia*, July 10, 1943.

3 Charles Baudelaire: *Oeuvres complètes* (Paris, Robert Laffont, 1980), p. 797: "La modernité, c'est le transitoire, le fugitif, le contingent, la moitié de l'art, dont l'autre moitié est l'éternel et l'immuable."

4. Ibid., "Si au costume de l'époque, qui s'impose nécessairement, vous en substituez un autre, vous faites un contresens qui ne peut avoir d'excuse que dans le cas d'une mascarade voulue par la mode."

Henri Matisse

Without doubt Henri Matisse (1869–1954) belongs among the few fully great charismatic personalities of twentieth-century art. After Paul Cézanne (1839–1906) and next to Pablo Picasso (1881–1973) – to whom he was bound through mutual respect, despite their striking differences in character – Matisse is considered the third decisive creative force in shaping the development of Modernist painting. Beginning with the tempestuous color experiments of his Fauvist years, and with great perseverance through fifty years of creative work, Matisse consistently developed his compositional idea of a perfected synthesis of color and form to the point where he celebrated his greatest triumphs in his eighties, with his positively youthful-looking late work. Matisse's work provided the essential impetus to his contemporaries as much as to succeeding generations of artists, above all to the young abstract painters in America. Viewers of his work get just as much delight today in encountering what one of his many biographers called "the fruit of happy meditations."

The whole of Henri Matisse's œuvre reveals an irrepressibly positive view of the world. We see it in the Arcadian scenes of such early works as *Luxe, calme et volupté* of 1904 and *Bonheur de vivre* of 1906, as much as in the "odalisques" of the 1920s, those orientalizing variants of the "Eternal Female" prefigured by *The White Turban (Lorette)* of 1916 (plate 21) – and finally in the *gouaches découpées*, the splendid, cut-out silhouette portraits of the early 1950s in which the artist once again turned to dance and music, two of his primary concerns. His devotion to the depiction of delight is by no means merely an unambiguous expression of a joy in the sensuous. It is not a matter of pure hedonism. Always tamed through the artist's sober self-reflection, it instead represents a search for an ideal synthesis of content, form, and color that would transport the mind of the viewer into a more pleasant realm.

"What I dream of," Matisse had himself formulated in 1908 in his *Notes of a Painter*, "is an art of balance, of purity, and serenity, devoid of troubling or depressing subject-matter, an art which could be for every mental worker, for the businessman as well as the man of letters, for example, a soothing, calming influence on the mind, something like a great armchair which provides relaxation from physical fatigue."[1] In the same treatise, in which Matisse sought to answer his critics and in which he explicated his artistic philosophy for the first time, but with

astonishing conviction, he also explained his thematic preferences and his relationship to color: "What interests me most is neither still life nor landscape, but the human figure…."[2] and: "The chief function of color should be to serve expression as well as possible…. My choice of colors does not rest on any scientific theory; it is based on observation, on feeling, on the experience of my sensibility…. But I simply try to put down colors which will render my sensation.

"There is an impelling proportion of tones that may lead me to change the shape of a figure, or to transform my composition. Until I have achieved this proportion in all parts of the composition, I strive toward it and keep on working. Then a moment comes when all the parts have found their definite relationships, and from then on it would be impossible for me to add a stroke to my picture without having to repaint it entirely."[3]

Matisse valued individual creativity above any rules, and he rejected the idea of sheer virtuosity. Having a sure feeling for the fine balance of form and color, he employed an increasingly streamlined technique to bring a world of serene composure into his work. But as logically consistent as his artistic development and fruition may look in retrospect, in the beginning it hardly seemed that he would ever amount to much as a painter.

He came from Le Cateau-Cambrésis, a small town in northern France near the Belgian border, where he was born on December 31, 1869. His mother was a decorator, his father a grain merchant. In keeping with his father's wishes, Matisse completed his high school education at Saint-Quentin, studied law in Paris, and then returned to Saint-Quentin to take up a legal apprenticeship in 1889. There he indulged his secret passion by attending morning courses in drawing at the Ecole Quentin de La Tour. In the end, it was during his long convalescence after an appendix operation that the twenty-two year old Matisse began to find his new orientation.

During the year he needed to recover, he passed the time by occupying himself with painting, and when he returned to Paris in 1891, he abandoned his legal career and entered the Académie Julian instead.

In the ten years that followed, Matisse worked unceasingly to master the world of traditional as well as contemporary French painting. He took courses at the Académie Julian from William Bouguereau

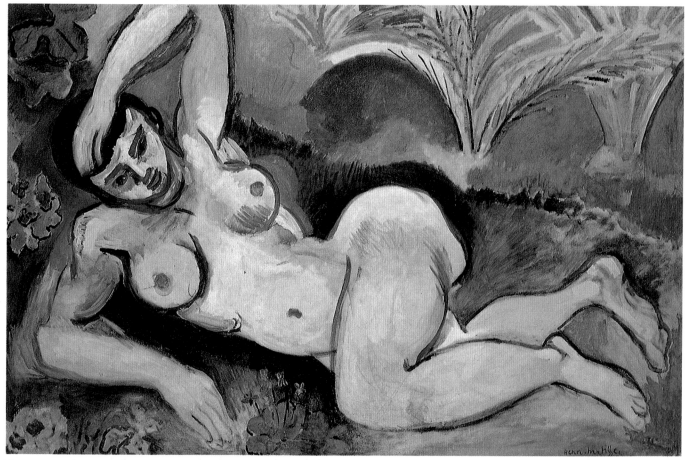

Henri Matisse, *Blue Nude (Memory of Biskra)*, 1906, oil on canvas, Baltimore Museum of Art, Cone Collection

(1825–1905), a highly-praised Salon painter, and then attended night school at the Ecole des Arts Décoratifs. From 1893 he became the unofficial pupil of the Symbolist artist Gustave Moreau (1826–1898) at the Ecole des Beaux-Arts, and in 1895 finally passed the test for official acceptance into the school. He continued studying in Moreau's studio for another four years. As a means of perfecting his manual ability, he also copied many of the masterpieces at the Musée du Louvre, from the work of Nicolas Poussin (1594–1665) to that of Jacques-Louis David (1748–1825). Although the luminous palette of Impressionist *plein-air* painting had by then become such an integral part of Modernist art, Matisse's early works are dark-toned studio pictures. But then, under the influence of the Pointillist Paul Signac (1863–1935), he began to explore methods of color separation. Matisse's discovery of Mediterranean light while on his honeymoon with Amélie Parayre played no small role in awakening his enthusiasm for the South – and for the radiant power of color. Returning to Paris, he still did not by any means feel mature enough to begin a career as an independent painter; instead, he began to study sculpture at the Académie Carrière. Cézanne, Paul Gauguin, and Vincent van Gogh also became his teachers, in that he carefully studied their paintings on display in the avant-garde galleries. In 1904, Matisse finally had his first exhibition, at the art dealer Ambroise Vollard's. Vollard acquainted him with a small circle interested in his work. But the difficult struggle for

existence – he was by now in his mid-thirties and had a wife and children – caused him for a while to seriously consider giving up his painting career.

The turning point came in 1905. After an inspiring summer stay at Collioure in the south of France, where Matisse worked with his fellow artists André Derain (1880–1954) and Maurice de Vlaminck (1876–1958), he showed his latest work at that year's Salon d'Automne in Paris. The public was outraged. "Tiens! Un Donatello parmi des fauves!" ("Look, a Donatello among the wild beasts!"). Thus exclaimed Louis Vauxcelles, critic for the magazine *Gil Blas*, upon viewing a bold gallery installation: a small bronze bust in the style of the Italian Renaissance sculptor set in the midst of colorfully effervescent paintings by Matisse, Derain, Vlaminck, Albert Marquet (1875–1947), Kees van Dongen (1877–1968), and others. The first genuinely revolutionary movement in twentieth-century art was thus given a name: Fauvism. What these "fauves," these wild beasts, had in common was by no means any kind of precisely defined artistic program. The only goal they had in common was a liberation from academic convention through their handling of color. The message of their work was that an arrangement of color and pictorial plane was independent, and could even be expressed in contradiction to the dictates of nature. Their objective was not to paint with the nuances of the Impressionist palette, but rather to strive for expressive power through the use of

pure color. For the art audience, their work seemed at first to be a provocative and arbitrary arrangement of loud colors. And the critical whirlwind centered upon Matisse's *The Woman with the Hat*. Even the buyer of the painting, the American collector Leo Stein, joyously described it as "the worst smearing of colors that anyone's ever seen."

Matisse – the Wild Beast! Hardly anyone was less meant for the role of *enfant terrible* than he. Even his outward appearance was so overwhelmingly bourgeois that he had been given nicknames such as "le docteur" or "the German Herr Professor."[4] His thick beard and severe gaze from behind eyeglasses certainly conferred the professorial attitude described by Fernande Olivier (one of Picasso's first mistresses) in her memoirs.[5] Matisse was also a caring father to his family. He had been seen sitting silently at the Café du Dôme, one of the legendary artists' haunts in Montparnasse, with a stern expression on his face while Picasso and his entourage were in the midst of loud discussion. Matisse seemed far too earnest to imagine that he wanted to gain notoriety by means of a headlong assault on the bourgeois art sensibility. Nonetheless, the greatest *succès de scandale* of 1905 was his, attracting a lot of attention from avant-garde collectors and, in the final analysis, delivering him from impending financial ruin.

According to Matisse's own estimation, his true life's work actually began in 1906, with the painting *Bonheur de vivre*. This work caused renewed and vehement controversy at the Salon des Indépendants, and was bought by the Steins. Two years later, it was acquired by the American collector Albert C. Barnes, who "entombed" it in his hermetically sealed Foundation in Merion Station, near Philadelphia, where it was not seen by the public for many years. In this painting, Matisse expressed everything that became most important to him in his work. He conjured an atmosphere full of serene sensuousness drawn from visions of humanity's Golden Age or of Antique pastorals. And the free play of line and color consciously approaches the decorative. Much later, when Matisse possessed the authority of advanced age, he even finally dared to admit it: "Il faut être d'abord décoratif," and: "Le décoratif pour une oeuvre d'art est une chose extrêmement précieuse...."[6] But this predilection had been recognizable since his earliest works. Also very much evident in *Bonheur de vivre* is the self-sufficiency of his compositional approach. Much like Picasso, it would elevate his art, up to and including his late works, above all schools and all movements.

By contrast, his Académie Matisse, founded in 1907 at the instigation of his admirers, remained but a fleeting episode. Mostly non-French artists, such as the Germans Hans Purrmann (1880–1966) and Oskar Moll (1875–1947), and the American Sarah Stein, assembled around Matisse. The school was closed in 1909 because Matisse felt a greater need to develop his own work than to convey his ideas to others.

He received an important commission from Moscow. The textile industrialist and art patron Sergei Shchukin asked him to create two large wall-paintings, *Dance* and *Music*, which would be reinterpretations of his earlier pictures, but in monumental form.

In the same year, Matisse was financially enough secure to put his bourgeois existence on display. He bought a house with a large garden for his family in the Parisian suburb of Issy-les-Moulineaux and invited

his father for a visit. In the following decades he would create many of his important works in the studio that he set up there. He then established a second studio in Nice, beginning in 1916, and regularly spent the winter months there. He finally moved to Nice permanently at the outbreak of war in 1939.

Beginning with the Nice period, and increasingly so in the 1920s, the theme of the white harem woman, the "odalisque," enters his work. Matisse received much inspiration for this from the tradition of French painting from Ingres and Delacroix through to Renoir. He was also influenced by his visits to Algeria and Morocco in 1906 and again between 1911 and 1913 (see illus. p. 31). But his interest in the ornamentally oriented art of Islam had always been pronounced, for it fit with his own predilection for decoration. Because of his mother's work, he had been familiar since childhood with fabrics, colors, and patterns, as he related to Françoise Gilot, Picasso's mistress.[7] He then became absorbed in the essence of Islamic art at special exhibitions in Paris in 1903 and Munich in 1910, among other occasions. Explaining his choice of odalisques as subject-matter, for which he was subjected to much criticism for being retrogressive, he later commented: "I was coming out of long, wearying years of effort, after many inner conflicts, during which I had given the best of myself to those researches to the point of achieving what I hoped would be an unprecedented creation. Besides that, I had been powerfully held by the requirements of important mural and monumental compositions. After beginning with some exuberance, my painting had evolved toward decantation and simplicity.... A will to rhythmic abstraction was battling with my natural, innate desire for rich, warm, generous colors and forms, in which the arabesque strove to establish its supremacy. From this duality issued works that, overcoming my inner constraints, were realized in the union of contrasts. I had to catch my breath, to relax and forget my worries, far from Paris. The odalisques were the fruits of a happy nostalgia, of a lovely, lively dream, and of the almost ecstatic, enchanted experience of those days and nights, in the incantation of the Moroccan climate."[8]

Certainly the odalisque theme represented both a historical anachronism and a kind of retreat from the progressive tendencies of his early work. Furthermore, it introduced a controversial image of Woman, propagating the myth of oriental women as exotic objects of desire, just as white harem slaves had been considered exotic in the Orient. But with Matisse the theme is devoid of any self-indulgent aspects. "I always rejected anecdote for its own sake," he said in an interview with André Verdet.[9] For him the intention was not at all to invoke an erotically charged atmosphere or the heavy smell of opium and ambergris, but much more the "specific painterly tension that grows out of the interplay and interrelation between the various elements."[10] This is exemplified in the exquisite little work, *The White Turban (Lorette)* (plate 21). In this painting of 1916 Matisse took up the odalisque theme for the first time. The model was an Italian woman, Lorette, who often posed for him from the end of 1915 to 1917, sometimes as a single figure, sometimes with her companions, who in the titles of the paintings were invariably referred to as her "sisters." The special attraction of the portrait lies in the spiral torsion of Lorette's body and her direct gaze at the viewer. Her frontality is echoed in the

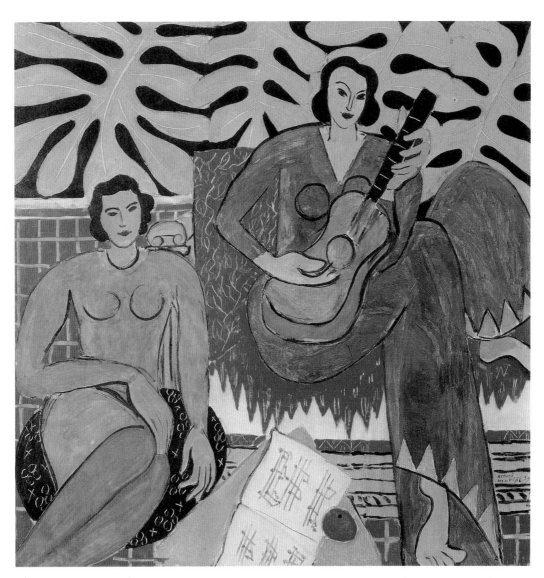

Henri Matisse
Music, 1939
oil on canvas
Albright-Knox Art Gallery,
Buffalo

rounded back of the chair and compels the viewer's attention in a calm, matter-of-fact manner. A touch of the exotic is conveyed not only by the white turban and the corresponding negligée-like garment, but also through her dark alluring gaze and the long narrow bridge of her nose ending in a point. Her long black hair casually swirls around the curves of her body, which the delicate garment also emphasizes. Everything is infused with soft, generous brushstrokes and rounded forms: turban and chair, hair and painterly figure. Mysterious femininity and pictorial qualities clearly achieve a balance. Despite vague indications that the garment is transparent, there is not the least hint of nakedness or sensual skin. The primary perception is much more of pale ocher, of the skin tone itself. It is no different with the figure as a whole. The cutting-off of the figure at the sides brings Lorette visually closer, and yet she ultimately eludes the viewer through the obviously "painted" nature of her existence. This form of sublimated sensuousness thoroughly corresponded to the painter's intentions: "Suppose I want to paint a woman's body: first of all I imbue it with grace and charm, but I know that I must give it something more. I will condense the meaning of this body by seeking its essential lines. The charm will be less apparent at first glance, but it must eventually emerge from the new image I have obtained, which will have a broader meaning, one more fully human. The charm will be less striking since it will not be the sole quality of the painting, but it will not exist less for its being contained within the general conception of my figure."[11]

In the creative process, Matisse sought to achieve an internalization, "that state of concentrated sensation...that makes up a picture."[12] And if it was a woman who inspired him, then "she always dominated the entire available space with her gently swinging play of lines," as Françoise Gilot wrote.[13] In the finely tuned ambivalence of seductive aura, in the exquisite color harmony of Lorette, Matisse created a small icon of the "Eternal Female," a beautiful phantasmagoria.

Another of the artist's favorite motifs that was found even in his earliest work is that of a woman or pair of women associated with music. In each decade the motif was expressed in different ways, appearing in the form of allegorical nymphs dancing in a circle in *Bon-*

heur de vivre and the wall-painting *Dance*, then as music played in the home in works from the 1920s such as *Two Women Making Music* and *Woman at the Piano* (plate 23), and finally in emphatic symbolism and striking coloration in the late work (see illus. p. 33). The painting of *Two Women Making Music* recalls a few other familiar devices, specifically the armchair and the often-used motif of a decorative tapestry that recalls the windows of oriental palaces in its effect. Matisse had decorated one of the windows of his studio in Nice with such fabric, lending it an exotic touch. As for the easy chair, it represents a comfortable withdrawal from the world. Just as Matisse once compared the intended calm aura of his pictures with "the soothing effect of an easy chair," a mental connection could be made between the woman and the easy chair – especially if one considers that the French word *bergère* means both "upholstered easy chair" and "female shepherd." Perhaps it is not only for formal reasons that in *Two Women Making Music* the pleated shawl of the woman seated in the easy chair exactly follows the curve of the upholstered chair-back. The painting merely wants to awaken pleasant associations, through the familiar feminine presence, the chair, the relaxing thoughts of music, and the intimacy of the room.

Less narrative, but instead hieratic in its grand simplicity, is *Woman before a Mirror* (plate 22) of 1930. Here, the increasing simplification of Matisse's technique after his so-called "Nice period" is unmistakable. He departed from the programmatic intimacy of his work of the 1920s by accepting a commission from the American pharmaceuticals magnate and art collector Barnes to decorate his Foundation with a modern and monumental version of *Dance.* The project took several years. During this time, Matisse's painting became bolder and flatter, and his colors gradually acquired greater radiance. Large, austere forms dominate *Woman before a Mirror.* Matisse's earlier interest in decoration is here reduced to a curved chair-back. He limits the picture space by use of a uniformly flat green tone, with areas of darker tone around the form in profile. The background is enlivened entirely through the structure imparted by brushstroke. Vertical stripes in bright green, pink, and black at the sides of the painting reinforce the severity of the seated figure and provide a contrast to the flowing striped design of her garment, a *gandoura*. The contrast also emphasizes the soft, curved rhythms of her hair and the chair-back. A small, brilliant red mouth stands out from the overall impression of restrained color. The model's rigid facial features are compensated for through this bright accent, and through the delicate clarity of her gaze.

Matisse had a special technique for achieving the relatively thin layering of color that lends his paintings their beguiling flat clarity. Instead of painting over a version of a picture with which he was not satisfied, he would use turpentine to repeatedly remove layers of paint altogether until the desired state was finally achieved – a lengthy procedure. Matisse delegated the task of photographing his work and removing previously painted areas to Lydia Delectorskaya, his assistant and muse from the 1930s. Her continuous presence finally caused his wife, Amélie Matisse, to leave him in 1939, after forty years of marriage – a chapter from mundane reality, surely in no way related to the ideally tuned spheres of the "Eternal Female."

Lydia is the figure in *Woman before a Mirror.* The picture itself provides no information whatsoever about her identity, situation, or place in society. Matisse was not interested in psychological examination, or even emphatic individualism. Far more important was the harmonic unity of a work. "Expression for me, does not reside in passion bursting from a human face or manifested by violent movement. The entire arrangement of my picture is expressive: the place occupied by the figures, the empty spaces around them, the proportions, all of that has its share. Composition is the art of arranging in a decorative manner the diverse elements at the painter's command to express his feelings."[14]

In portraying Lydia, Matisse often chose a frontal arrangement of the figure, in this case doubling it through the mirrored profile. Or is it perhaps not a mirror image, but her twin sister? In fact, no mirror is visible, nor is the profiled figure a precise reflection of the one who faces the viewer. Like an echo, which does not send back its transmitted message exactly, but in a slightly altered form, *Woman before a Mirror* shows one image responding to the other, in a constant state of change, in an endless dialogue between full-face and profile.

This effect of a persistent continuity in search of transformation seems to be an essential characteristic of Matisse's artistic practice – perhaps even of his work as a whole. His boldness, however, does not arise from an exuberance, but from consideration; his clarity and balance stem from preparation; and the serenity of his compositions is a result of a concentration of his emotion. He himself put it poetically: "Je continue, jusqu'à ce que ma main chante…." ("I keep going on until my hand sings….")

Ursula Straatmann

1 *Henri Matisse* (Dresden and Basel, 1995)
2 Jack Flam, ed.: *Henri Matisse, 1869–1954* (Cologne, 1994), p. 80
3 Ulrich Weisner, ed.: *Matisse: Das Goldene Zeitalter* (Bielefeld, 1981), p. 277
4 Roland Dorgelès: "Der Prinz der Fauves", *Henri Matisse, 1869–1954* (Cologne, 1994), p. 124
5 Fernande Olivier: "Henri Matisse", ibid, p. 54
6 Pierre Schneider: in: *Henri Matisse* (Zurich, 1982), p. 13
7 Françoise Gilot: *Matisse und Picasso: Ein Künstlerfreundschaft* (Munich, 1990)
8 Volkmar Essers: *Henri Matisse, 1869–1954* (Cologne, 1993), p. 52
9 André Verdet: "Über Odalisken", *Henri Matisse, 1869–1954* (Cologne, 1994), p. 239
10 Ibid., p. 240
11 Jack Flam, ed.: *Henri Matisse, 1869–1954* (Cologne, 1994), pp. 77ff
12 Ibid.
13 Françoise Gilot: *Matisse und Picasso: Ein Künstlerfreundschaft* (Munich, 1990), p. 178
14 Jack Flam, ed.: *Henri Matisse, 1869–1954* (Cologne, 1994), p. 77

Kees van Dongen

Kees van Dongen (1877–1968) has entered into the annals of modern art as a talented colorist and a passionate painter of women. He is often called one of the fathers of Dutch Modernism, together with Vincent van Gogh (1853–1890) and Jan Toorop (1858–1928). But most of all he is associated with the Fauves, the group of "wild beasts" who formed in Paris in 1905, and gained notoriety among art audiences and critics through their use of intense colors. The Fauves explored the use of color as independent from perceptions of nature, and they hoped to enhance the power of visual expression through color. Van Dongen was one of the principal members of this young group who had coincidentally formed a circle around Henri Matisse (1869–1954), and he played a special role. Among Matisse and Albert Marquet (1875–1947), André Derain (1880–1954), Maurice de Vlaminck (1876–1958), Georges Rouault (1871–1958), and the other Fauves, he was the only one who was not French (in 1929 he took out French citizenship), and, quite apart from that, was one who very much went his own way in terms of the content of his paintings. He expanded the expressive palette of the Fauves through a psychic dimension of vibrating eroticism. The fascination of the female body, and the pleasure van Dongen took in bold, extraordinarily dynamic coloration, led to a very personal form of Fauvism, one that went far beyond the limits of that revolutionary but short-lived movement. In 1907 the high point of Fauvism had already passed, but the Dutch painter continued to let color triumph.

He found his themes in the dance-halls and cafés of Montmartre, in the shabby but enigmatic Parisian *demi-monde* milieu, and in the glittering world of the snobbish upper class into which he gained entry as a society painter. Paris was his sphere of activity, for here his curiosity about life could develop unhindered. With an insatiable hunger for living and an unerring eye for human vanity, he mixed with different types of people and explored both the radiant side and the dark side of the "conditio humana." And especially "The painted woman, like the landscape between Amstel and Alkmaar, but flowering with an exotic essence, became for him, a born landscape artist, the landscape of his preferences as a man which Paris had begun to reveal to him," as one contemporary remarked about van Dongen's pictorial world.[1] "He is a master of these pictures. He is the cruel, gripping, reckless, passionate painter of parables of life," wrote Saint Georges de

Bouhélier on the occasion of an exhibition at the Galerie Kahnweiler in 1908.[2]

Through his portraits of the upper classes in the Paris of his day, and even more through his portrayals of countless anonymous figures, we get a very revealing picture of the particular frenetic, unsettled atmosphere in Paris from the turn of the century to the madness of the "roaring twenties." Van Dongen was a perceptive and frank recorder of his time, as well as a satirical wit. His paintings and drawings provide a sarcastic commentary on a society celebrating its own downfall, champagne glass in its hand. And yet his attitude had no moralizing tendencies, was not the least misanthropic, and in the final analysis was shaped by the deepest human feeling. When he painted the cocottes of Montmartre in loud, sharp colors, then it was because "I know every one of those womens' histories, which are deeply tragic. They have experienced life in all its facets.... I cannot help painting these women in garish colors; perhaps I do so in order to express the intensity of their lives?"[3] And when he portrayed eccentric women of the *beau monde*, he did not make the concessions that were normally expected of artists in their commissioned work: "I never flatter the women, and they take no offense that I don't spare them, for they know that I am just."[4]

Even as van Dongen mercilessly revealed the fantastic dramas of life, large and small, he at the same time went to great lengths to conceal his background. He loved mystifying his own life, and he invented all manner of anecdote and legend in order to remain unknown, hidden behind the mask of a cynical *bon vivant* that he wore in the society with which he associated.

Contrary to the mystery which he ensured surrounded him, his origins and education were thoroughly respectable. Cornelis (Kees) Theodorus Marie van Dongen was born in 1877 into a wealthy Rotterdam family. After completing high school, he attended the Royal Academy of Art in Rotterdam. Until 1894 (according to some sources[5] until 1897), he studied with J. Striening and J. C. Heyberg; a fellow student was Augusta Preitinger, who was later to become his wife (see illus. p. 38). After a stay of several months in Paris in 1897, he returned to the Netherlands and worked as an illustrator for the newspaper *Rotterdamsche nieuwsblad*. Two years later, in 1899, Guus (the diminutive of "Augusta") obtained a job in Paris as a retoucher of pictures, and in the same year van Dongen followed her, to finally settle

there. In order to make a living, he sold newspapers and was a tour guide at the 1900 Exposition Universelle for his Dutch countrymen. Of greater significance, however, were the publications of his drawings in illustrated weekly magazines such as *L'Assiette au beurre* and *Gil Blas,* later in broadsheets with anarchist leanings such as *Froufrou* and *L'Indiscret,* and finally in the stern *Revue blanche,* to which he was introduced by the critic Félix Fénéon. Beginning in 1901, the year of his marriage to Guus Preitinger, he supplied quite a few periodicals with his biting and amusing sketches of the boulevards, which were the result of his stimulating excursions through the vaious quarters of Paris. His unbridled "lust for life" was expressed in the temperamental aspect of the pictures that he now produced, and with which he enjoyed a much-celebrated debut in the Parisian art world in 1904. In February of that year, he showed six paintings at the Salon des Indépendants, and two more at the Salon d'Automne. In November, the Galerie Ambroise Vollard gave him a large solo exhibition, featuring 105 paintings and 20 drawings and watercolors.

The work of the first Parisian years reached its high point in a series of moving portrayals of the entertainment district around Montmartre, also including *The Moulin de la Galette* (plate 25), a painting of 1904. The Moulin was an unpretentious local dance-hall next to the former grain mills on the "butte," Montmartre's hill. On weekends it attracted many young people, artists, students, and working-class families from the surrounding neighborhood, who gathered to chat or dance. A small orchestra provided traditional entertainment, and a stage offered opportunity for occasional performances by clowns and street-singers. The locale became famous – indeed immortal – through representations by such artists as Pierre-Auguste Renoir (1841–1919), whose *Moulin de la Galette* of 1876 focuses upon the merry, relaxed atmosphere of the Sunday dance shows, and Henri de Toulouse-Lautrec, who observed there the nuances of human interaction and depicted them trenchantly in his work. In his versions of *The Moulin de la Galette* van Dongen set a far shriller tone than Renoir, or even Toulouse-Lautrec (1864–1901). He plunged headlong into the colorful activity there, as ever directing his attentions to the exalted figures of the Parisian *demi-monde,* who also went there to romp. They are identified by their conspicuous appearance. Their make-up is a bit too garish, their headdresses too flamboyant – their goal is to stand out from the crowd!

Emerging from a veritable confetti of colorful brushstrokes covering the entire canvas, two mask-like female faces of this type can be recognized between the bluish hats of several male figures. They all seem to be crowded together. The women are accompanied by what appears to be a gentleman in a top hat, and by another man in a round hat, seen in profile in the left half of the picture. Three other figures in round hats appear in the foreground. On the right edge of the painting a series of blue brushstrokes suggests the presence of yet another man wearing a top hat, oriented toward the center of the picture. Cut off at the bottom edge of the picture are the round shape of a hat in extreme close-up, and a figure, seen from behind, to the left of it – conveying the impression that the viewer is also an immediate part of the action. At the same level as the central pair of figures, the viewer follows, almost as though sucked into a whirlpool, the flow of people who

dissolve into colorful lash-like strokes as they move out of the picture at the right. The viewer is irresistibly carried along, almost missing any opportunity to notice whatever is apparently entertaining the couple at the left. This extremely clever composition reveals itself fully only on a second glance. By avoiding a calm center and placing the main focuses of activity outside the field of view, van Dongen arouses the viewer's curiosity and lends dynamism to all the visual events. The vehement brushstrokes evoke the atmosphere of a lively social theater that has the painter entirely under its spell.

The Fauve-like, intense, and coarse Pointillism of *The Moulin de la Galette* is further developed in *Yellow Boots* (plate 24) and *Torso* (plate 26). Both works have the same rough and choppy, yet compact, brushstrokes. Set off against dark backgrounds, the female figures in both paintings radiate an individual, mysterious power. Their undeniable presence, emphasized by the large dimensions of the canvases, is in both cases melancholy and shadowy. This sinister element of feminine eroticism, with its touch of the "dangerous" femininity of the *femme fatale,* especially fascinated van Dongen. And yet this does not sufficiently explain the mood created in each painting.

The woman in *Yellow Boots* gazes tranquilly at the observer with her overly large dark eyes. She supports her bent leg on a stool so as to reveal her low yellow boot from beneath the gathered-up flounces of her dress. She might be one of the women from Montmartre whose "tragic histories"[6] the painter knew so well. Her coquettish gesture indeed appears as part of a well-rehearsed pose, struck hundreds of times to attract the attention of men and offer her charms to them.

Guus, van Dongen's wife, was the model for the figure in *Torso.* This was one of the paintings exhibited at the controversial Salon d'Automne of 1905, when the Fauvist movement received its (derogatory) name from the critic Louis Vauxcelles.[7]

Powerful, in its self-confident nakedness, the form extends throughout the picture using all available space. A pulsating brushstroke surrounds her, fluctuating from a brownish tone to the luminous red contour outlining her arms folded behind her head. The contour reciprocates the glowing coloration of her face, turned to one side and bathed in various intense shades of red. It is here that the painting's temperature rises to a boil. Van Dongen's passion for colorful subjectmatter is coupled with an elemental female sensuousness, forcibly heightening the temperature of the painting. To achieve this kind of vivid chromaticity, the artist sometimes used spotlights. Full of admiration for his work, Guillaume Apollinaire later wrote: "This colorist has, above all, drawn an acute excitement from electric lighting, and has added it to the nuances. The result is an intoxication, a dazzle, a vibrancy, and the color, holding fast to an extraordinary individuality, swoons, exhausts itself, sails,...."[8]

In the same year, 1905, van Dongen painted *Guus and Dolly, Mother and Child* (plate 27). In an unusual composition that recalls Symbolist art, the mother and child appear in the sky, tantamount to an apotheosis, above a barely perceptible stretch of landscape. Only tiny objects in the distance stand out somewhat on the extremely low horizon: two barns and the suggested silhouette of a town. Above this, the *Madonna lactans* rises as a radiant vision out of encircling and flickering brushstrokes. Perhaps inspired by the reddish ball of the sun seen

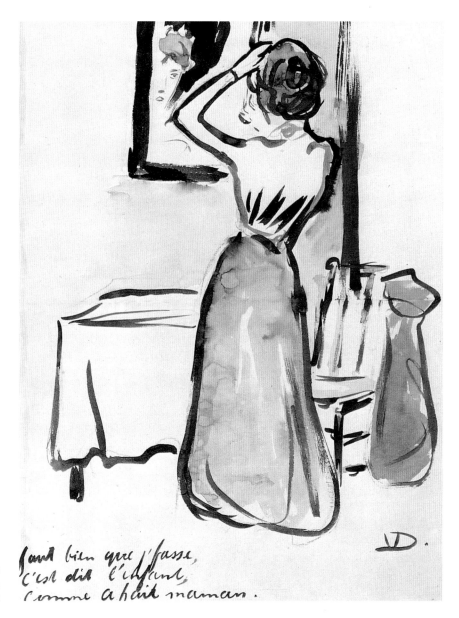

Kees van Dongen
Fate, 1901, watercolor,
private collection

from the large glass windows of his studio, associating it in his mind with the female breast, van Dongen here combines a motif from the Western, Christian tradition – that of the nursing mother – with a recent event in his life – the birth of his daughter.

Augusta was born in April, 1905. To distinguish her from her mother she was called Dolly instead of Guus. The young family spent the summer of that year away from Paris in the countryside around Fleury-en-Bière. There van Dongen often painted out-of-doors and was inspired to create his fantastic, heavenly shapes.

Back in Paris, he, Guus and Dolly moved into the *Bateau-Lavoir*, an artists' studio-residence on Montmartre. The building became well-known because many of the avant-garde artistic *bohème* ending up living there. Together with Pablo Picasso (1881–1973), van Dongen tried to sell his paintings on the street outside the studio, even though he was acquiring a reputation with his participation in various exhibitions in Paris, then in the Netherlands, Germany, and Russia. His favorite themes in the years between 1906 and 1909 were prostitutes, gaudily

dressed up or naked, and circus performers – both images were related to the socially marginal existence of the artist at the time.

When he left Montmartre, van Dongen began his social rise. His insatiable hunger for new subject-matter drove him to seek out more select places of entertainment – to the Folies Bergère and finally to the most chic society circles of Paris.

According to Fernande Olivier, Kees and Guus van Dongen gave original and "very lively parties" that could be compared to Classical bacchanalia. With his usual keenness and enthusiasm, van Dongen had occasion to study a class of people new to him, now that finer society was beginning to assemble in his increasingly spacious studios. He was assured of a regular income beginning in 1908, when the Galerie Bern-heim offered him a contract. Then, at the beginning of the First World War, circumstances caused van Dongen and his wife to part their ways. Guus and Dolly had gone on vacation to the Netherlands, and had to remain there because of the war. Although he did not entirely break contact with his family, van Dongen had by 1917 formed a

Kees van Dongen
Portrait of Guus on a Red Ground
1910, oil on canvas
Collection Mlle D.A. van Dongen,
Paris

steady relationship with Jasmy Jacob, head of the renowned fashion house Jenny. She introduced him to the highest echelons of Parisian society, and he slipped easily into the role of the highly sought-after society painter. "Tout Paris" demanded to be painted by him. For many years van Dongen was a supreme master of the tricky business of reconciling his own artistic integrity with that of serving a pretentious clientele, as is evidenced by *Loulou* (plate 29) of 1924–25. The inimitable coloration and delicate impasto of his earlier works is also seen here in its impressive boldness. The artist was thus no less a master when capturing the morbid charm of decadent society. But because his models of this period seem slightly anemic, the paintings occasionally incline to an overrefined elegance that lacks the vitality of earlier works. The figures – thin as greyhounds – rise up in the paintings as slender forms with overly elongated limbs in poses of supple yet languid physicality. Henceforth his coloring, still harmonious, begins to express itself in nuance rather than sensation. A figure as delicate as the one in *The Violin-player* (plate 28) could hardly "survive" being painted

in vibrant, expressive colors. Thus, van Dongen could not always free himself from the label of a "fashion painter." His close association with his clients was not only to his advantage. Even when he apparently did not accede to their demands, and although he kept receiving dazzling high-society figures, from the Aga Khan to Maurice Chevalier, always dressed in the same khaki-colored sweater and with his pipe in his mouth, and although his inclination to sarcasm was by no means mellowed as he got older, the verbal attacks especially starting having consequences in the long run. "The bourgeois women are stupid and insignificant, the *nouveaux riches* are boring, but according to them the paintings are masterpieces,"⁹ was one of these hardly flattering remarks. He held up a mirror to fashionable society, and the image reflected in it was too bizarre to be tolerated forever. He was just as withering in his dealings with art critics, and annoyed them by constantly re-dating his pictures. They especially paid back in kind with increasingly nasty commentaries or by stubbornly ignoring his works, although his exhibitions always met with public approval. Increasingly withdrawn and

marked by a deep pessimism, he spent his later years with Marie-Claire, with whom he had a son in 1940. Van Dongen died in 1968, at the age of ninety-one, in his villa in Monaco, called "Bateau-Lavoir."

For all his euphoria in sensual joy, the passionate hedonist van Dongen never concealed the tragic aspect of his art, and this is evident not only in his favorite subject, the *femme fatale*. His personal written statements also attest to tragedy, whether it was in reference to his famous countryman, Rembrandt ("the only drug against his nihilism is art...")[10] or to himself ("A picture must be something exciting that exalts life, for the depths of life are sad and somber.")[11]

Ursula Straatmann

1 Fritz Vanderpyl: *Peintres de mon époque* (Paris, 1931), in: Gaston Diehl: *Van Dongen* (Paris, 1968), p. 38
2 Saint Georges de Bouhélier, in: Gaston Diehl: *Van Dongen* (Paris, 1968), p. 49
3 Fred Leeman, in: *Vincent van Gogh und die Moderne, 1890–1914* (exhibition catalogue, Essen, Amsterdam, Freren, 1990, p. 258)
4 Gaston Diehl: *Van Dongen* (Paris, 1968), p. 78
5 Jean Leymarie: biography of artist, in *Die Kunst des 20. Jahrhunderts, 1880–1940*, xii of Propyläen Kunstgeschichte (Frankfurt am Main, 1985), p. 147
6 see also footnote 3
7 *Kees van Dongen* (exhibition catalogue, Rotterdam, Museum Boymans-van Beuningen, 1989, cat. no. 5)
8 Guillaume Apollinaire, in: Gaston Diehl: *Van Dongen* (Paris, 1968), p. 85
9 Ibid. p. 72
10 Ibid. p. 61
11 Ibid. p. 70

Amedeo Modigliani

Depiction of the human subject, especially of Woman, was the main creative concern in the work of the Italian artist Amedeo Modigliani (1884–1920). Although his female nudes earned him a legendary reputation as a painter of women and enriched the theme of the "Eternal Female" through the addition of an "eleganza tutta toscana,"[1] his portraits are by far the more numerous. His works taken as a whole, however – nudes, portraits, and the few sculptures and drawings – merge into a single fabric of rare unity and high aesthetic appeal.

From the very outset, Modigliani's artistic touch was characterized by an insistence on form that seemed almost Classical. During his short life as a painter, clarity, proportion, and order remained the determining factors in a composition. After joining the Parisian artistic *bohème* in 1906 at the age of twenty-two, he engaged in a lively exchange with nearly all of his best-known fellow artists of the same generation, from Pablo Picasso (1881–1973) to Max Jacob (1876–1944) and Chaim Soutine (1894–1943). But Modigliani remained entirely committed to his own line, in the most literal sense. So deeply rooted in him did the visual traditions of his Italian home – ideals extolling beauty, harmony, and elegance of proportion – seem to be, that even the radically innovative temperament of Picasso could have influenced him only peripherally. Modigliani was never part of a particular group of artists, nor did he belong to any contemporary art movements. Certainly his first seminal influence, as for so many other artists, was the work of Paul Cézanne (1839–1906), whose memorial exhibition he saw at the Salon d'Automne in 1907. But what he learned from Cézanne was not the new concept of disassembling form to create pictures independent of reality – something that would find manifestation in Cubism. It was much more Cézanne's cool, formal construction that initially influenced Modigliani's graphic style. But no matter how much he may have subsequently simplified his formal vocabulary, he always remained very deeply attached to the portrayal of the human being. At a time when portraiture seemed to be outmoded as a genre, Modigliani insisted on giving a complete portrayal of the features of his models as if it were a matter of course. His role within the avant-garde of his time was thus very much that of a moderate Modernist. But supreme stylistic ease, and cultivated draftsmanship

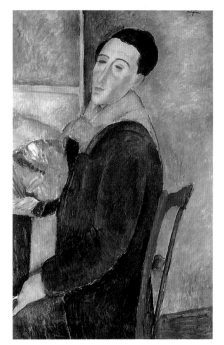

bespeaking a "high aesthetic ethos,"[2] ensured Modigliani's place as one of the greatest portraitists and outstanding painters of nudes in the first half of the twentieth century.

What a contrast to his life!

Modigliani succumbed to tuberculosis in Paris at thirty-five, impoverished and barely acknowledged, after an excess of drugs and alcohol had left him physically broken. Women also seem to have played an important role in his life. He was a *peintre maudit,* a bohemian, having all the characteristics that the bourgeoisie recognize in this type. On the day after his death, his last mistress Jeanne Hébuterne, with whom he had already had a child in 1918, took her own life, leaping from her parents' sixth-floor apartment. She was twenty-one years old and nine months pregnant.

Modigliani's short life, filled with drama that can scarcely be surpassed, offers more than enough material for a "chronique scandaleuse," and thus it is unsurprising that certain legends, insofar as they are spectacular enough, entwine about his life like stubborn vines. Certainly the film version of his life once more celebrated the cliché-laden image of a licentious drunkard.

How is it possible for the artist and his work to be so completely divergent? Had not Modigliani avoided every extreme in his painting? Was not destruction, even disharmony, foreign to his very being? The hypothesis that art was his therapeutic measure, a kind of compensation for a life out of control, is hardly satisfying, for the essential characteristic of his art was precisely that: self-control.

In fact, Modigliani provides manifest evidence for the autonomy of the work of art, answering only to itself and rising unconditionally above the biographical circumstances of its origin. Evidence from numerous sources also demonstrates, however, that while Modigliani's way of life is by no means reflected in his work, his life itself and his character certainly are.

Testimony from Modigliani's peers provides a more balanced verdict, and the painter is depicted as an extremely complicated and sensitive person possessed of both a highly unconventional mentality and an exceptional artistic discipline. All accounts speak of *noblesse,* of "inner refinement that could not tolerate dressing in a stained suit even if it were brown,"[3] of generosity and deep humanity even at times when "his life [was] ruled by torn and tortured ups and downs"[4] or when his

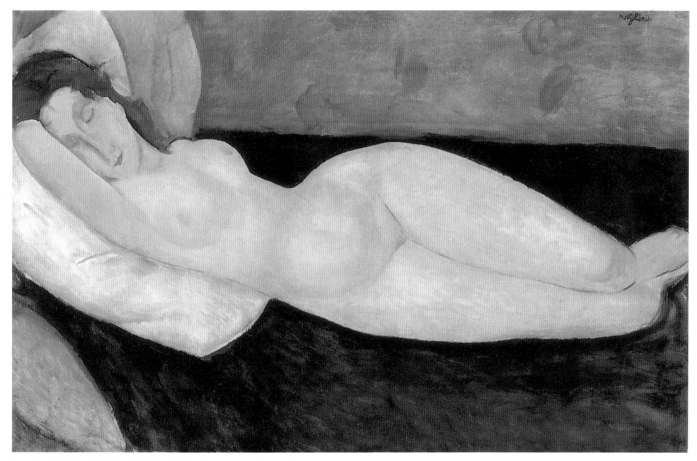

Amedeo Modigliani, *Nude with Necklace*, 1919, oil on canvas, private collection

studio was little more than a "dilapidated barracks, as depressing and unkempt as a beggar's retreat."[5]

Maurice de Vlaminck (1876–1958), a fellow Fauvist painter, wrote: "Modigliani was an aristocrat. His entire work bears overwhelming witness to this. His canvases are stamped with infinite dignity and refinement. Nothing common, coarse, or banal can be found in them."[6]

In his memoirs, the writer Ilya Ehrenburg (1891–1967) delivered a lyrical plea in defense of his friend: "It is true that Modigliani went hungry, drank, swallowed pellets of hashish – but not out of a love for slovenliness or 'artistic ecstasy.' He was hardly pleased about being hungry; he had a healthy appetite. The martyr's crown held no attraction for him. Perhaps no other person was meant to be so very happy as he. He clung to the gentle sounds of the Italian language, to the soft landscapes of Tuscany, to the art of their Old Masters. In the beginning there was no hashish…. Of course, he could have painted his pictures in keeping with the tastes of critics and clients. Money, a fine studio, and general recognition would certainly have been his. But Modigliani was capable of neither lies nor conformity. All who ever encountered him know how very proud and uncompromising he was."[7] Finally, another contemporary describes him as generous on the one hand, but utterly lacking "any business sense" on the other – an outsider to "the large social mechanisms."[8]

Growing up in an educated, but financially unstable, Jewish family in Livorno, and suffering tuberculosis from his early childhood,

Modigliani discovered his passion for literature and drawing early in life. Supported intellectually by his mother, he took his first drawing lessons outside of school in 1897, at the age of thirteen, and he entered the Academy of Arts in Livorno the following year. A preoccupation with the writings of Charles Baudelaire, Oscar Wilde, the Comte de Lautréamont, and Henri Bergson would soon bring his view of life almost into the same orbit as that of the so-called "suffering artists," the *peintres maudits.* Beginning in 1902 – following a first year's attendance at the Scuola Libera di Nudo in Florence and after paying a visit to the marble quarries of Carrara and Pietrasanta – his desire was to become a professional sculptor. He then spent an interval of three years in Venice, where he registered at the Reale Istituto di Belle Arti, and he soon became acquainted with the work of the Symbolists and the French Impressionists, especially that of Henri de Toulouse-Lautrec (1864–1901), at the Biennales of 1903 and 1905. In 1906 he finally felt compelled to go to Paris, the center of avant-garde art.

Financial support from his uncle at first allowed him the luxury of living in a hotel near the Madeleine. His money soon ran out, and he moved to the artists' quarter in Montmartre.

It was there that he met the painters, sculptors, and literary figures who would so fundamentally determine the appearance of art in the twentieth century: Picasso, Georges Braque, Juan Gris, André Derain, Vlaminck, Kees van Dongen, Constantin Brancusi, Alberto Giacometti, Giorgio de Chirico and Carlo Carrà, as well as Guillaume

Apollinaire, Jean Cocteau, and Blaise Cendrars. Modigliani also kept in close contact with the Jewish intellectual circle around the poet Max Jacob – Ossip Zadkine, Jacques Lipchitz, and Chaim Soutine. As Modigliani painted portraits of nearly all of them, he incidentally created a document of the period before the First World War, which was so rich with creative talent.

His initial attempts at gaining an artistic foothold in his adopted country were highly promising. In 1907 he exhibited five drawings and a painting at the Salon d'Automne, in 1908 six works at the Salon des Indépendants, and a further six in 1910. He enthusiastically attended the retrospectives of the work of Henri Matisse and Paul Gauguin in 1906, and the large retrospective of Cézanne's work in 1907. Although he still lacked a distinctive style of his own at this time, it was clear right from the outset that line would be the most important formal element of his work.

At the Salon d'Automne in 1912 he showed a selection of his most recent works: stone sculptures – totemic heads suggesting the contemporary concern with African sculpture, as well as evincing influences from Egyptian and Archaic Greek work. In the years from 1909/10 to 1914, Modigliani almost completely abandoned painting, instead devoting himself exclusively to sculpture and drawings for sculpture. This first break with painting corresponded with his move from Montmartre to Montparnasse. Presumably, contact with the Romanian sculptor Constantin Brancusi (1876–1957) led him to finally seriously pursue his longstanding desire to become a sculptor. Certainly a kind of sculptural spirit was already inherent in his earliest drawings, and it is clearly reflected in his paintings after 1915 as well. Yet it is remarkable how suddenly he switched mediums. Sculpture disappeared from Modigliani's work as suddenly as it had appeared. This was due possibly to the difficulties he had in obtaining the costly materials for sculpture, as well as the additional strain on his already weakened lungs caused by inhaling stone dust.

When Modigliani again turned his attention to painting in 1914, he immediately showed himself to be at the height of his artistic expressiveness. With a sculptor's eye for form and volume, he painted a series of significant and highly original depictions of people. But even with his stylization and careful construction, he was able each time to create an amazing likeness to the model; the evidence of this can be seen in the many photographs of painters and literary figures who sat for him. It is almost as if the character of the sitter emerged all the more clearly precisely through an economy of painting technique and a calculated absence of expressive gesture on the part of the painter. When Modigliani did manipulate the figure – elongating the neck, or accentuating the contours of a face – it was only for the purpose of effecting a purely formal intensification of expression, and had nothing to do with the psychological examination of the model. Indeed, Modigliani's primary interest as an artist during these years was to capture the physiognomic character of people – the phenotype. But whatever the extent of "Modiglianesque" distortion of form, his "aesthetically exquisite, educated talent" always guaranteed that the painting as a whole never lacked a total pictorial unity.[9]

After 1916, portraits of women and nudes increasingly became a central concern. This corresponded to a new fullness of graphic contour; earlier emphasis on structure, and on the particular stereometric shapes of the face such as the nose and the eyes, gave way to organic, musical lines. Grace and elegance became the determining factors in the outward appearance of Modigliani's art.

He succeeded in creating truly beguiling works – especially his nudes, who radiate an aura by turns attractive and deceptive – through a combination of detached sobriety, formal stringency, and warmth of color. Their taut, sculpted bodies and finely modulated, warm sienna hues imbue them with an air of Classical beauty (see illus. p. 41 and p. 43).

Modigliani's exhibition of female nudes at the Galerie Berthe Weill in 1917 – his first solo show - caused a scandal. His depictions of women were judged indecent, the police ordered them to be removed, and the show was closed. Modigliani, who had no doubts about the quality of his work, is said to have remarked in laconic desperation: "Will Paris never wake up?" Ironically, Paris did begin to take notice of his work, but only after the fact, on the day of his death. He had exhibited at Weill's hoping to improve his material situation, but the closure of the show shattered his hopes. Perhaps even aware that he had not long to live, he began his self-destructive lifestyle. Nonetheless, the circumstances of his frequent changes of studio that did nothing but lead him "out of the frying pan and into the fire," his precarious health, and his financial desperation were not at all reflected in his work. The formal discipline of his art seemed to overcome the trivial details of existence.

Despite the efforts of his patrons and art dealers, including Paul Guillaume and the Polish poet Leopold Zborowski (who often sat for Modigliani), recognition and financial success were always denied him.

During the winter of 1918, with conditions in wartime Paris increasingly precarious and his tuberculosis worsening, Modigliani and his young mistress, Jeanne Hébuterne, decided to move to Haut-de-Cagnes, on the Côte d'Azur, for half a year. It was there that their daughter, Jeanne, was born. According to his own letters, he worked a great deal during that time, and his spirits were high, except for a disappointing encounter with the aged Renoir, whose works he had once so admired in Paris.

Here, Modigliani expanded his portrait-painting techniques, adding to his repertoire three-quarter profiles and full-length paintings of children and young people from the countryside around Cagnes. In addition to many portraits of Jeanne Hébuterne, *Madame Modot (La Belle Espagnole)* (plate 31) and *Two Children* (plate 30) belong to this period.

The sitter in *Madame Modot* is the wife of the silent film star Gaston Modot, whom Modigliani knew from his days in Montmartre. They met again in southern France. In 1918–19 he painted two portraits each of Modot and of his wife.[10]

The defining characteristic of the earlier portrait figures, with their cylindrical necks and wedge-like noses, may have been the general emphasis on structure. But in the last years of Modigliani's creativity, formal design became a softly flowing arrangement of elongated lines. The sitter was painted with a greater verisimilitude, but this, however, was coupled with a certain mannerism and affectation.

In *Madame Modot*, any danger of conveying too much sweetness is precluded through the woman's expression: a peculiar, smug skepticism

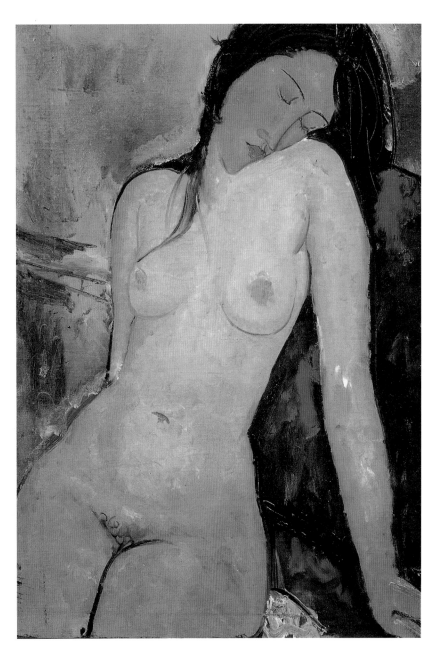

Amedeo Modigliani
Seated Female Nude, 1919
oil on canvas
Courtauld Institute Galleries,
University of London, London

emphasized by her firmly tucked chin and her oblique gaze out of the picture. The oval of her slightly tilted head, with its flat hair, is echoed in the clean curve of her *décolletage*. The descending lines of her shoulders, and the drop of her right arm across her subtle abdominal curvature, lend a fatalistic note to her appearance. While her seemingly transparent, yellow-orange flesh tone is taken up by the ochre of the dress, the novel arrangement of her black hair around the temples corresponds in color and form to the arabesque in the background. No other work in Modigliani's oeuvre depicts ambiance as does *Madame Modot*, where background and figure are so totally in harmony that a narrative effect – quite unusual for the artist – has been created.

Restellini[11] interprets this as an homage to Matisse. Modigliani had been familiar with Matisse's works since 1906, and again had occasion to view some of them while in the south of France.

A certain relationship to the decor in Matisse's *Seville Interior I* and *Seville Interior II*, two paintings of 1911, is recognizable. Possibly the similarity was inspired by the sitter's Spanish appearance – hence the picture's second title, *La Belle Espagnole*. On the whole, Madame Modot belongs to that category of slim figures with small heads that, as André Warnod wrote, "sway on fragile necks like flower blossoms too heavy for their stems."[12] For all the distortion, Modigliani was nonetheless not in the least trying to caricaturize anyone. Rather, he always strove to pointedly characterize on the basis of precise observation.

The spirit emanating from the double portrait of *Two Children* (plate 30) can hardly be more different. In place of Madame Modot's vegetative pliancy, there is the formal, structural orientation that is recognizable in the portraits of his earlier period – even if it is less rigid, and more natural.

Calm and dignified, their hands folded on their laps, the two young girls of different ages await their destinies. They appear almost as though imprisoned, with a passivity worthy of a still-life enhanced through restrained color and avoidance of any narrative element, such as might be found in *Madame Modot.* There is a severe and melancholy air about the picture. The bare wall behind the small figures vaguely reflects their silhouettes, and is rendered with brushstrokes that convey a coarse and rough effect. The two figures seem to be connected with the room only through the indication of a curtain at the top left, and the back of a chair at the bottom right — two details that stabilize the gradual rhythm of curves and diagonals that run through the picture. *Two Children* faintly recalls Cézanne's portraits, or fourteenth-century Italian frescoes. What distinguishes *Two Children* from those, however, is the artist's emotional participation. Since Modigliani consciously avoided sentiment in all of his earlier portraits, the powerful emotion in the paintings of anonymous children done while in the south of France is all the more remarkable.

The differing forms of the two girls are also worth noting. They are contrasted not only through the use of lighter or darker tones in their clothing and hair, but most of all through the rendering of their faces. The older girl's overlarge eyes stare steadfastly from her delicate, pointed-oval face. In clarity and silent contemplation, her eyes attract the observer's gaze yet do not reciprocate it. This young female is marked by an exceptional grace, paradoxically accompanied by full awareness of, and necessary submission to, immutable circumstance.

Here a part of the artist's private grief at his own fate seems to find an echo.

The doll-like face of the younger girl has a far less urgent, more ambiguous, effect. Only her left eye gazes out of the picture; the blind right one lacks a pupil. The differentiation also underlines the asymmetrical proportions of the smaller subject's eyes. The girl's disability, on first sight disturbing, is nonetheless not meant to be understood literally. It instead suggests perception of an "inner world" and an "outer world," a motif that often appears in Modigliani's work.[13] The younger girl, in her dress still white, remains an untouched entity in the internal dialogue with her soul. She embodies hidden possibilities. In the mute, resigned world-weary view of the older girl, who is dressed in black, potential has already congealed into painful reality. The younger girl's alienating gaze also helps in lending greater autonomy to the painting, guarding it against false sentimentality.

The artist's inner disquiet drove him to return to Paris with his young family in 1919, where miserable accommodations once again awaited him. Yet he had further exhibitions. In fact, Modigliani showed internationally that year, with ten works at a gallery in London. A gradual improvement in his depressing situation seemed underway. But at the end of the year his health began to decline rapidly, and he died in Paris on January 24, 1920, not yet thirty-six, at the Charité hospital for the destitute.

At a time of rapid upheavals, Modigliani's goal was to give renewed and lasting expression to the human subject in portraiture, drawing upon great reserves of sensitivity and artistic responsibility. How little importance he assigned to his own self in the process becomes clear when one considers that there is only a single self-portrait in his entire oeuvre. He painted it in 1919, a few months before his death.

Ursula Straatmann

1 Gino Severini on Modigliani, in: *Modigliani — dipinti e disegni: incontri italiani, 1900–1920* (Milan, 1984), p. 107
2 Werner Schmalenbach: *Amedeo Modigliani: Malerei, Skulpturen, Zeichnungen* (Munich, 1990), p. 9
3 Florent Fels: "Zeitgenossen über Modigliani," *Amedeo Modigliani: Malerei, Skulpturen, Zeichnungen* (Munich, 1990), p. 192
4 André Warnod, ibid., p. 203
5 Ludwig Meidner, ibid., p. 198
6 Maurice de Vlaminck, ibid., p. 203
7 Ilya Ehrenburg, ibid., p. 191
8 Curt Stoermer, ibid., p. 201
9 Adolphe Basler, ibid., p. 186
10 *Amedeo Modigliani au Japon,* (exhibition catalogue, Tokyo-Ibaraki, 1992–93), p. 130
11 Ibid.
12 André Warnod, in *Amedeo Modigliani: Malerei, Skulpturen, Zeichnungen* (Munich, 1990), p. 204
13 Patrice Chaplin: *Modiglianis letzte Geliebte* (Reinbek, 1995), p. 156. When the painter Léopold Survage sat for Modigliani and then wondered about the asymmetrical form of the eyes in his portrait, Modigliani answered: "One of your eyes looks without, the other within."

Marc Chagall

Marc Chagall (1887–1985) lived for almost one hundred years. Unfortunately, he was not to reach his one hundredth birthday, but nevertheless died at the biblical age of almost ninety-eight.

Throughout his life Chagall remained faithful to his unmistakable style, his painterly poetry, and his grand vision. For him, art was a message of love, and of reconciliation and compromise; it was a mediator for mutual understanding, and a medium that integrated different religions. Like no other artist, Chagall knew how to reach out to people, to fascinate them and inspire them with poetic metaphor.

From his youth he was a dreamer – a searcher suddenly finding himself seized by art. He experienced poverty, suffering, war, wandering – and exile. But to the end of his life his Russian home and the Jewish milieu in which he grew up remained deep in his heart, a constant point of reference.

Anyone who hopes to understand Chagall must also know his home, and must become acquainted with Vitebsk. The familiar squares, the lively busy streets and alleyways with their shopkeepers, carts, carriages, small wooden houses – Vitebsk sets the prevailing mood that runs through his whole life like an indelible feature. Vitebsk was the place of childhood familiarity, of cozy warmth, and of a gradual widening of horizons, but it was also the place of departure, of permanent abandonment, and of a thousand revisitings through his drawings, watercolors, paintings – idealized pictures.

Nothing in Chagall's eventful life could even begin to supplant Vitebsk. His paintings are grouped like concentric circles around this constant factor. They reflect Russia as transfigured childhood memory and represent a constant inner dialogue with his homeland.

Chagall's art is a perpetual search for *le temps perdu*, for lost times, for the paradise of childhood and youth that he always brought back to life in the form of painted images that emerged from a rich store of recollections, whereby the simplest impressions became subliminal and the everyday was made poetic.

Chagall believed and lived through his pictures, which are archetypal visions of the *conditio humana*. He absorbed life in pictures, accumulated experiences through visual thought and translated them back into paintings. His art is an illustration of life, a picture gallery extending from birth to death. In the process he was guided by no rational thought, but was inspired by emotion. Pictorial composition was not constructed, but was free and associative. The psychic dimension was the determining compositional element – a soulful expression carried over into his painting. "What I wanted was a kind of realism, if you will, but a psychic realism, something entirely different from the realism of objects," Chagall himself professed. Detailed descriptions of his memories were expressed in the free variations and fantasies of his nostalgia:

The streets are mine,
but there are no houses.
They have been gone since childhood,
Their inhabitants wander through the air
in search of a home.
They live in my soul.

Only the visionary moment can defy the laws of gravity, make animals and people float freely and with ease, and bear them on wings of emotion and of love (see illus. p. 47). Chagall's typical liberated figures rise from the deepest levels of consciousness. Drawn from the rich treasure of his youthful memories, they become independent and associative, and float in space: proximity and distance, yesterday and today, real and imaginary, actual and fictitious, here and hereafter. Dream subjects become reality, and the concrete turns into dream. In enchanting metaphors Chagall develops his own language of form – a poetry of ease and elation, and of hallucination. The picture bursts through from the lowest depths of consciousness. It is evocative and eruptive; it crystallizes ecstasy, burning enthusiasm, and an exuberant joy in life. Through the lyrical explosion of color, space turns into Dionysian euphoria. Chagall was one truly possessed by his art, and he recorded the moods and emotions of his soul with devotion and passion. He released himself through his painting and developed a choreography of great richness and epic proportion.

The religious and mystical sources of Chagall's work are surely just as important as Vitebsk, and they perhaps provided the more profound inspiration. "Mysticism and religion played a great role in the world of my childhood and left their traces in my art, like everything else that belongs to this world."

Chagall's art originates in the emotional and ideal world of orthodox Judaism rooted in Hassidism. The thoroughly pious Hassidim allowed themselves to be guided by a love of nature and humanity, and Chagall also painted with the deep conviction that the world was based upon a cosmic order and could not end in chaos. Hassidic mysticism and Slavic folktales are the keys to decoding his poetic metaphors; they encouraged Chagall to create legends, to dream, and to envision. Thus, his paintings were increasingly governed by visions arising out of mysticism and pointing toward eternity. Painting reflects a state of the soul, and the picture manifests transcendental and metaphysical joys. Corresponding to the Platonic, bipolar division of the world, the laws of *mundus sensibilis* are dissolved; gravity loses validity, and free-floating figures achieve the intoxicating dimension of *mundus intelligibilis.*

Thus, Chagall's pictures are the echo of an enthusiastically received world of experience and adventure bound in mystic inspiration and devoted to the metaphysical. He looks backward and forward at the same time, which is one reason why the metaphor of an open window separating two realities from each other often occurs in his iconography.

The icon must be mentioned as a key mystical and religious element of his work. Familiar to Chagall since childhood, icons were his first contact with representational art, along with painted store signs and illustrated folktales. Icons represented a powerful combination of childhood memories, religion, and mysticism, and exercised a lasting influence upon him.

Chagall received his most important artistic impulses during his years in Paris, and an examination of his work soon reveals that these all have their origins in memory. As Chagall admitted: "I brought my subjects from Russia, and Paris threw its illumination upon them. In Paris I found what I had been blindly searching for: the refinement of subject-matter and wild color."

The earliest work in the exhibition, *Nude over Vitebsk* (plate 32) of 1933, perfectly reiterates his statement above, for it is painted entirely from memory. The artist depicts his home Vitebsk, with buildings strung out along a street, groups of people, and the typical horse-drawn carts and drivers. A nude woman, lying on a divan, floats monumentally above the village. It is love that allows us to rise up, and that gives us a true feeling of exaltation. The vase of red roses in the lower left corner is an expressive symbol of this. Whatever form Chagall gives Woman, she will always be the sign of love, associated with feelings of purity and nobility. So even in *Nude over Vitebsk*, the figure, although the focal point of the picture, is discrete and restrained in her nakedness, turned away from the viewer. The cloth that reveals only one side of the woman removes her from voyeuristic eyes.

The oil painting of 1944, *The Wedding* (plate 34), combines quite divergent facets of "L'Eternel Féminin". The bride in a long veil represents love and is associated with other music-making women who float around her like angels. Music and floating are the metaphors for endless love. The color blue — ethereally light, sublime, and transcendent — adds a touch of liberation to the couple united in love. The color red, running diagonally through the picture, stands for Promethean fire, mother earth, fertility, the secret of birth and life. The

duality of red and blue corresponds to the secret of life, death, and deliverance. The painting once again demonstrates why Chagall's treatment of color earned him a reputation as a brilliant colorist, as one who succeeded in conjuring a unique allegory of life, love, hope, and faith on canvas. As soon as light descends into the picture, the euphoria of color can be heightened to the point of hallucination. Chagall's true medium is the color blue. Ethereal and transcendent, blue bespeaks the eternal human desire for peace, warmth, and eternity. It leads to the metaphysical, where faith confers upon pictures the power of salvation: to paint the yearning for paradise with the colors of the earth! Chagall mastered precisely that in his oeuvre. His palette here ranges from a material concentration of color to a crystalline transparency, releasing us from temporal matters and allowing us to turn to the eternal.

The oil painting of 1950, *Village with Dark Sun* (plate 37), is flooded with a volcanically glowing, slightly blackened tone of red. The picture is very much in the tradition of Woman as "eternal bride." Here white, the color of innocence and eternity, stands in sharp contrast to the materiality of red. All-consuming, blazing fire has the same power as selfless love. Ephemerality and eternity are the decisive coordinates in decoding this flamboyant picture. But the symbolic meaning of the fish cannot be ignored. Like so much else in Chagall's iconography, it was part of his childhood memory. But the fish also retains its original significance from the Old Testament, from the story of Jonah and the Whale. The fish should be seen as a symbol of life associated directly with the woman.

Chagall's acquaintance with the Orphism of Robert Delaunay (1885–1941) resulted in color gaining an ever-increasing importance in his work. Color soon becomes the outstanding component of his art. Chagall himself professed that encountering the works of Paul Cézanne, Edouard Manet, Claude Monet, and Pierre-Auguste Renoir, as well as that of the Fauves, was extremely important for him. All of these artists' works are filled with great bursts of color that Chagall further developed into a glorious spectrum of "lyrical explosion," as André Breton (1896–1966) called it.

If Paris was the place where Chagall found new impetus and where he achieved his great breakthroughs, and was thus emotionally a kind of second Vitebsk for him, the subsequent influence of the south upon his painting can also hardly be underestimated. His colors became more intense and luminous under the influence of omnipresent light. In the Mediterranean, where Chagall finally settled permanently, he conjured up on canvas landscapes flooded with light and painted his bouquets of flowers that reach a feverish pitch of color and joy. As had once been the case with Cézanne or Vincent van Gogh, the light of the south inspired in him a new, more intense way of seeing, and a more refined understanding of his environment. The paintings in this exhibition bear witness to that transformation. They are a lyrical apotheosis of light. The mood of the Mediterranean pervades all of these works.

In his exaltation of creation in the form of flowers, animals, and people, and in the violin-player and the singer, we are drawn back into the Mediterranean nature myth and into Chagall's own cosmological mysticism. That Greece is ever present in this Mediterranean world is

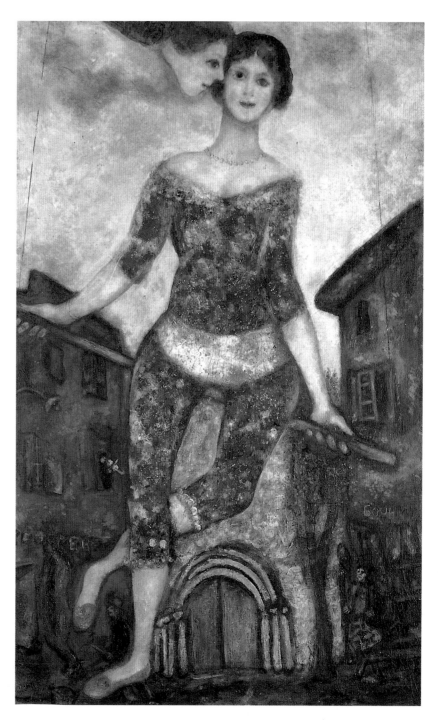

Marc Chagall
The Girl Acrobat, 1930
oil on canvas
Museé National d'Art Moderne,
Centre Georges Pompidou, Paris

self-evident, as seen in his gouaches based on the novel *Daphnis and Chloë* by the Greek author Longus (see plate 38).

In Nice, at one time a Greek settlement, Chagall finally established his philosophy. His "Message biblique" offered the seeker a path to faith that found constant confirmation in the act of creation.

"Art begins where nature ends," Chagall said.

Those who search will discover that Chagall's pictures are rooted in deep piety. They do indeed have the power to grant deliverance. They are painted images of hope.

Fernand Léger

A painter whose entire life and work were based on an unshakable faith in the future of socialist society would surely have different ideas about the "Eternal Female" from most of his fellow French artists. It even seems likely that Fernand Léger (1881–1955) rejected the concept of an "Eternal Female" as a relic of nineteenth-century bourgeois education and did not consider it appropriate to his time. Visions of a *femme fatale* or *femme fleur* were not to Léger's taste. And yet, on closer observation, an archaic picture of Woman does inhabit his depersonalized and monumentally stylized female figures. Thus, *Two Women* of 1939 (plate 40) radiates power, calm, and a melancholy optimism. In their monumentality and sensuous aloofness the two heroines seem to be descended from a race of Gods, but the robust substance of their physical presence still suggests a thoroughly earthbound reality. Their ochery-brown flesh tones make them seem as though made of clay, only just brought to life by the artist. The two women stand erect stiffly and solemnly, isolated from their surroundings, but as though fused with each other. An underlying sensuousness is created by the tension set up between the differing poses and gestures of the two figures. The one on the left hides her gaze beneath the fall of her hair, suggesting an attitude of shame as she protectively crosses her arms; the one on the right, however, projects confidence and freedom from inhibition. The schematic compactness of these nudes plays upon the formal canon of classicism, which Pablo Picasso (1881–1973) had revived around 1920. But here the grandeur of the classical is played down in favor of the crudeness of the figures and their bodily distortion. Provocatively awkward bodies differentiate the nudes from idealized, bourgeois female figures. This type of anti-ideal had been set up by Gustave Courbet (1819–1877) in the nineteenth century to oppose the bourgeois cliché of physical beauty. Léger's nudes far more resemble the working women of the lower classes, with whom the painter felt solidarity. Thus, they are far removed from the sphere of sensual associations and instead become messengers of a new image of woman shaped by the socialist idea. In his estimation of Woman, Léger proves to be avant-garde. Possibly he has interwoven his own positive experiences with women into this picture, even if in encoded form. In 1919, after having been seriously wounded in the First World War and having barely survived, he married Jeanne Lohy. Five years later he opened a studio with

Amédée Ozenfant (1886–1966), where he worked together with such confident artists and emancipated women as Marie Laurencin (1885–1956) and the Russian Alexandra Exter (1882–1949). That year Nadia Khodossevich became his student and assistant. After twenty-eight years of close friendship, she and Léger married two years after the death of his first wife Jeanne.

The enigmatic classicism of Léger's figures reaches back to two painters he admired Piero della Francesca (1410/20–1492) and Paolo Uccello (1396/7–1475) but above all recalls the work of Jacques-Louis David (1748–1825): "I wanted to proclaim a return to simplicity by way of an immediate art without any subtlety, comprehensible to all. I love David because he is anti-Impressionist."[1] Léger was also probably fascinated by David as *the* painter of the French Revolution, in which the motto of "Liberty, Equality, Fraternity" served as the guiding principle of an order worthy of human dignity. Concerning the significance of the human figure, Léger himself related: "For me, the human body is no more important than keys or bicycles. It's true. For me, these are plastically valuable objects to make use of as I choose....This is why the figure in the evolution of my work since 1905, remains deliberately inexpressive."[2]

In this way Léger believed he had done away with the last vestiges of any hierarchy of themes and subjects, and had effectively socialized pictorial elements into equivalent and emotionless objects. This does not apply to *Mother and Child*, however, a gouache of 1952 (plate 42), the year of his marriage to Nadia. Entirely within the Christian iconographic tradition of the Virgin and Child, affection is displayed here in the child's inclined head and the flower being offered to the mother, which can be interpreted as a further symbol of the mother's beauty and youth. Cheerfulness is also indicated by the strong colors, entirely free of the drawing's contours or any nuance of esthetic *peinture*. And the playful decoration of the clothing defuses the sober severity of the contours, enhancing the basically joyous mood. By contrast, *Dancers with Key (the Triangle)* of 1928 (plate 41) seem entirely subordinated to inherent formal qualities of the composition. Concerning the motif of a key, Léger recalled: "One day I had painted a bunch of keys on a canvas, my bunch of keys. I didn't know what to put next to them. I needed something that would be the absolute opposite of a bunch of keys. So when I finished work I went out. I had only walked a few yards

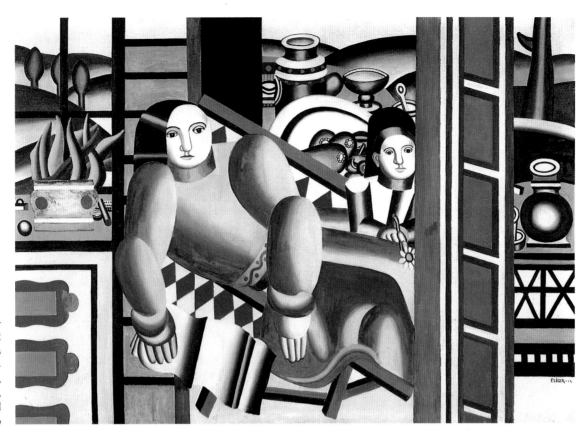

Fernand Léger
Mother and Child, 1922
oil on canvas
Öffentliche Kunst-
sammlung Basel,
Kunstmuseum,
Gift of Dr. h.c. Raoul
La Roche, 1956

when what should I see in a store window? A postcard of the *Mona Lisa!* At once I knew that was what I needed: what could have made a great- er contrast to the keys? That is why I put the *Mona Lisa* on my canvas. Then I also added a can of sardines. It was such a strong contrast!"[3]

In *Dancers with Key*, Léger contrasts the organically distorted women with the abstract, geometric structures of the end of a key. The entire ensemble is embedded in a cloudlike shape, floating above an ocher background. Similar to Joan Miró's *Dancer II* (plate 44), but in a far less minimal way, the composition itself, polarized into masculine and feminine elements, performs the dance. Soft, round forms push against hard, geometric objects and shapes, static persistence resists advancing movement, and cool sleekness slides over softly modeled relief. And all this happens within a space that is diffuse, kaleidoscopic, and broken. Yet Léger's work is very different from Miró's. In contrast to Miró's poetic dream-dancer, Léger's dancers are the product of sober, calculated construction.

Léger is considered one of the principal practitioners of Cubism. Following his encounter with Picasso and Georges Braque (1882–1963), he developed his own unmistakable variant of the style. Because of his predilection for cylindrical forms, as seen most impres- sively in his early "Contrasting Forms" series, he was given the gently ironic title of a "Tubist," and his art was called "Tubism."

At the end of Léger's artistic development stood the social utopia of a free world – one that was equally cheerful in work or in leisure, and was entirely without oppression. He shows this world of the common people – to which he as a Socialist remained devoted throughout his life – as an Arcadia purified of any romantic trappings, where work becomes play and play becomes work.

1 Fernand Léger: *Mensch, Maschine, Malerei: Aufsätze und Schriften* (Bern, 1965)
2 Ibid. p. 92
3 *Fernand Léger: The Later Years*, exhibition catalogue (Nicholas Serota, ed.; Whitechapel Art Gallery, London; Staatsgalerie Stuttgart; 1987–88), p. 24

Joan Miró

Joan Miró, who was born on April 20, 1893 in Barcelona, was far more than the childlike, naive daydreamer and creator of ludicrous hieroglyphics that many made him out to be. Perhaps his skeptics were propelled by confusion as to his aims. For the taciturn Catalonian's work is supreme in eluding all attempts at any rational interpretation or formal definition. Much to the annoyance of professional interviewers and knowledgeable critics, Miró always successfully defended his work against any sweeping categorizations. He refused to reflect about his art, let alone talk about it – at any rate, not in any specialist jargon. He was not interested in scholarly subtlety, and he loathed the vocabulary of academic aesthetics. He certainly was able to verbalize his thoughts about his art; not, however, in the language of the rational sciences but in that of poetry, as his many letters to philosophers, poets, and painters bear out. And he was always very conscious of his activities and confident in himself as a creator, as his sovereign position among the Surrealists shows. He never unconditionally recognized their authoritarian instructions or dictatorial programs. The Catalonian, so the Spanish say, loves freedom.

Miró's youth – like that of Paul Cézanne (1839–1906) – was shaped by deep conflict between his father's authority and his mother's support of his artistic tendencies. His father's wish to make an accountant out of his son was counteracted by the rapture the young Miró felt when seeing the fantastic and bizarre architecture of Antoni Gaudí (1852–1926), creations that mock everything rational. Miró's fascination in the monstrous and bizarre, the fantastic and occult, which is evident in all of his works, is strongly rooted in Spanish tradition – for example, in the suggestive power of Catalonian Romanesque Art with its unique murals. The rigid antinaturalism of art from that period also made a lasting impression on the young Pablo Picasso (1881–1973). Miró's bent for the fantastic also arose out of his love of ornamentation rooted in Catalonia's Arabic heritage. The treasures of the Museo del Prado in Madrid, especially the hellish fantasies of Pieter Brueghel (ca. 1525/30–1569) and the paintings of El Greco (1541–1614), in which figures extricate themselves from their earthly confines, were also a significant influence.

Miró's education was troublesome and was broken off prematurely. Acceding to pressure from his father, he became a bookkeeper

in 1910. The result was disastrous, and he suffered a nervous breakdown. The subsequent year of recovery spent in the seclusion of the mountain village of Montroig became, as he described it, his "rebirth." Here he found a direct contact with "Mother Earth," observed the sun, moon, and stars, the world of insects and birds, rock formations and plant growth. In his Montroig retreat lay the roots of Miró's primitive conceptions of Nature and Cosmos, of Creation and Passing Away, of the all-pervading polarity of Male and Female, and of his "Eternel Féminin."

In 1912 Miró, in order to make something artistic from these elemental experiences, began attending the private art school run by Francesc Galí. In 1920 he finally moved to Paris. After a period of fussily and quite naively painted landscapes, he turned to Surrealism in 1924.

Now objects took the form of signs, codes, and symbols. Miró found his technique, gained courage, and abandoned his inhibitions to delve into the memories of his childhood, creating visual statements that are also poetic ones. His pictures have titles such as *Ciphers and Constellations in Love with a Woman* and *Dog Barking at the Moon*.

The 1925 painting, *Dancer II* (plate 44), from the Rosengart Collection, dates from this period. It is one of Miró's most austere, but also most poetic, pictures. The coarse canvas is primed with a brownish ground, on top of which is a large area of brilliant ultramarine with gestural brushstrokes at its edges, suggesting slight movement. The yellow and red stippled circles, a bumblebee's dance of points ending in a spiral, convey further motion. Here it is largely the compositional techniques themselves that jump over the surface of the canvas and turn pirouettes. The "dancer" eventually takes shape from the simplest forms. She dances between space and plane. The form of her round head is rendered plastically with a light side and a shaded side. By contrast, her body is planar, and her legs and neck consist only of lines. A red heart functions as a pelvis, with a beetle hanging from its lower point to represent her sex. The legs express movement and tension.

"The inspiration for this picture came during the Christmas vacation in Barcelona, when he went to the 'Eden Concert,' at the time a famous dance-hall, and did some small sketches of a dancer he saw there. Back in Paris on rue Blomet, Miró painted this picture, which he

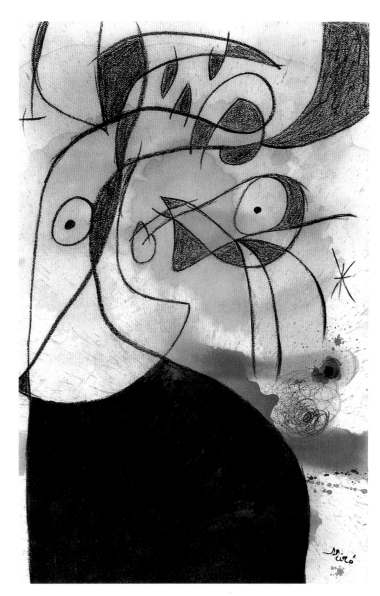

Joan Miró
Woman with Birds, 1973
charcoal, pen-and-ink, watercolor, and gouache
Fondation Maeght, Saint-Paul-de-Vence

treasured greatly, for to him it documents a very important phase in his artistic development."[1]

By combining folk art, astrology, primitivism, the Spanish grotesque, and his personal history, Miró created his own unmistakable variation of Surrealism. Programmatic theories held no interest for him. It was precisely this carefree authenticity that impressed even the leading theorist of the group, André Breton (1896–1966), who called Miró "perhaps the purest Surrealist of us all."

"How did I think up all these ideas for my pictures?" Miró asked himself in retrospect. "Now, I often returned to my studio on rue Blomet late at night and went to bed, sometimes without having eaten a thing. Then I saw things that I wrote about in my notebooks. I saw visions on the ceiling." Miró may have found a way to transform reality into a universe of signs and symbols, but they always had concrete parallels with the real world. This is why the artist stubbornly refused to be called an abstract painter: "Everything in my pictures – sun, moon, stars, plants and animals, hieroglyphics, signs and spirals – all of it came out of the visible world. Nothing gets invented; it is all already there." Especially so in his later years, Miró always saw real objects, and never an imitation or an illusion of reality (see illus. p. 51). Canvas and solid material became a place of Creation and of Passing Away, a microcosm of Mother Earth, into which he as artist-observer intervened: "I think of my studio as a vegetable garden. At a certain moment, you must prune. I work like a gardener or a wine-grower. Everything takes time."[2]

1 Hajo Düchting, in: Walter Erben: *Joan Miró* (Cologne, 1992), p. 46
2 Walter Springer: *Magier Miró* (Balingen, 1994)

Pablo Picasso, Painter of the Human

There was no dearth of words spoken in his praise: Picasso, the genius, Titan, Proteus, colossus and continent; Picasso, the destroyer and protector of tradition, the artistic pioneer, the revolutionary.

Clearly, the appellations are contradictory. Picasso's work allows no reduction to a common denominator, no discovery of a convenient leitmotif. The art of the twentieth century is for this reason inconceivable without Pablo Picasso (1881–1973). His relentless process of creation was a guiding spirit that established a completely new way of seeing.

After a lifetime of ninety-one years, he could look back on an oeuvre of about 26,000 works – works that were already important, or were still to gain decisive significance, for the course of art history.[1] The Spanish artist had utilized every conceivable technique and every medium of the visual arts to create unending transformations, variations, and series.

As tremendous as the inventive wealth of his technique and style may have been, just as unmistakable is the theme around which his art revolves: "Picasso is the painter of the human. He is a traditionalist who paints the same subject today as he did seventy years ago – people and their relationship to a reality that he demonstrates to us by means of his own exemplary life," wrote Klaus Gallwitz on the occasion of the artist's ninetieth birthday.[2]

Indeed, no theme occupied or fascinated Picasso more than human beings, their likenesses, their forms and shapes; and also their myths, dreams, and fantasies. Personal experience impelled the artist's interest in these issues. For Picasso, his life and his work were inseparable: "I paint in the same way that others write autobiography," he said. Art became his text, his diary, a seismograph of his situation. The development of Picasso as a person can be read in the works of Picasso as an artist.

Attempts to understand Picasso's development in terms of stylistic categories are almost endless.[3] But such approaches invariably fail, beginning with the work produced at the outset of the First World War. From that time Picasso expressed himself unpredictably and in the most divergent styles, and adapted each into a tool of his own icnography. He juggled with his own painterly achievements as lightheartedly and stunningly as he did with tradition. Picasso stood above styles. He became a synonym for the freedom of art.

His fluctuations in style occurred within the context of an immense cultural and historical transition – indeed, in the whole of civilization. This took place at the end of the nineteenth century. The positivist-materialist view of the world was collapsing, and a new age was dawning that would completely transform the world: the age of Modernism.

Beginnings: Early Pictures, the Academy

Visiting an exhibition of children's drawings, Picasso observed that when he was that age he had never seen the world uninhibitedly, or had never taken a naive joy in things: "When I was as old as these children, I already drew like Raphael. In the end I needed sixty years before I learned to see as they do." As a painter and draftsman, Picasso had made a quick entry into the world of adults. His father, Don José Ruiz Blasco, was an academic drawing master, and he never allowed his son the chance to develop himself by exploring the world through his drawing – to draw like a child should, without inhibitions. On the contrary, as a child Picasso was already expected to live up to the academic ideal of the nineteenth century and to execute three-dimensional reproductions of surfaces, exact detail, and *rilievo* draftsmanship. He practiced reproducing the volume of an object, through a modelling of light and shade, and sketched antique statues and fragments (see illus. p. 53). Drawing portraits, Picasso learned the spontaneous recording of individual characteristics and acquired the solid foundation of a precise graphic and painterly visual perception (see illus. p. 53). His themes came from the academy and from his father: history paintings, traditional Spanish subject-matter, portraits and animals.

Youthful Rebellion

Once Picasso had acquired the tools of composition, he began to revolt against the academy and its standards. "Why should I go there, why?" He was bored with facile approaches, critical of the academy's stifling aesthetic norms, and attracted to the idea of playfully circumventing them. His interests naturally gravitated toward "Modernism." In a search for freedom, Picasso broke with his father's world and became part of the European avant-garde. He found a spiritual home in intellectual circles in Barcelona, among the currents of Spanish Art Nouveau.

The pictures of the Norwegian artist Edvard Munch (1863–1944) – reflections of isolation and despair – posed a great artistic challenge. Within traditional Spanish painting, the figures in the paintigs of El Greco (1541–1614), wriggling out of their material imprisonment, exercised a powerful fascination.[4] Psychological elements began to play a greater role in his pictures, and he also started showing interest in physical deformation and disability.

In carefree fashion Picasso now experimented with the manners and styles of many different artists. His brilliant talent for absorbing the essential visual techniques of others, for working according to their rules, opened up a wide range of artistic expression: "It is understandable that a virtuoso disposition, one that seeks to evade every authority, runs up and down the scales of its time and plays endless preludes in search of an unprecedented chromaticity" (Werner Spies).

The encounter with the work of Henri de Toulouse-Lautrec (1864–1901) caused Picasso to begin using themes based on the social milieu and "the isolation of the individual in the crowd." Figures acquired a caricature-like exaggeration. Pictures began to lean toward the anecdotal and to show the decadence of a *fin-de-siècle* mentality. "In Paris I noticed for the first time how great a painter Toulouse-Lautrec is," he said. For a time his main themes were the café and cabaret.

Pablo Picasso
Academy Study, 1894
charcoal and black chalk

Pablo Picasso
Self-Portrait "Yo," 1899
ink and watercolor
Metropolitan Museum
of Art, New York

The World of the Traveling Circus: The Blue and Rose Periods

"Things observed through a blue glass appear in a sorrowful light," Goethe wrote in 1810 in his theory of color, *Zur Farbenlehre*. A melancholy blue character marked the pictures from Picasso's early Parisian period and served to describe his own mood. He was living in a country where he did not speak the language, moving among the bohème on the fringes of society. In the midst of this self-imposed exile, he lost his best friend and companion Casagemas, who committed suicide. Picasso's pictures from this time show frail and broken people. The figures are isolated and lonely (see illus. p. 53).

The mood first begins to lighten up in 1906. Themes and colors gradually change. The social motif of alienation begins to be displaced by a mere scenic approach. Circus performers, traveling artists and harlequins now appear in his pictures as symbols of artistry (see illus. p. 54). Art makes existence bearable, but it cannot overcome the isolation of the individual. The artist's gaze is truncated, and stares into emptiness. There is only a pretense of communication. Loneliness acquires a sentimental flair. A soft pink tone begins to supplant the blue shades. Picasso began to feel a greater sense of security, having established a relationship with Fernande Olivier and now living at the *Bateau-Lavoir*, the artist's colony on Montmartre. Wealthy Russian collectors were buying his paintings.

Searching for the Elemental: Archaic Forms

A summer spent in Gósol, a small mountain village in Catalonia, caused Picasso to turn away from psychological themes and to renounce any identification with those who were outside of society. His figures now become static, heavy, and archaic. They acquire the static solidity of painted sculpture. Picasso abandoned the reliance on the

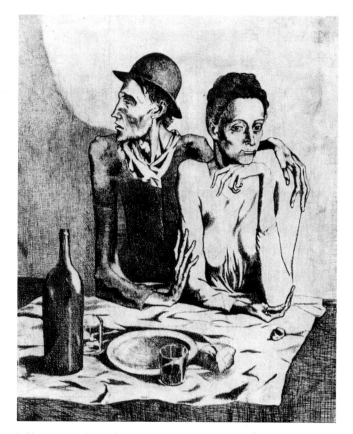

Pablo Picasso, *The Frugal Repast*, 1904
etching, Museum of Modern Art, New York

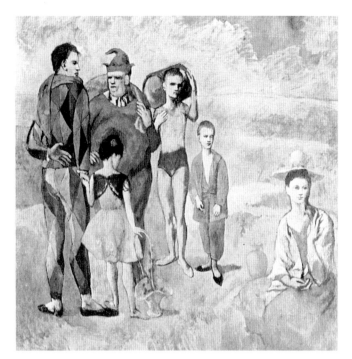

Pablo Picasso, *The Family of Saltimbanques*, 1905, oil on canvas
National Gallery of Art, Washington DC, Chester Dale Collection

momentary aspect which was intrinsic to psychological description, and instead searched out what was elemental in the form. He began to show an interest in the early Iberian sculpture of the Bronze Age, as well as a fascination for African masks and their expressive confirmation of the human.[5] He sensed the enormous potential for expressive intensification lurking within such archaic forms. In 1907 Picasso finally abandoned all the conventional rules of European painting. His artistic statements now revolve entirely around a struggle with form. He banished the "spiritual" and reduced the forms. In his crucial work, *Les*

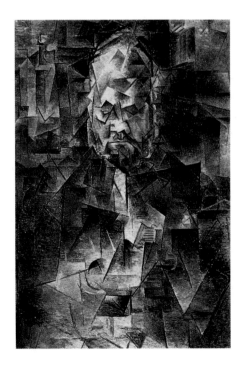

Pablo Picasso
Ambroise Vollard, 1910
oil on canvas
Pushkin Museum,
Moscow

Demoiselles d'Avignon, he broke with European tradition and subjected it to a radical questioning. Even his closest friends were unsettled by the picture. It became a milestone of Modernism.

Cubism: The Picture Becomes the Issue

Paul Cézanne (1839–1906) had long ago observed that all forms in nature could be broken down into elementary geometric shapes – into cones, spheres, and cylinders. In their paintings, Picasso and his friend Georges Braque (1882–1963) now began to systematically dismantle the object, breaking it up into geometric shapes. Since the early Renaissance, the spatial illusion of vanishing-point perspective provided the basic framework for European painting. It was now dissolved and supplanted by a rhythmic division of the picture plane. Figure and background become unified and are broken up into small geometric shapes (see illus. p. 54). All attention is concentrated upon form; color becomes peripheral. Painting becomes its own central theme, and subject turns into mere pretext. By analyzing the object in a graphic way, Picasso creates the guidelines for a new pictorial language independent of nature.

Analysis and Synthesis

Braque and Picasso soon began to reverse the process of formal disassembly. Instead of merely analyzing the model of nature geometrically (Analytic Cubism), they now increasingly combined geometric forms and lettering to create new figures (Synthetic Cubism). And materials that until then had been completely foreign to painting were applied to the surface of the picture. Thus, an important new technique was created in twentieth-century art: collage.

For almost 500 years, painting had been determined by spatial illusion, by *trompe-l'oeil*. Picasso replaced it with a *trompe d'esprit*. No longer was the eye to be exercised, but rather the intellect. Perception needed to be constantly questioned.

There has been much speculation over the true significance of cubism.[6] Cubism has been understood as the addition to pictures of a fourth dimension – that of time – and associated with the simultaneous discoveries in physics. It has also been seen as related to theories of linguistics and logic. Picasso kept away from such theoretical speculations. For him Cubism was always a question of form.

Return to the Classical Ideal

After the First World War, Picasso could go no further with his dissection of form. As a kind of dialectic reaction to the complete dissolution of form and perspective in Cubism, he now re-discovered the formal language of Classicism. The geometric fragmentation of the human form was followed by its naturalistic, harmonious depiction. Here, too, personal experiences played a role, among other things his acquaintance with the Russian dancer Olga Koklova. Picasso traveled to Italy with Sergei Diaghilev's *Ballets Russes*. Impressions gathered in Rome, Pompeii and Naples caused him to recall the ideals of Classical art. Out of this experience he began to create monumentalized, mas-

sive bodies in Classical poses (plate 21), and masterly outline drawings in the style of Jean-Auguste-Dominique Ingres (1780–1867) (see illus. p. 55).

With these neo-classical monumental forms representing the ultimate intensification of volume, and with the earlier complete dissolution of volume in Cubism, Picasso had effectively covered the two extremes of the portrayal of the body. He had mastered both physical mass and its dematerialization. Between these two poles lay a universe of design potential.

The World of the Unconscious: Surrealism

Picasso participated marginally – and then only in terms of formal rendering – in the efforts of a group of writers and artists who employed various techniques to bring images up to the surface from the depths of the unconscious. In his opinion, Freud's vision of the unconscious could not be rationalized. Surrealist collages and the use of form as symbol provided a stimulus, but he steered clear of the Surrealists' theoretical disputes and fundamentally rejected the idea of psychic automatism as expounded by André Breton (1896–1966).

He nonetheless introduced elements of Surrealism, especially "biomorphic distortion," into his repertoire of visual technique. And in 1925 Picasso took part in the large Surrealist exhibition in Paris, as did Paul Klee (1879–1940) and Max Ernst (1891–1976).[7]

Dissolution of Chronology and Style

At this point one can still speak of a development in Picasso's style, if only in conditional terms. That becomes impossible from the 1930s.

Picasso now possessed a broad range of compositional techniques. He had struggled with both the traditions of painting and its avant-garde aspects. He had thematically employed both the beautiful and the ugly, and had perfected Classical form as well as a totally Cubist distortion. He ordered area and space, and commanded the painterly as well as the graphic. He dismantled nature into its parts, and used these parts to reconstruct it. He moved effortlessly between fragmentation and monumentalizing. Henceforth Picasso operated without a stylistic framework, independent of public judgment, free and unbound in the world of art. "A free availability of all acquired tools" manifests itself in the paintings, "from a Baroque intensification of expression to its Spartan reduction" (Werner Spies).

No meaningful criteria for his late work can be established, either in terms of period or of style. In each work Picasso simply selected one of the many styles and modes of design at his disposal, depending on the situation in each case, his mood at the time, the theme, or the model. Different styles might appear in one painting. The choice of a style itself acquires content and meaning, says something about the subject, and becomes iconography. Thanks to his creative potency, Picasso could allow himself the luxury of foregoing a personal style that served as a kind of "brand name."

Pablo Picasso, *Léonce Rosenberg*, 1915, pencil

Picture of the Human

Picasso's central theme is the human being. Once he freed compositional technique from illustrative representation, he arrived at a completely new and daring understanding of portraiture, and became one of the few artists of the twentieth century to find a contemporary expression for the genre.

From the beginning of time human beings have tried to transcend the fleeting nature of existence by immortalizing external appearance. Quite beyond illustration, the portrait always took on different functions according to the particular historical period in which it was created. Medieval donor portraits may show the humble piety of the person depicted, but the individual's status rose in the Renaissance period, when the image of the self-confident protagonist was common. From then on, the autonomous portrait became the carrier of human self-understanding and mirrored the ideals of an age – of the faithful individual of the Reformation as much as the self-confident and status-conscious Dutch citizen of the seventeenth century. Portraits demonstrate the power of a Baroque ruler, or the humanist ideals of an Enlightenment philosopher, or reveal the polite reserve of the Biedermeier age. After the invention of photography, however, and with the dissolution of a reliable social order at the end of the nineteenth century, the painted portrait entered a period of crisis.

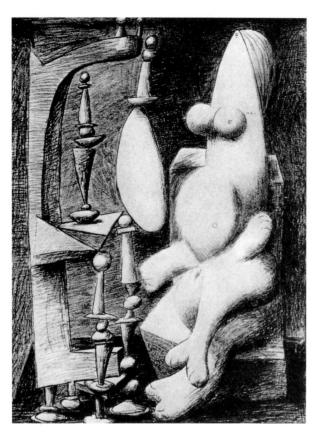

Pablo Picasso, *Nude in Front of a Dresser*, 1936, pencil
Musée Picasso, Paris

Portraiture in Modernism

The main characteristic of traditional portraiture is the similarity that exists between depiction and actual external appearance. No other genre so completely subjected painters to the dictates of optical illustration. What was demanded of portrait painters was something more akin to a reflection in a mirror than to a work of art. But, beginning in the nineteenth century, photography was able to assume that function. The painter freed himself from illustration and instead entered into an artistic dialog with the person being portrayed, through the medium of the picture. The portrait became a subjective statement by the artist. Employing the tools developed by Modernism, the artist created an inner likeness – a "visage interieur" (Picasso).

The artistic part of a portrait photograph is limited to identifying characteristic features – the means of portrayal being a technical matter. But painted portraiture demands both – on the one hand that the essence of a person's multifaceted inner self be captured, and on the other hand that there be a mastery of artistic craft. In the twentieth century, only a few artists were able to portray the "inner face" of a person. Alexej Jawlensky (1864–1941), Henri Matisse (1869–1954), Otto Dix (1891–1969), Max Beckmann (1884–1950), Oskar Kokoschka (1886–1980) and Picasso are the great portrait painters of classical Modernism.[8]

Woman: Mirror of the World

Next to the motif of "painter and model," the main topos in Picasso's work as a whole is undoubtedly the depiction of Woman. Nothing else in his work exceeds the formal and stylistic variety with which his portraits of women are rendered.

"One should only paint what one loves. I am in love with every motif, and the most beautiful is Woman," Picasso said. Indeed, Picasso's marvellous portraits of women are among the masterpieces of his painting as a whole. The subjects show unusual immobility, stoic contemplativeness and tranquillity, and an extraordinary plasticity that represents the true greatness of Picasso's art (plates 46 to 51).

Picasso's images of women strive toward an ideal form of Woman, and toward an original symbol of nature. Closed, suggesting a harmonious and self-contained calm, and yet full of tension, his Woman recalls the "universal female qualities" of one of Jean Racine's women. Woman, as a mirror of the human and of the world, is revealed to us as an exaggerated but at times inwardly torn being, rendered in every possible perspective, in profile and full-face, polyvalent and polymorphous. Verism, alienation, Cubist rearrangement, plasticity, and great fantasy merge in Picasso's transformations of Woman.

An encounter with a new woman, whether as a lover or a model, would always seize Picasso completely in its grip. Each time, "the Female" would grow into an obsession and would generate a new-style of portrayal. Thus, Picasso's depictions of women are also subject to the rich variety of artistic representation that he had at his command.

Picasso represented Woman independently from principles of realistic imitation. Too much verism – an exact correspondence of picture to model – was never intended. He placed a far greater emphasis on the independence and internal logic of a picture. Art must provide that which nature cannot give.

Faces acquire many levels of meaning, reflecting the various elements of the psyche. Picasso designed a female world of shifting variety and multiple layers. To express that, vanishing-point perspective was supplanted by a way of seeing that viewed the model from multiple perspectives, capturing her multidimensionally. This method of depiction stems from the Cubist principle of constantly shifting viewpoints. The separation of particular aspects creates divergent views from differing perspectives, simultaneous frontal and side views, and two or more faces within one. The "face within the face" certainly represents the essential innovation in Picasso's portraiture.

Through the simultaneity of full and partial views, of views from front and rear, or of profiles and full faces, an entirely new "facial space" arises, one that constantly reveals additional aspects of itself. Multiple layering and a constant shifting of light and shadow show the sitter's various aspects, and reveal the landscape of the face. Several faces within a single face: one must indeed recall Jung and the discovery of the psyche as a deep phenomenon with its countless facets (see especially plates 50 and 51).

Picasso was the great destroyer of pictorial standards, and yet at the same time he was a Classicist. He was also the destroyer of the face, and the architect of new physiognomy of his own invention.

He wanted to acquire and possess persons and objects within his sphere, often to destroy them in order to then grant them new life. He was the destroyer, and at the same time creator, of a mythology.

But in all his works he sought to express his truth, and this truth was for him the human, and the life of the human was for him of the highest value.

Underlying that, however, was a different human truth – the knowledge of creation and passing away, the knowledge of life's inconsistency – ruled by a nature that always generates new life, and yet destroys that life through the irreversibility of death.

In the field of conflict between the classical poles of Eros and Thanatos – between the magic of eternal love and the finality of an all-destroying death – Picasso's art crystallizes on the one hand into a mirror of the great Mediterranean cultural civilization of ancient Greece and Rome, while nonetheless standing on the other for the inner strife of the modern individual of the Western world.

Seen in this context, Picasso's portrayals of women are not only aesthetic, but also highly dramatic, and today serve as prototypes for the eternally youthful inspiration of the painter through his model. They bear rapt witness to great human passion.

1 Klaus Gallwitz: *Picasso Laureatus: Sein malerisches Werk seit 1945* (Lucerne and Frankfurt, 1945), p. 184
2 The most important catalogues of Picasso's works are: Christian Zervos: *Pablo Picasso: Catalogue des peintures et dessins*, 30 volumes (Paris, 1932–1975) Fernand Mourlot: *Picasso lithographe*, 4 volumes (Monte Carlo, 1949) Werner Spies: *Pablo Picasso: Das plastische Werk* (Stuttgart, 1971)
3 What is decisive in Picasso's work is not a sequence of dissimilar elements, but rather their simultaneity. It is basically impossible to fit Picasso's oeuvre into any kind of chronological unity. Alfred H. Barr was the first to attempt to assign stylistic descriptions to specific groups of works and to particular phases, and he created a schema that has remained authoritative to this day. See Alfred H. Barr: *Picasso: Fifty Years of his Art* (New York, 1946). Other authors attempt to categorize his later works according to the time he spent with each of his female companions: e.g. the Dora Maar period, the Jacqueline Roque period, etc.
4 Anthony Blunt and Phoebe Pool examined the formative influences on Picasso's early work in: *Picasso, the Formative Years: A Study of his Sources* (London, 1962).
5 For a comprehensive treatment of the reception of primitive art, see: William Rubin: "Picasso," *Primitivismus in der Kunst des zwanzigsten Jahrhunderts* (Munich, 1984), pp. 249–53.
6 The term "Cubism" originated with the art critic Louis Vauxcelles, who, in viewing a painting of Georges Braque's spoke of "les petits cubes" and "bizarreries cubiques." Edward Fry discusses the various theories of Cubism in his book *Der Kubismus* (Cologne, 1966). An important contemporary observer of Picasso in the significant year of 1907 was his friend and art dealer Daniel-Henry Kahnweiler (see Daniel-Henry Kahnweiler: *Der Weg zum Kubismus* Stuttgart, 1958).
7 Picasso's position within the Surrealist movement is examined in: Lazlo Glozer: *Picasso und der Surrealismus* (Cologne, 1974). Surrealist elements in Picasso's work are limited to "biomorphic distortion," meaning the metamorphosis of the anatomy into plant-like, rounded forms. The method of enhancing a subjective vision through an accumulation of unconnected levels of meaning such as found in the works of Max Ernst, Giorgio de Chirico, or René Magritte, is not present in Picasso's work.
8 The portrait in modern art is discussed by Alexander Gosztony in: *Der Mensch in der modernen Malerei: Versuche zur Philosophie des Schöpferischen* (Munich, 1979). See especially chapter I on "Die Photographie als Konkurrenz zur Bildnismalerei," and chapter VI on "Picasso und die Nostalgie des Heidentums."

Plates

Pierre-Auguste Renoir · The Eternal Female · *Plates 1 to 8*

Edgar Degas · Love is Here, Painting is There · *Plates 9 to 10*

Paul Cézanne · The Metamorphosis of Eros into Color · *Plate 11*

Paul Gauguin · Painting against the Corruption of Civilization · *Plate 12*

Pierre Bonnard · The Painter of Stylish Women · *Plates 13 to 20*

Henri Matisse · Luxe, calme et volupté · *Plates 21 to 23*

Kees van Dongen · From Madonna to Cosmopolitan Woman · *Plates 24 to 29*

Amedeo Modigliani · Eros and Melancholy in Classical Form · *Plates 30 to 31*

Marc Chagall · The Sacred Song of Painting · *Plates 32 to 39*

Fernand Léger · "L'Eternel Féminin" as "Contraste des Formes" · *Plates 40 to 43*

Joan Miró · The Eternal Female as Cosmic Principle · *Plate 44*

Pablo Picasso · Painter, Muse, and Model · *Plates 45 to 51*

Picasso as Draftsman · *Plates 52 to 79*

Pierre-Auguste Renoir

The Sensuousness of Flesh Tone

Pierre-Auguste Renoir's image of Woman was far more relaxed and less problematic than that of his friend and fellow painter Paul Cézanne. Instead of preoccupying himself with Baudelaire and Flaubert, the young Renoir spent his early years as an apprentice porcelain painter transferring Rococo motifs on to cups, saucers, and plates. He was the son of a simple and poor family of tradesmen from Limoges. What distinguishes him from the rest of his fellow Impressionists is that he was the only one to grow up in a family that remained intact. Renoir was always "full of gratefulness" when speaking of his mother, as is repeatedly emphasized in *Renoir* (1962), the biography of the artist by his son Jean. Renoir was always happy to visit his mother and did so regularly until her death.

Family was the most important concern in Renoir's life. This becomes clear in his many pictures on the theme. He painted his wife Aline with affection and without a trace of artifice, whether portraying her nursing their sons or in group portraits with family members. The paintings of his wife are filled with respect and recognition. Renoir's idea of Eros is shaped by the uninhibited sensuousness of the Rococo. Already frequenting the galleries of the Musée du Louvre at the age of thirteen, he declared François Boucher's *Diana at the Bath* (1742) to be his favorite picture, and he later claimed that this work was the one that initially inspired his interest in painting. But in the Louvre Renoir surely had occasion to admire the more frivolous and titillating paintings by Boucher and Jean-Honoré Fragonard in the Louvre as well. Among the nudes that he valued and sometimes also copied — and certainly not merely for the painterly qualities — were those of Peter Paul Rubens, whose "sensuousness of flesh tone" he often praised. Nor should the works of the sixteenth-century Venetians, from Titian and Giorgione to Veronese and Tintoretto, be ignored as influences. In his late work Renoir took up their motif of the nude in an Arcadian landscape, but he greatly deemphasized their naturalism in favor of a monumentalization, finally imbuing them with a modernity that prefigures the sculptures of Henry Moore (1898–1986). In the process, Woman loses more and more of her individualism and is transformed into an idol.

1 Pierre-Auguste Renoir
Nude, Rear View, 1879
pastel, 16 ¹/₂ × 10 ⁵/₈ in. (42 × 27 cm)
private collection, Switzerland

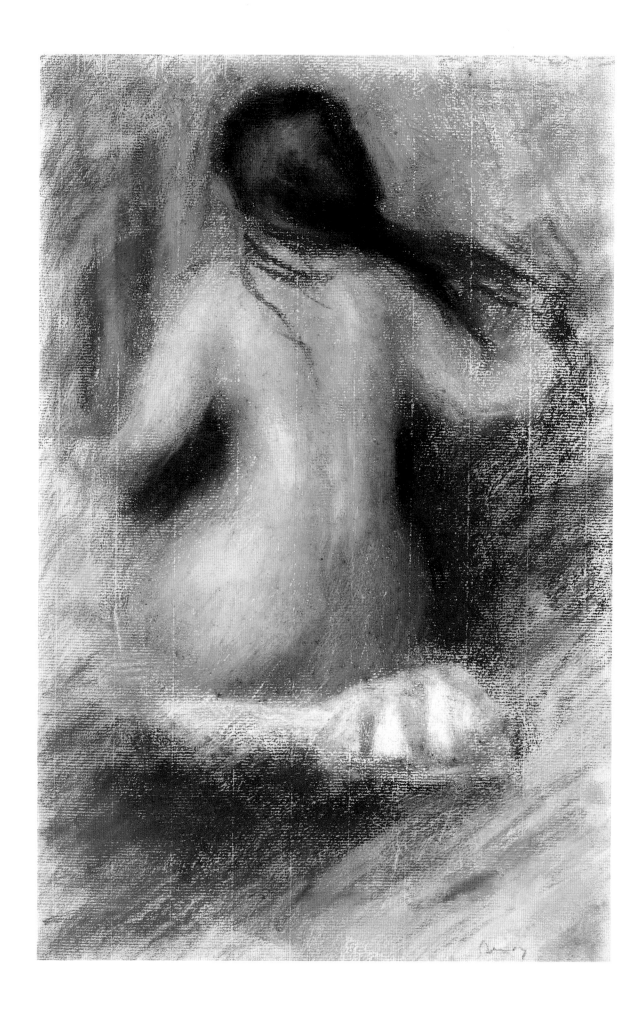

2 Pierre-Auguste Renoir
Italian Woman with Tambourine, 1881
oil on canvas, 30 $\frac{7}{8}$ × 13 $\frac{1}{2}$ in. (78.5 × 34.2 cm)
private collection, Switzerland

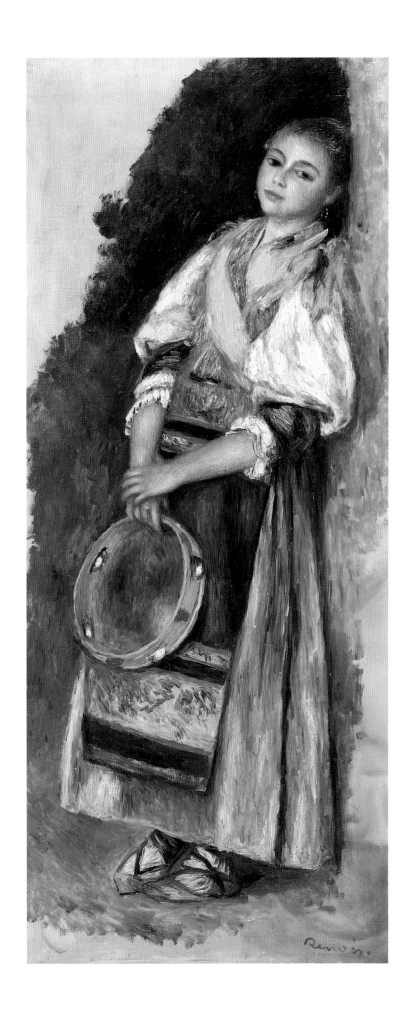

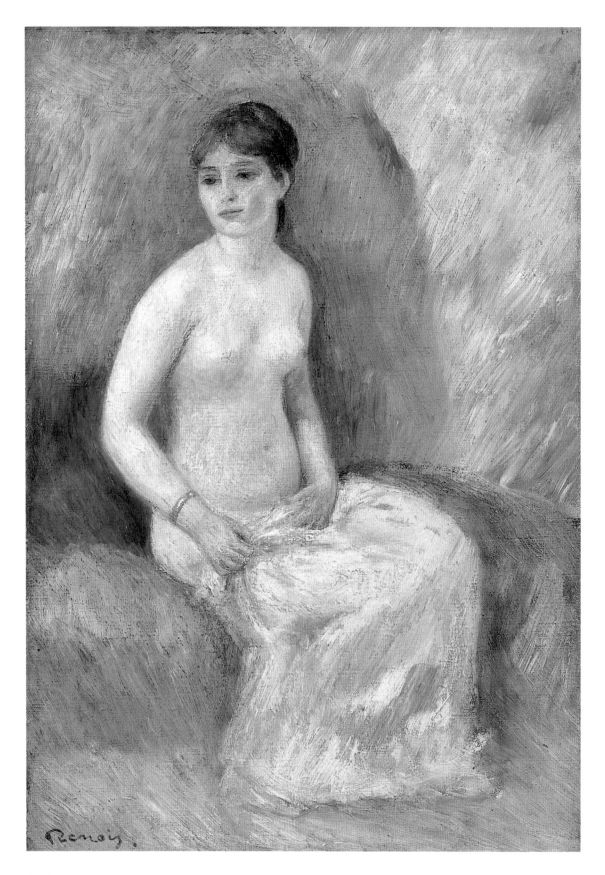

3 Pierre-Auguste Renoir
Bather, 1882
oil on canvas, 16 ¼ × 12 ⅝ in. (41 × 32 cm)
private collection

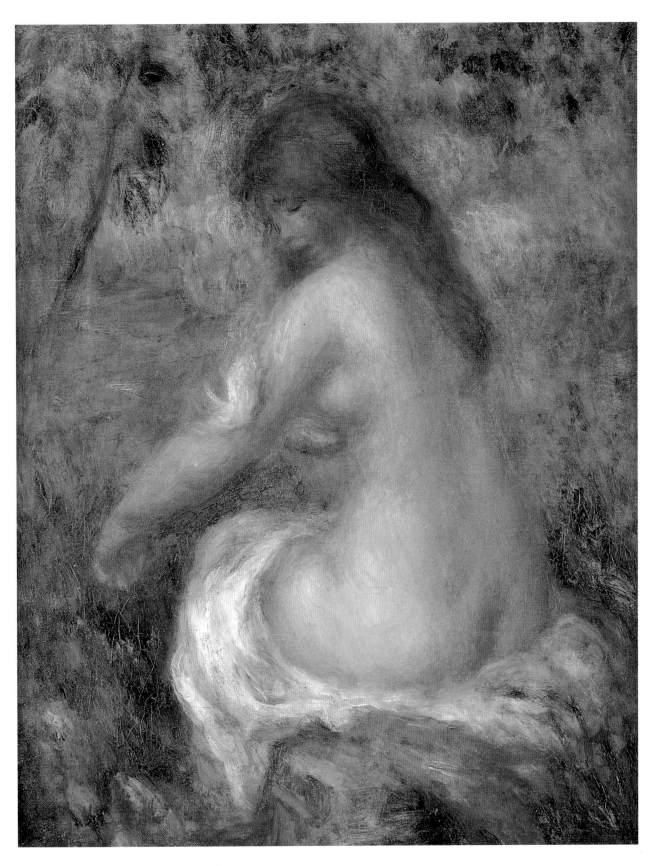

4 Pierre-Auguste Renoir
Bather, 1883
oil on canvas, 18 ⅛ × 12 ⅝ in. (46 × 32 cm)
private collection

5 Pierre-Auguste Renoir
Woman Reading, 1891
oil on canvas, 16 ⅝ × 13 ½ in. (42.2 × 34.3 cm)
Museum of Fine Arts, St. Petersburg, Florida

6 Pierre-Auguste Renoir
The Picture-book, 1895
oil on canvas, 22 ³/₄ × 19 ¹/₂ in. (58 × 49.5 cm)
The Dixon Gallery and Gardens, Memphis, Tennessee

7 Pierre-Auguste Renoir
L'Ingénue, 1895
oil on canvas, 15 ¾ × 11 ¾ in. (40 × 30 cm)
Memphis Brooks Museum of Art, Memphis, Tennessee

8 Pierre-Auguste Renoir
Reclining Nude, Rear View, 1909
oil on canvas, 16 $\frac{1}{8}$ × 20 $\frac{1}{2}$ in. (41 × 52 cm)
Paris, Musée d'Orsay,
Gift of Dr. and Mrs. Albert Charpentier

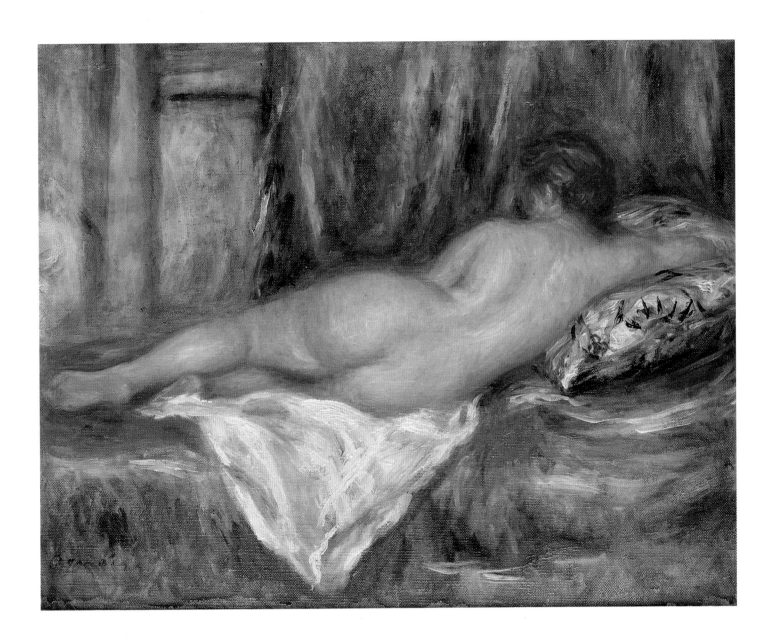

Edgar Degas

Love is Here, Painting is There

"Edgar Degas," the poet Paul Valéry wrote, "had the most difficult nature imaginable." Degas made no efforts to conceal his exasperating and mysterious character. As is demonstrated by the many *bon mots* his biographers love to relate, he seems to have hardly ever missed an opportunity to make himself unpopular through some chauvinistic remark. Degas found refuge in sarcasm, and lost most of his friends through cynicism and gruff mockery.

In his early self-portraits he depicts himself as shy, reserved, and insecure. The loss of his mother at the age of thirty-two seemed to have plunged him into a deep depression from which he only slowly recovered. During this time he painted *Young Spartan Girls Provoking the Boys*, in which he concealed an erotic theme behind a mythological title but without disguising the nudes in his-

torical costume or giving them an antique ambiance. The painting, the boys' courting and the girls' reaction, can be understood as a depiction of the artist's own yearnings and fears. Commenting on one of his later *Femmes au Tub*, Degas remarked: "But my women are simple straightforward women, concerned with nothing beyond their physical existence. Just look at this one: she is washing her feet. It is as if she were being observed through a keyhole."[1]

He explained the reason why he never married: "I would have hellish torments for fear my wife might see one of my pictures and say, 'Oh, how pretty'.... Love is over here, painting is over there. And we have but one heart." Yet Degas was not a misogynist, as his friendships with the painters Berthe Morisot, Suzanne Valadon, and Mary Cassatt demonstrate.

1 Bernd Growe: *Degas* (Cologne, 1991), p. 81

9 Edgar Degas
The Amazons, 1882
pastel, 38 ¼ × 25 ¼ in. (97 × 64 cm)
private collection

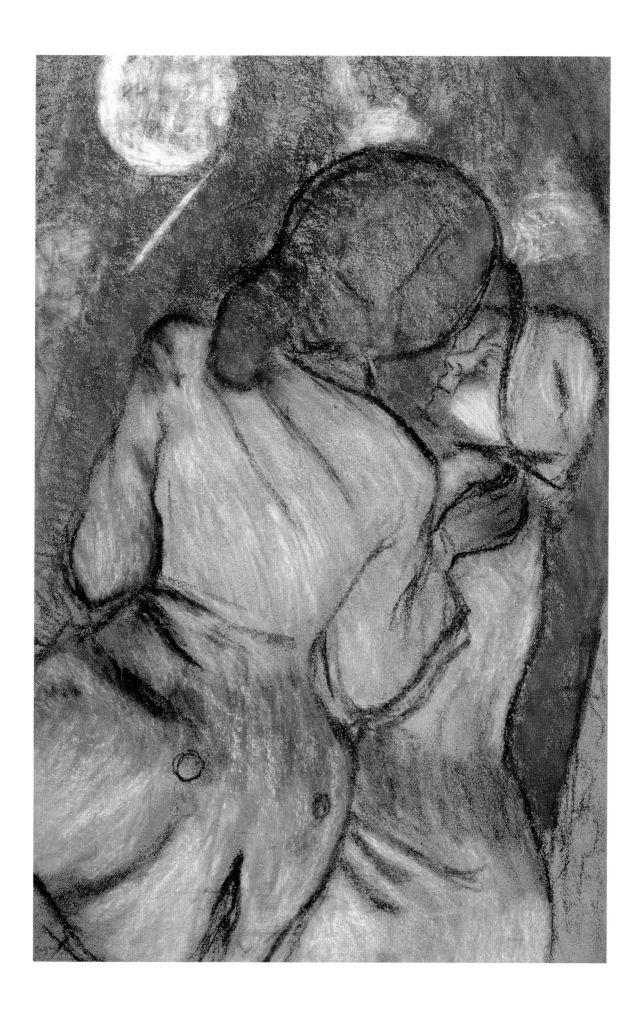

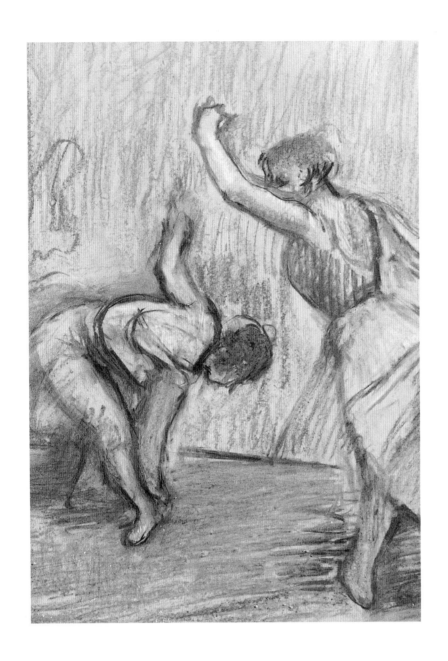

10 Edgar Degas
Dancers, 1902
pastel, 32 ¾ × 44 ⅛ in. (83 × 112 cm)
private collection

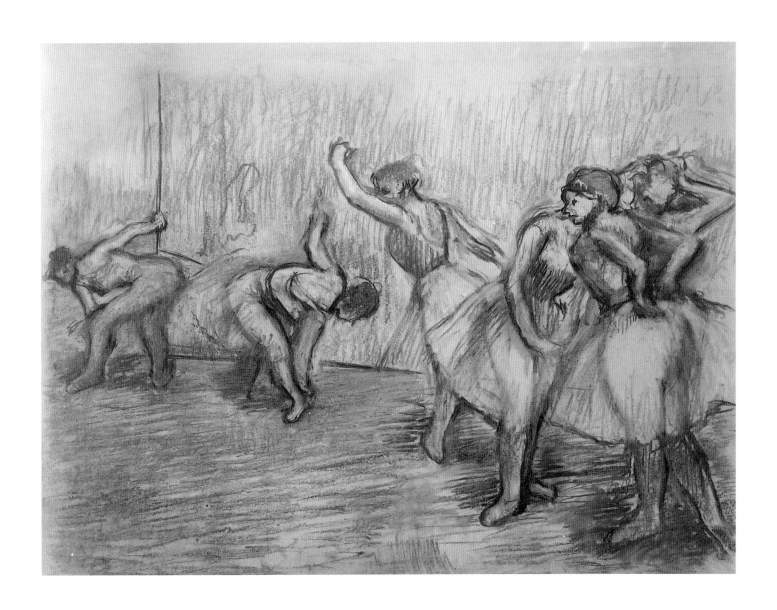

Paul Cézanne

The Metamorphosis of Eros into Color

There has been much speculation about Cézanne's image of Woman. As the American art historian Meyer Schapiro remarked long ago, Cézanne's early work is shaped by unfulfilled erotic conflicts and the constant humiliations perpetrated by his tyrannical petit-bourgeois father, a man who routinely had his way with the female servants. Cézanne preferred to draw his female nudes from sculptures. He also did not use live models for his renderings of bathers, as the painter Francis Jourdain (1876–1958), who visited Cézanne in 1904, reported: "In front of his *Bathers* he explained to us that he...had long ago given up the idea of having a model undress in his studio. Painting as a whole.... 'It is in here!' he added, and struck his forehead as he spoke." It was not until he was thirty that Cézanne had his first

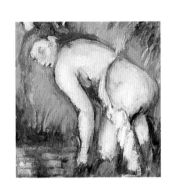

intimate contact with the female sex. In 1869 he met Hortense Fiquet. Although their son was born just two years later, Cézanne – fearful of his father – kept her existence a secret from him, not marrying her until 1886. If the early portraits of Hortense from his sketchbooks still show an emotional engagement, in later years he transformed her into a purely painterly phenomenon, with all traces of emotion being dissolved in favor of color and formal relationships. In this way the confused eroticism of Cézanne's early works is also transformed into an Arcadia freed from any battle between the sexes, where male and female figures merge into androgynous beings of color. One could say that Cézanne had transcended the "Eternal Female" through an interaction of color and form.

11 Paul Cézanne
The Bathers, ca. 1870
oil on canvas, 12 ⅞ × 15 ¾ in. (32.8 × 40 cm)
private collection

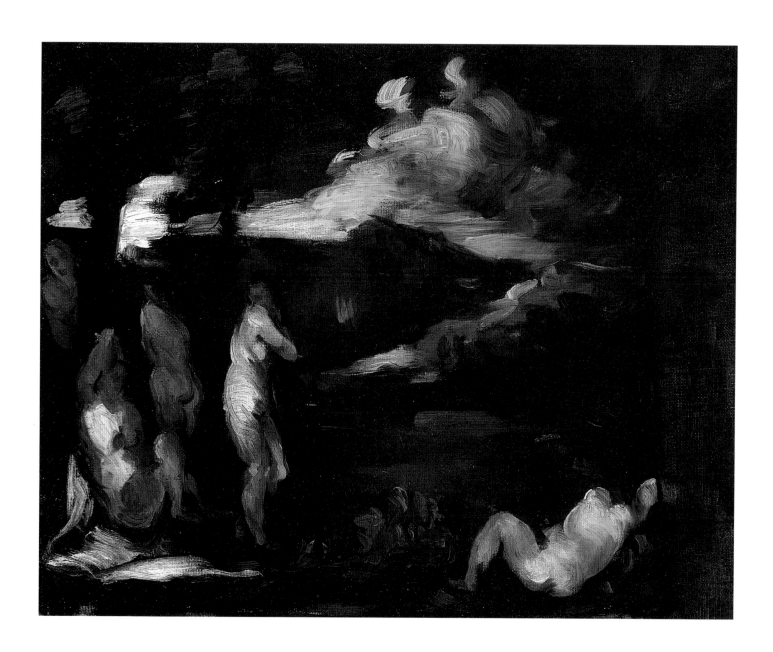

Paul Gauguin

Painting against the Corruption of Civilization

A yearning for a lost paradise and an "Eternel Féminin" untouched by patriarchal civilization were the driving forces behind Paul Gauguin's painting. In Tahiti he believed he had finally found his lost paradise. The pictures painted there almost all show women as carriers of plot and as the means by which religious experience is conveyed. In *Where Do We Come From? What Are We? Where Are We Going?*, a large painting of 1897 which helped him in healing and overcoming his life's crisis, women again possess the secret knowledge of supernatural powers incarnated in idols and icons. They are guardians of Paradise, living at leisure in a peaceful and tranquil harmony with a nature that gives them its fruits.[1]

In contrast to the sublime, symbolist-filled vision of his art, Gauguin's real life was far removed from any moral ideal. The outward appearance of the South Pacific as a paradise world did not correspond to the everyday reality of colonial rule. The idealized portrayals of happiness in his pictures are in contradiction to the depraved life that he led and from which he suffered: "I know not love, and I had to force the words through my teeth just to say 'I love you'... Intelligent women can sense this, and that is why they don't like me."[2] In 1901 Gauguin left Tahiti and settled on Hiva Oa, one of the Marquesas Islands. He was full of hope that there he would finally escape from the civilization he despised. But his wish was not to be fulfilled. On Hiva Oa he did indeed find vestiges of the old Maori culture, but also found the colonial structure that was present elsewhere in French Polynesia – a world of government officials, clerics, and policemen. Since Gauguin championed the interests of the indigenous peoples, it was not long before he again experienced problems with the gendarmerie.

In 1902 he painted *The Magician of Hiva Oa* (plate 12). The work shows a figure with unusually long hair flowing over its shoulders – one that may well be female. It is remarkable that during this time Gauguin painted a whole series of androgynous figures. The picture was probably first exhibited in Paris at Ambroise Vollard's in 1903, but without a title. The earliest confirmed instance of the painting being illustrated occured in 1910, when it appeared in the magazine *Deutsche Kunst und Dekoration* under the title *Aux Iles Marquises*. The work appeared again under that title at a large auction held at the Galerie Fischer in Lucerne, where it was presented together with other pictures as "degenerate art." Acting for the Musée des Beaux-Arts in Liège, Auguste Buisseret acquired it with a bid for 50,000 SFr. The painting is now in the collection of the Musée d'Art Moderne in Liège, with the title *The Magician of Hiva Oa* or *Marquesan with Red Cape*.

1 J. Held and N. Schneider: *Sozialgeschichte der Malerei* (Cologne, 1993), p. 382
2 Eckhard Hollmann: *Paul Gauguin: Bilder aus der Südsee* (Munich, 1996), p. 78

12 Paul Gauguin
The Magician of Hiva Oa, 1902
oil on canvas, 36 ¼ × 28 ¾ in. (92 × 73 cm)
Musée d'Art Moderne, Liège

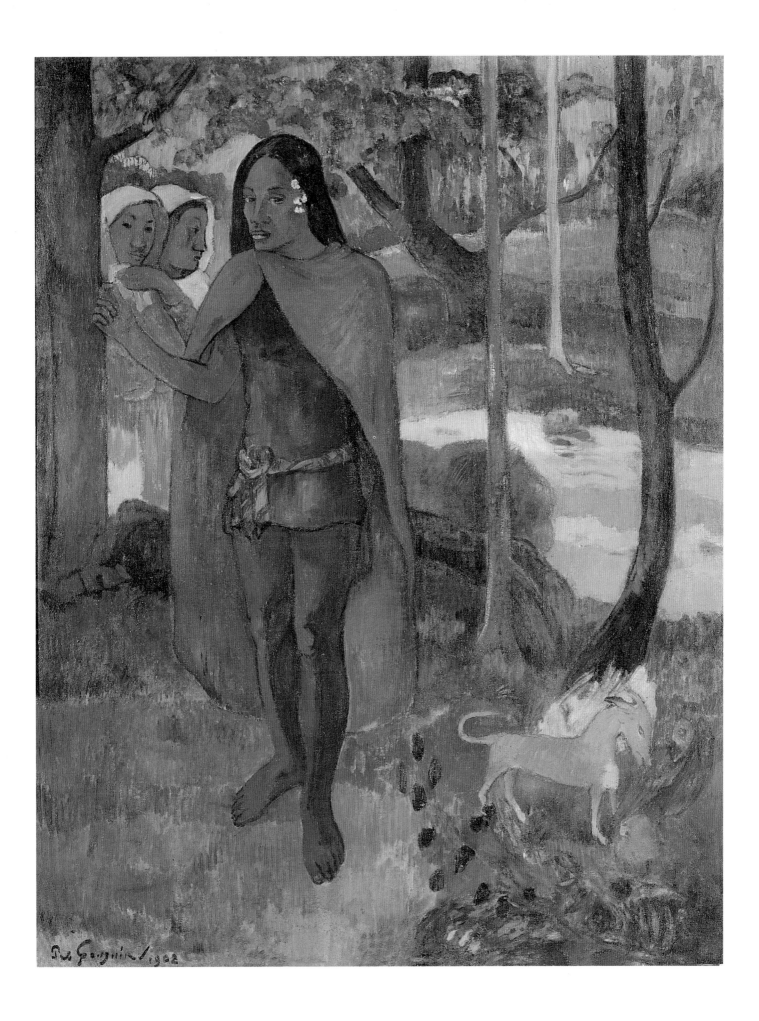

Pierre Bonnard

The Painter of Stylish Women

Woman is the preferred subject in Pierre Bonnard's work. She might be the fashionable lady to be found looking in shop windows or sauntering along a lively boulevard. Fashionably dressed, she plays the "Grand Dame" in all her coquetry and with all the other attributes expected of the wealthy bourgeois woman. We find her not only in the midst of the hustle and bustle of the big city, but also by herself – having withdrawn to her bath, in the act of dressing, at the fireplace, or viewing herself in the mirror. Illuminated by diffuse light and warm tones, her physical presence is noble and restrained. Bonnard never renders his women mercilessly; they are always shown full of grace and spirit. Nonetheless, there are also pictures of highly concentrated eroticism such as *"Indolence"* (plate 15), painted ca. 1899. At this time Bonnard was using a similar motif in his pencil drawings for Paul Verlaine's *Parallèlement*. Reviewing the exhibition for the *Revue blanche*, Bonnard's friend and critic Thadée Natanson wrote about a second version of this painting, which differs from the one in this exhibition only through the presence of a cat cuddling near the woman's left shoulder[1]: "Bonnard conjures up golden-yellow flooding light onto bed-sheets and lets splendidly stretching female bodies play."[2] This painting exemplifies the fascination of "L'Eternel Féminin," the aura of dignified mystery that in all its eroticism always surrounds Bonnard's women. His pictures need to be seen very much in the context of the Art Nouveau movement, fully imbued with a *fin-de-siècle* atmosphere, and they are also comparable to the written work of Emile Zola.

1 In the collection of the Musée d'Orsay, Paris
2 Auction catalogue for the Thadée Natanson collection (Paris, Hôtel Drouot, 1908, Nr. 14)

13 Pierre Bonnard
The Flower Shop, 1894
oil on canvas, 8 7/8 × 8 7/8 in. (22.6 × 22.6 cm)
collection of Mr. and Mrs. Spencer Hays

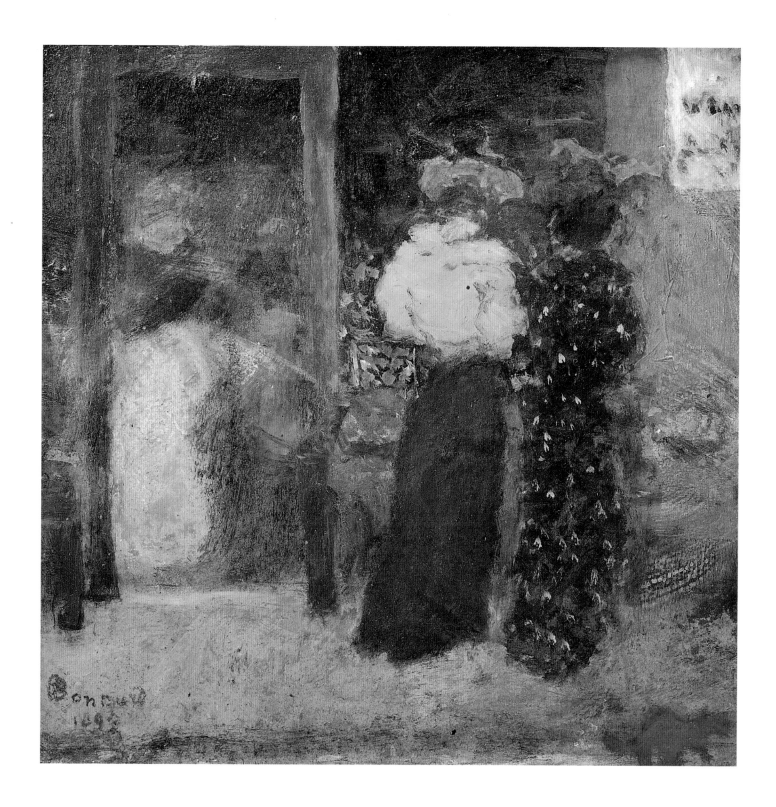

14 Pierre Bonnard
Café in the Woods, 1896
oil on canvas, 19 ¼ × 13 in. (49 × 33 cm)
collection of Mr. and Mrs. Spencer Hays

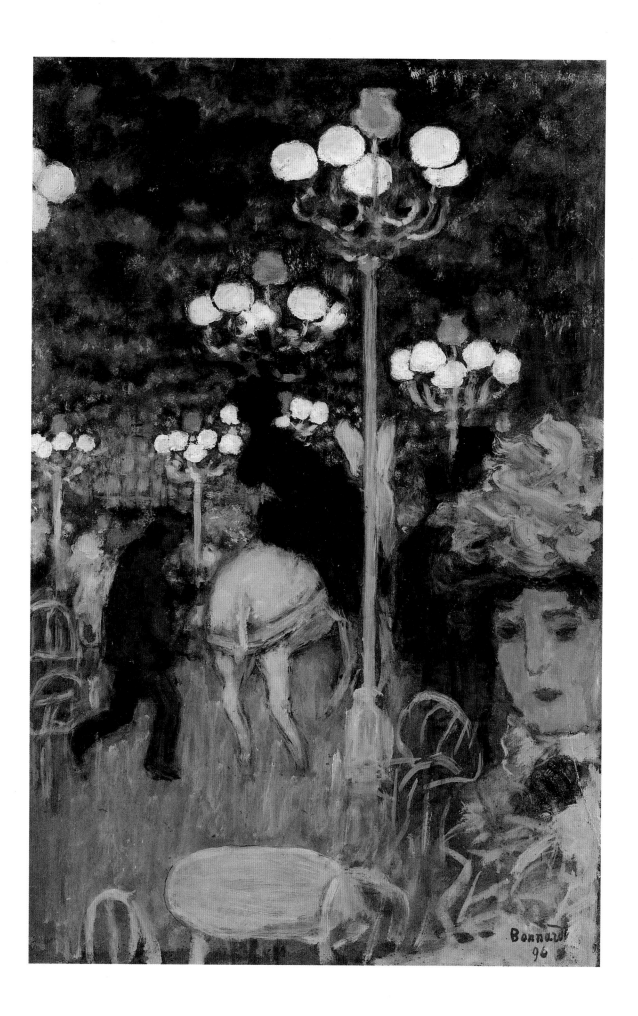

15 Pierre Bonnard
"Indolence", ca. 1899
oil on canvas, 36 ¼ × 42 ½ in. (92 × 108 cm)
Josefowitz Collection

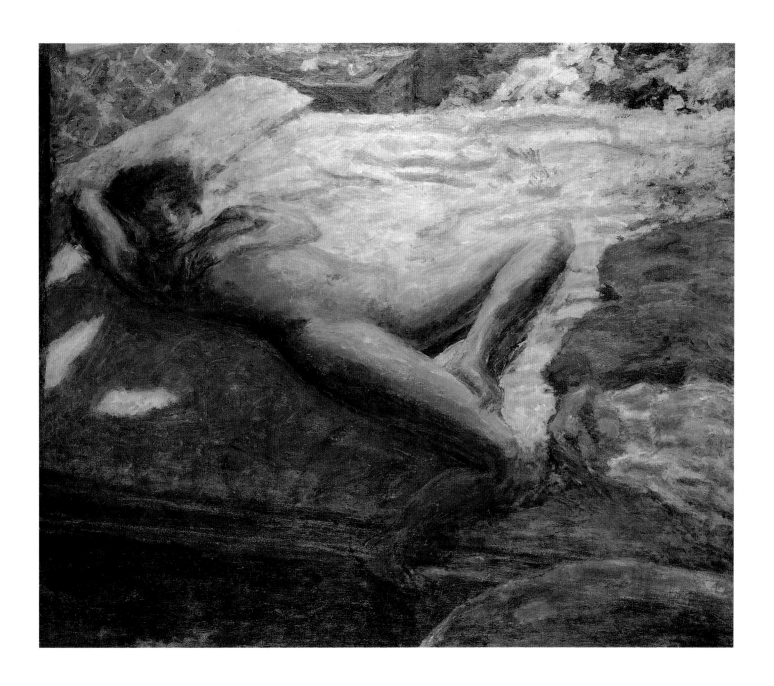

16 Pierre Bonnard
Woman with Black Stockings or *The Shoe*, ca. 1900
oil on canvas, 24 ⅜ × 25 ¼ in. (62 × 64.2 cm)
private collection, Switzerland

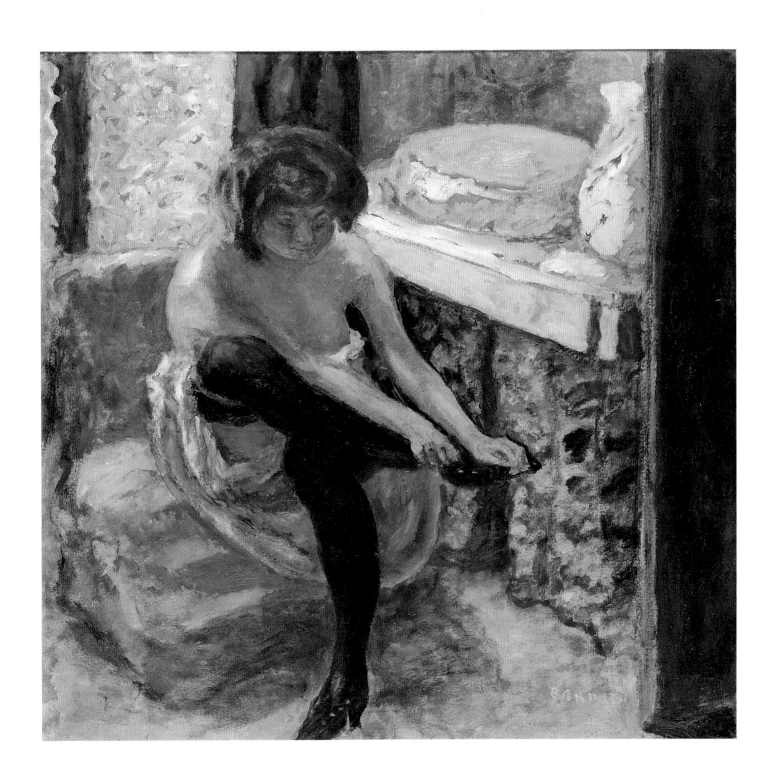

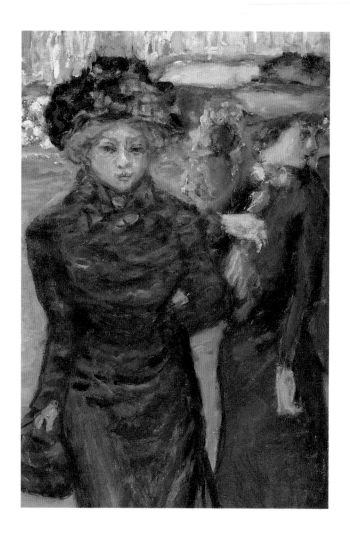

17 Pierre Bonnard
Place Clichy, 1906–07
oil on canvas, 40 ⅝ × 46 ⅛ in. (103 × 117 cm)
Duménil Collection

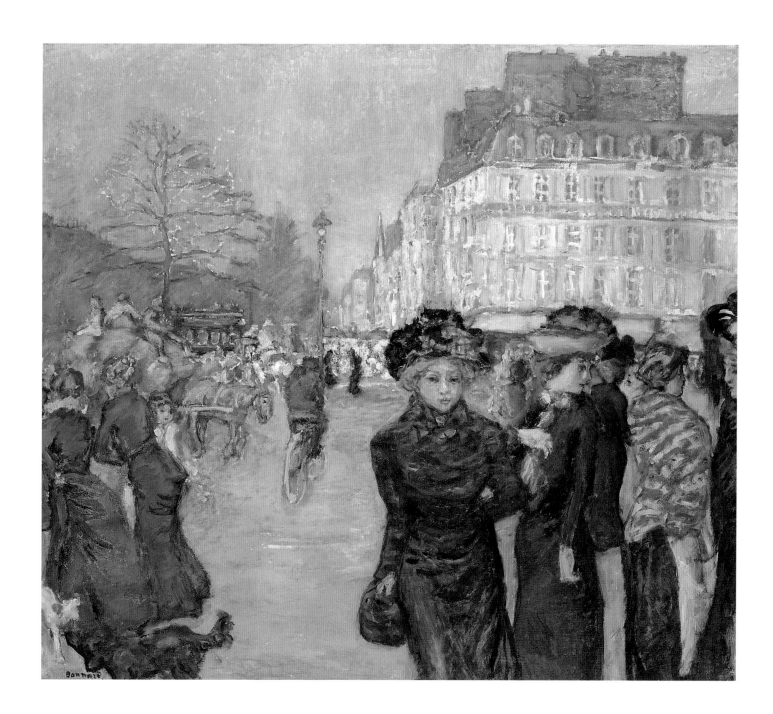

18 Pierre Bonnard
Crouching Woman or *Nude at the Tub*, 1913
oil on canvas, 29 ¹⁄₂ × 20 ⁷⁄₈ in. (75 × 53 cm)
private collection

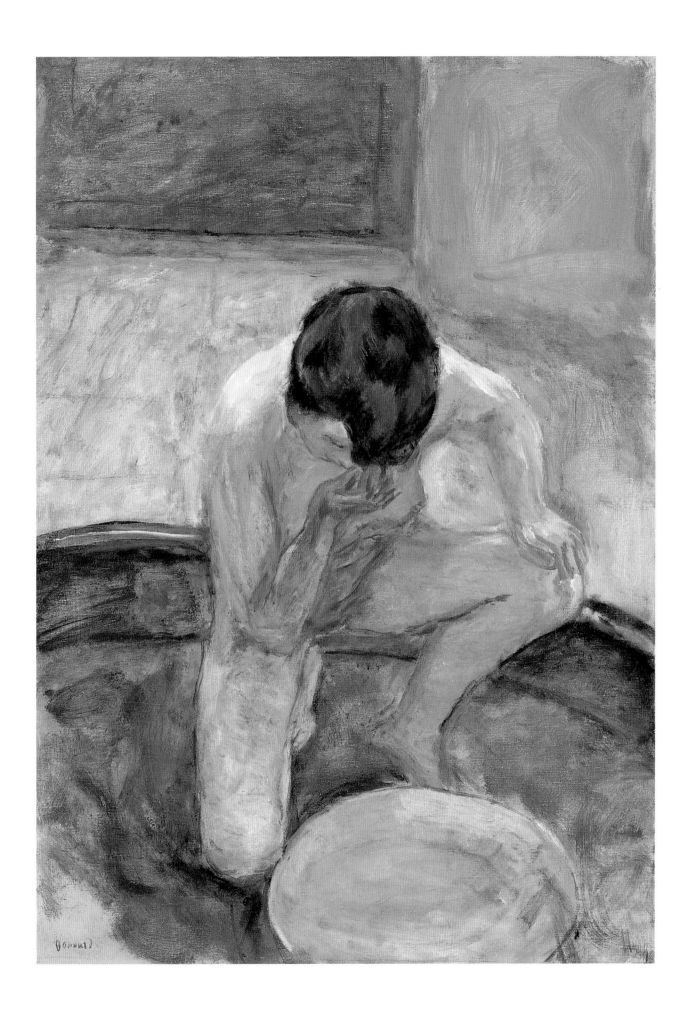

19 Pierre Bonnard
Marthe Dressing, 1919
oil on canvas, 28 ³⁄₈ × 15 in. (72 × 38 cm)
Musée des Beaux-Arts et d'Archéologie, Besançon

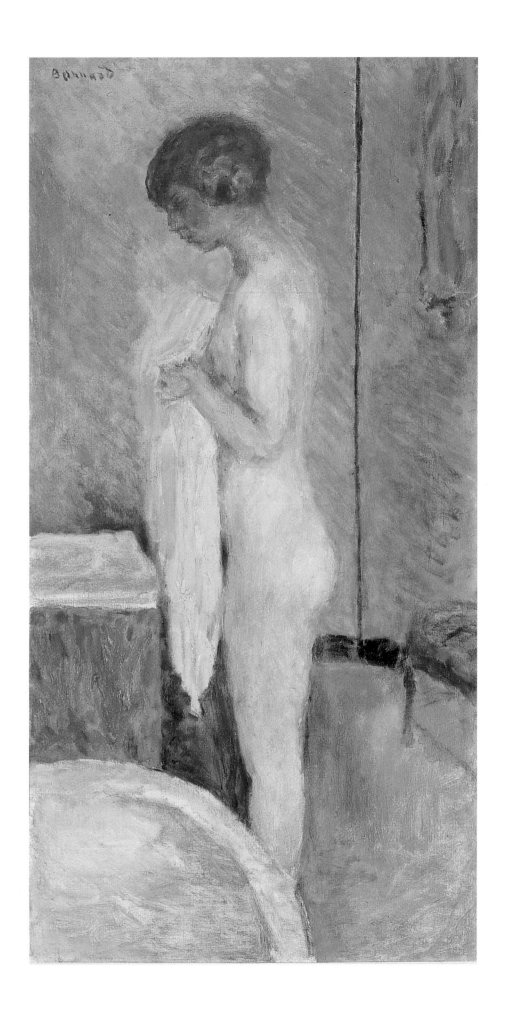

20 Pierre Bonnard
Portrait of Maria Lani, 1930
oil on canvas, 22 ½ × 18 ½ in. (57 × 47 cm)
private collection

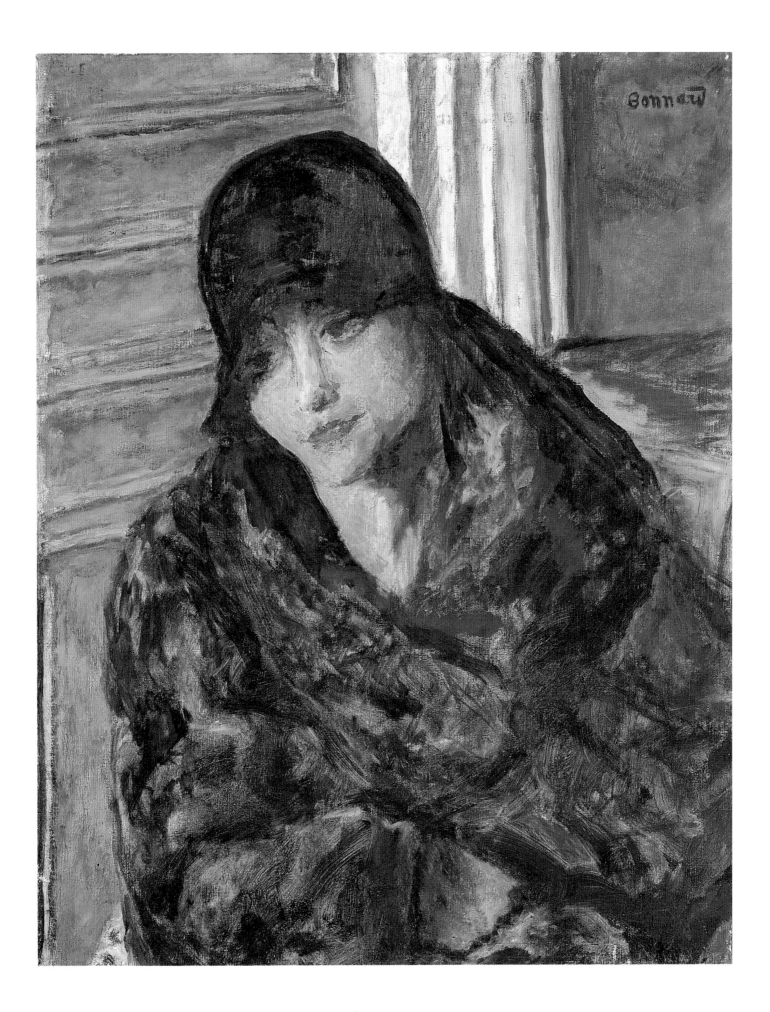

Henri Matisse

Luxe, calme et volupté

Much like Marc Chagall, Henri Matisse was supported in his desire to become a painter by his mother, who overcame the stubborn resistance of his father. Especially revealing is a comment Matisse made on July 22, 1949 to Brother Rayssignier, who, after paying a visit to the painter, wrote: "He had just completed a picture — not for the Salon, but to give to his mother, for 'my mother likes everything that I do. Out of my love for her I completed my picture by adding to it everything that I could not find in a theory.'"[1]

During his years of study Matisse came into contact with the variants of Symbolism, especially while working in Gustave Moreau's studio between 1893 and 1899.

The somnambulent Eros of Symbolist depictions of the *femme fatale* was nonetheless foreign to Matisse. His nudes are free of literary or anecdotal trappings.

His figures metamorphose into *femmes fleurs*, into colorful arabeques, and ornaments that convey a spectrum of moods and emotions. For Matisse, a Platonic identification with his model was always a basic prerequisite of his work. "He studies and explores the female model on many different levels — as a woman who reacts actively to the process of being drawn and as a pictorial motif in the creation of abstract systems of lines and forms, all handled with extraordinary variety and melody."[2]

1 Pierre Schneider: *Matisse* (Munich, 1984), p. 118

2 Jack Flam: *Henri Matisse: Zeichnungen und Gouaches Découpées* (Stuttgart, 1993), p. 10

21 Henri Matisse
The White Turban (Lorette), 1916
oil on canvas, 13 ³/₄ × 10 ¹/₄ in. (35 × 26 cm)
private collection, Switzerland

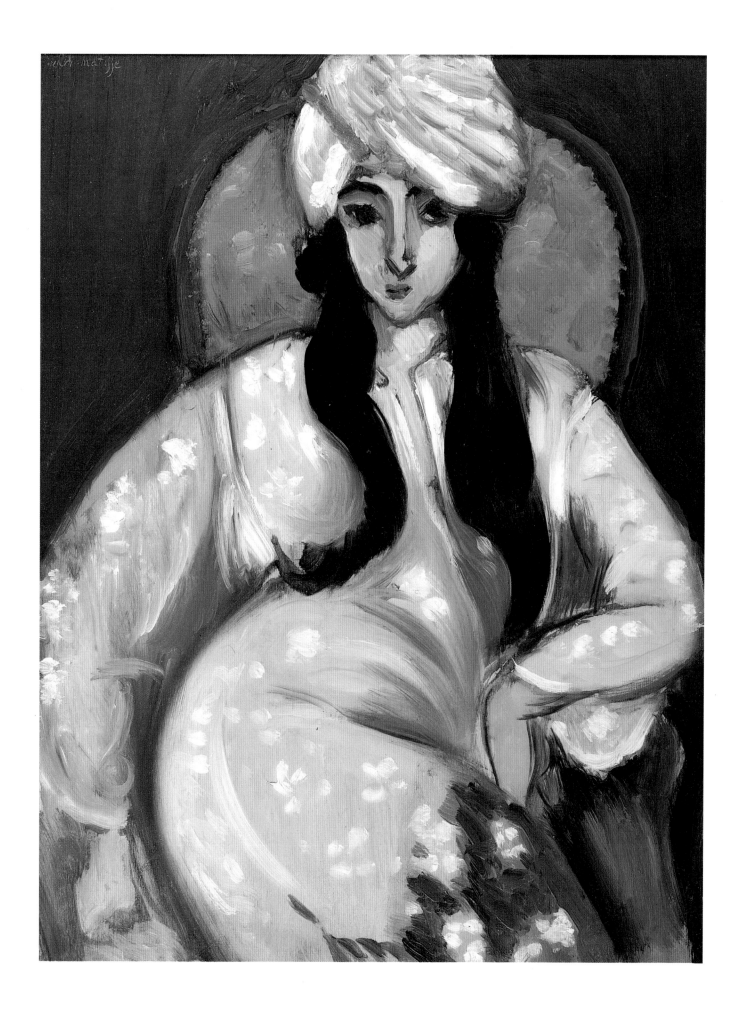

22 Henri Matisse
Woman before a Mirror, 1930
oil on canvas, 18 ⅛ × 21 ⅝ in. (46 × 55 cm)
private collection

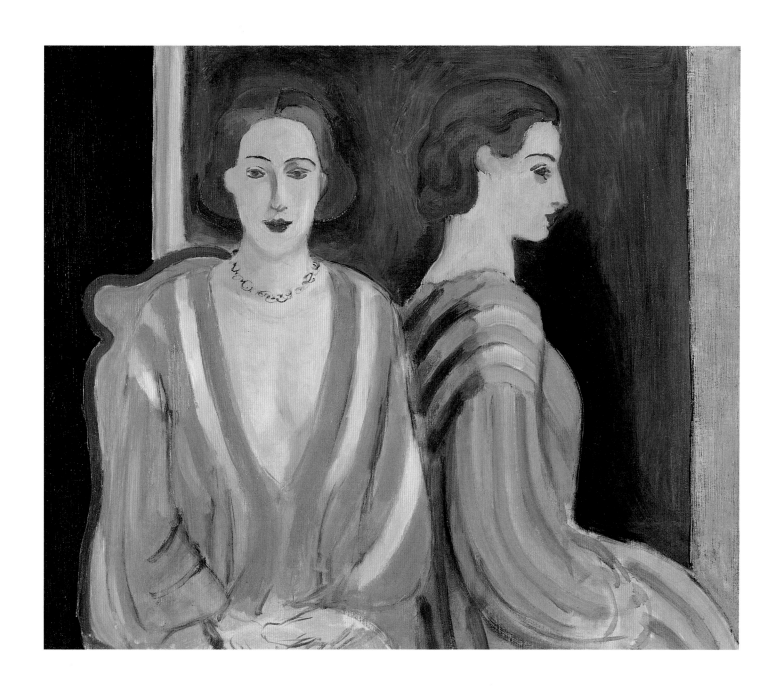

23 Henri Matisse
Woman at the Piano, 1925
oil on canvas, 24 × 29 in. (61 × 73.7 cm)
private collection

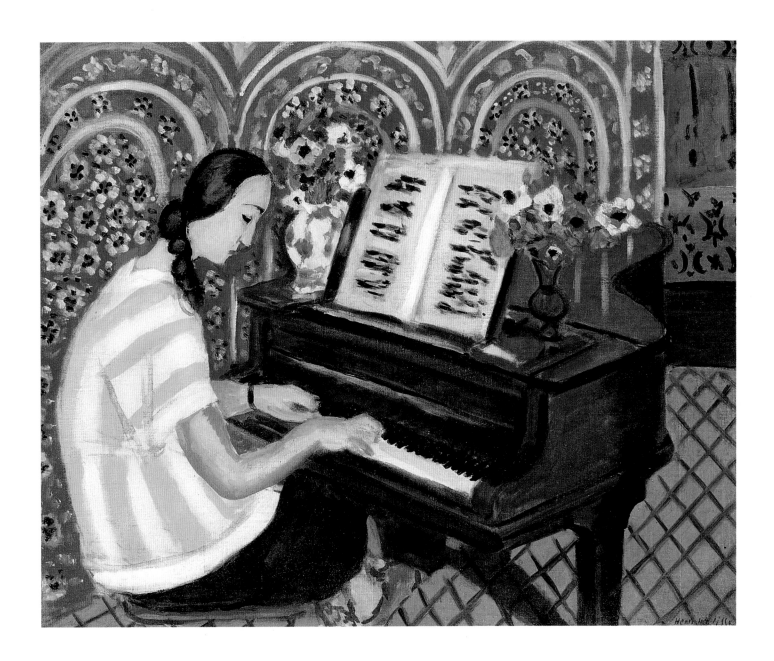

Kees van Dongen
From Madonna to Cosmopolitan Woman

Kees van Dongen made every effort to cover up his complex life story, instead preferring to mystify his careeer. He is considered the prototype of the fashionable society painter of the 1920s. In his painting *Guus and Dolly, Mother and Child* (plate 27) of 1905 he may have mystified wife Augusta and daughter Dolly by depicting them as the manifestation of a *Madonna lactans* looming above a low landscape horizon. But in 1921 he left them behind in order to enter the world of high society through his liaison with the eccentric Italian Marchesa Luisa Casati. At eighty-one he looked back and confessed, "I have to work a lot in order to catch up with all the lost years that I wasted playing around with life." After beginning his career in the circle of the Fauves around Henri Matisse, where he acquired the label of the wildest among the wild painters, the Rotterdam native van

Dongen moved on to become a painter of the fashionable world. The writer Michel George-Michel reported: "Rue Juliette-Lambert: a *vision à la Véronese*, two, three projecting studios separated by grounds, balconies, terraces almost. And in each studio silver divans wide as lawns, where during receptions in the good years the prettiest women from Paris, from Europe, from America all crowded in a strange, pleasant phantasmagoria of silk, naked shoulders, thighs, hundreds of pink legs shining out of transparent dresses, heads with wigs in every color seemingly sprinkled with diamonds and precious stones. From Boni de Castellane in his last glory as the Maharaja of Kapurthala, from Gould and Rothschild down to his very last model, the whole *crème* of the world was there, and they observed their portraits, hanging up on the walls as though on the gallows."[1]

1 Michel Georges-Michel: *Künstler die ich kannte* (Berlin 1965), p. 64

24 Kees van Dongen
Yellow Boots, 1902–07
oil on canvas, 51 $\frac{1}{4}$ × 38 $\frac{1}{4}$ in. (130 × 97 cm)
private collection

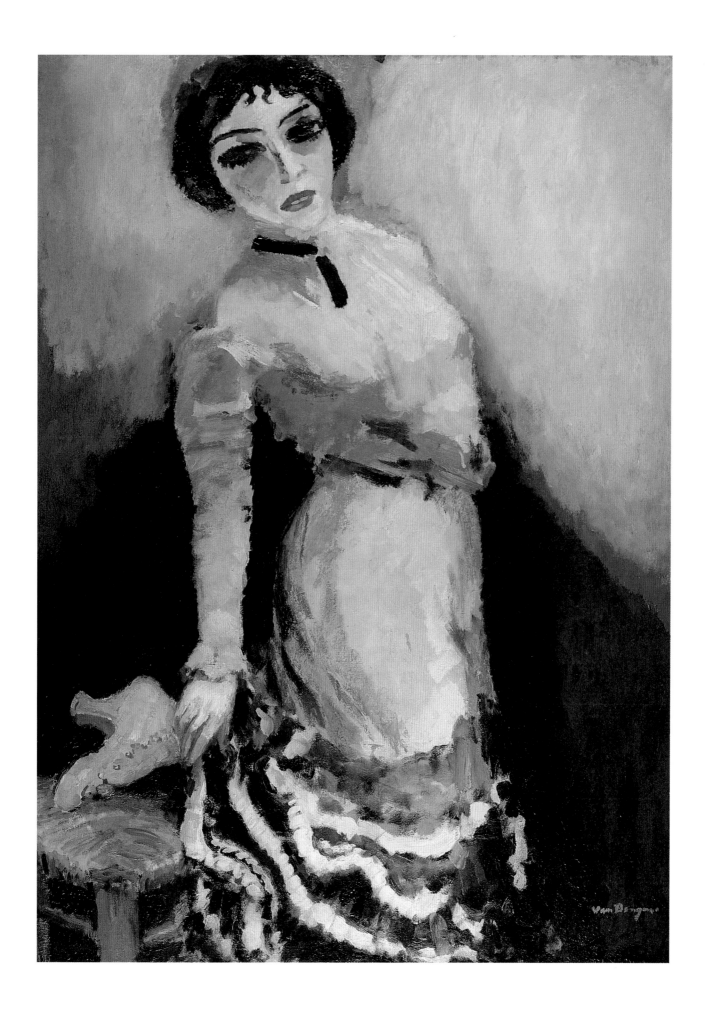

25 Kees van Dongen
The Moulin de la Galette, 1904
oil on canvas, 21 ¾ × 18 ⅛ in. (55 × 46 cm)
private collection

26 Kees van Dongen
Torso, 1905
oil on canvas, 36 1/4 × 31 7/8 in. (92 × 81 cm)
private collection

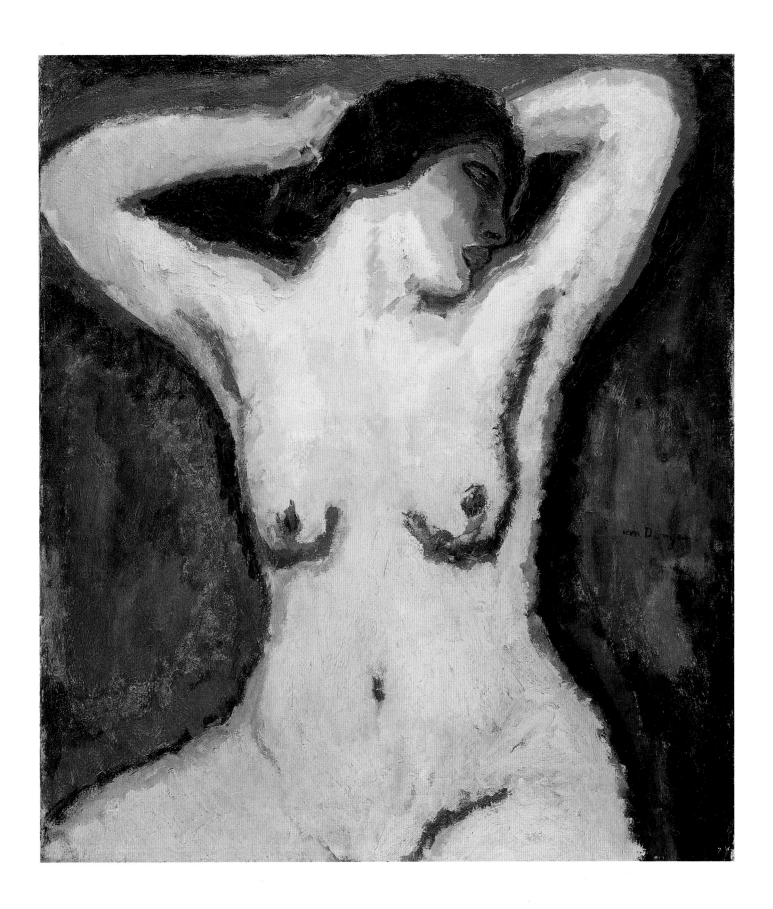

27 Kees van Dongen
Guus and Dolly, Mother and Child, 1905
oil on canvas, 28 ¾ × 36 ¼ in. (73 × 92 cm)
private collection

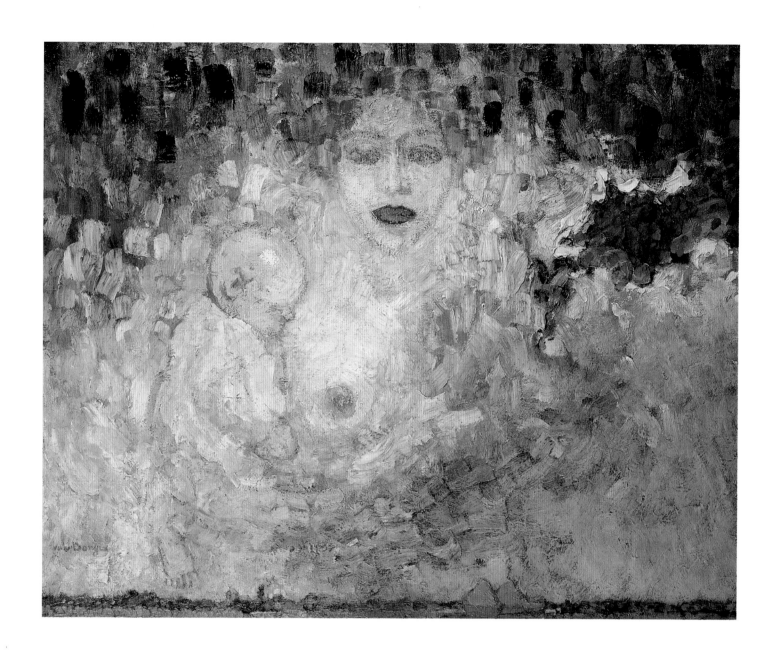

28 Kees van Dongen
The Violin-player, ca. 1920
oil on canvas, 31 ⅞ × 23 ⅝ in. (81 × 60 cm)
Musée d'Art Moderne, Liège

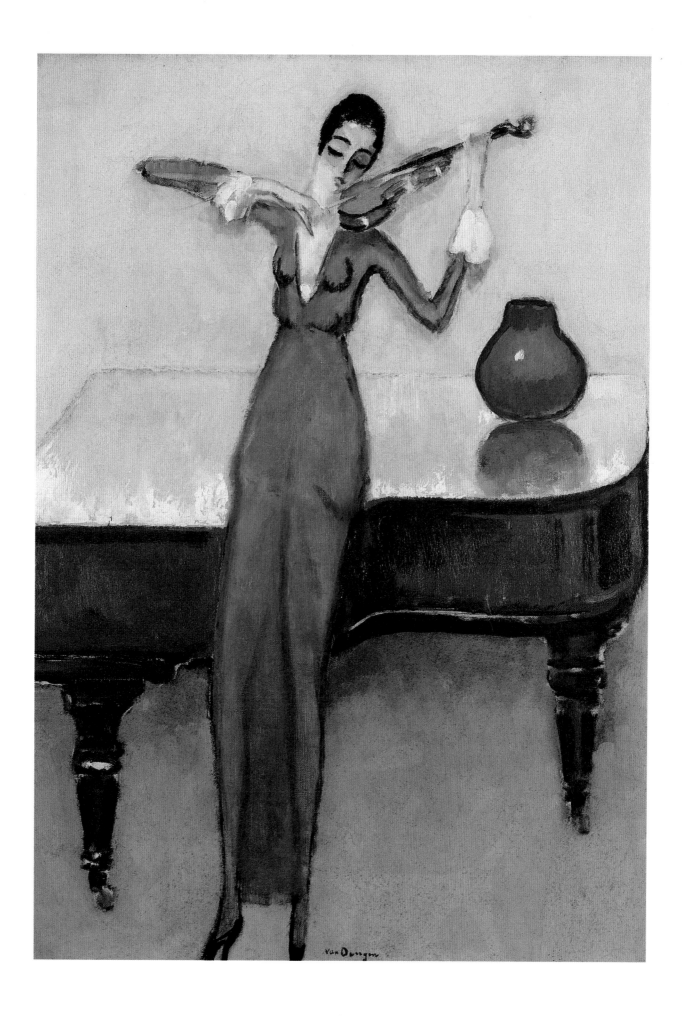

29 Kees van Dongen
Loulou, 1924–25
oil on canvas, 22 $\frac{1}{8}$ × 18 $\frac{1}{2}$ in. (56 × 47 cm)
Museum of Fine Arts, St. Petersburg, Florida

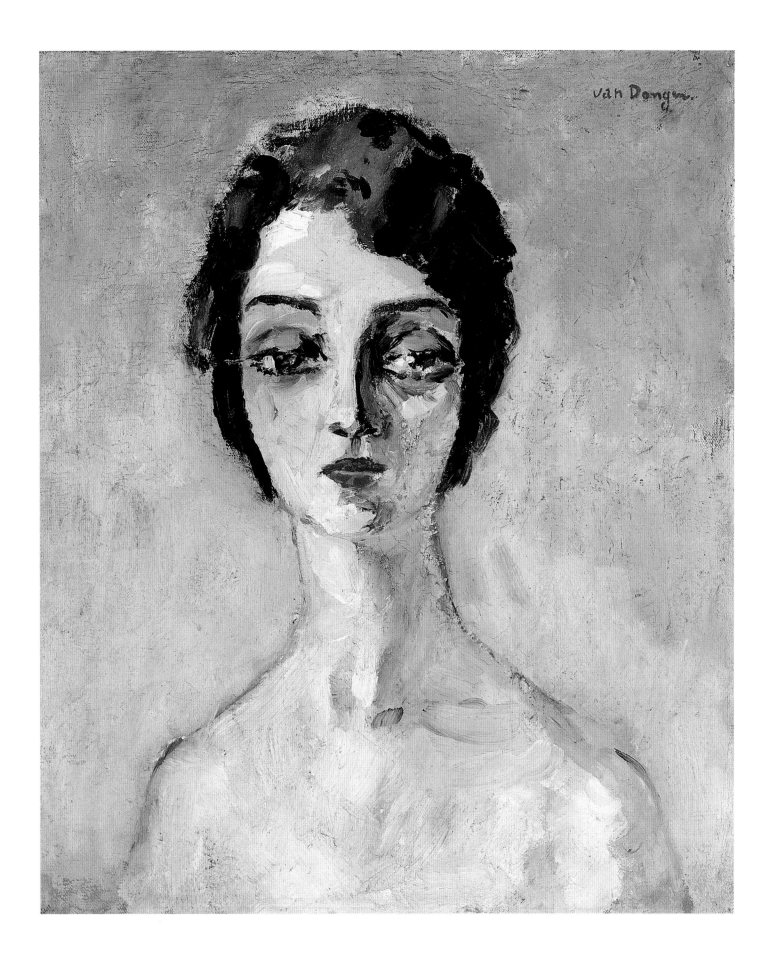

Amedeo Modiglani

Eros and Melancholy in Classical Form

Amedeo Modigliani lived a life of romantic tragedy. The only themes treated by the *peintre maudit*, who died young, were nudes and portraits, all shrouded in an aura of lyrical melancholy and existential rootlessness. In the last three years of his life, the addicted, alcoholic, and completely destitute artist sought relief in the caring arms of Jeanne Hébuterne, who took her own life just one day after his death. Modigliani was the pampered and always sickly child of Sephardic Jews in Livorno. Described as a highly arrogant boy, he was brought up by servants. He received a comprehensive education and was quite familiar with Italy's artistic treasures.

His idea of "L'Eternel Féminin" was characterized by a yearning for timeless, classical beauty, which he discovered in Greek caryatids, Egyptian busts, and African masks from the Fang of Gabon.

In the direct sensuousness of his nudes, Modigliani presented the usually anonymous model as an object of desire. Much like the nudes of the Rococo, such as those of François Boucher, the works arouse the impression of availability to the viewer. The sober concentration on the body and the careful treatment of flesh tones, with a complete eschewing of any distracting accessories, reinforce the effect. In 1917 five of his nudes on display at the Gallerie Berthe Weill in Paris were declared obscene and were confiscated.

The poet Max Jacob said this of his friend: "Everything in him strives for the purity of art: his unfounded pride, his horrible ungratefulness.... But that was nothing more than the yearning for crystalline purity. In life, as in art, he wanted to remain true to himself. He was hurtful, but also as fragile as glass — and as inhuman as glass, if you will."

30 Amedeo Modigliani
Two Children, 1918
oil on canvas, 39 ³/₈ × 25 ⁵/₈ in. (100 × 65 cm)
private collection

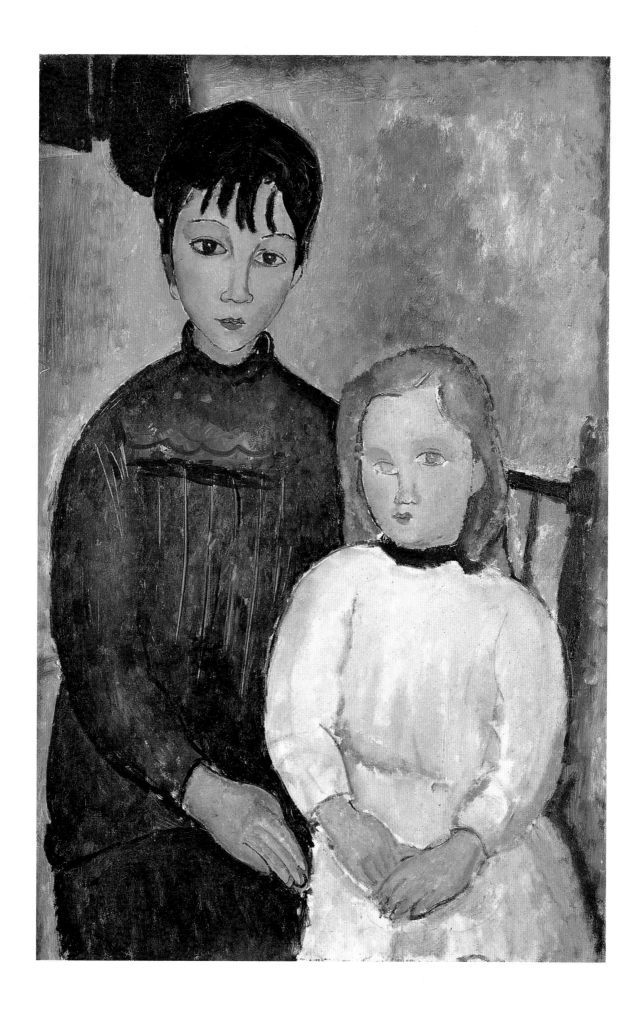

31 Amedeo Modigliani
Madame Modot (La Belle Espagnole), 1919
oil on canvas, 36 ¼ × 23 ⅝ in. (92 × 60 cm)
private collection

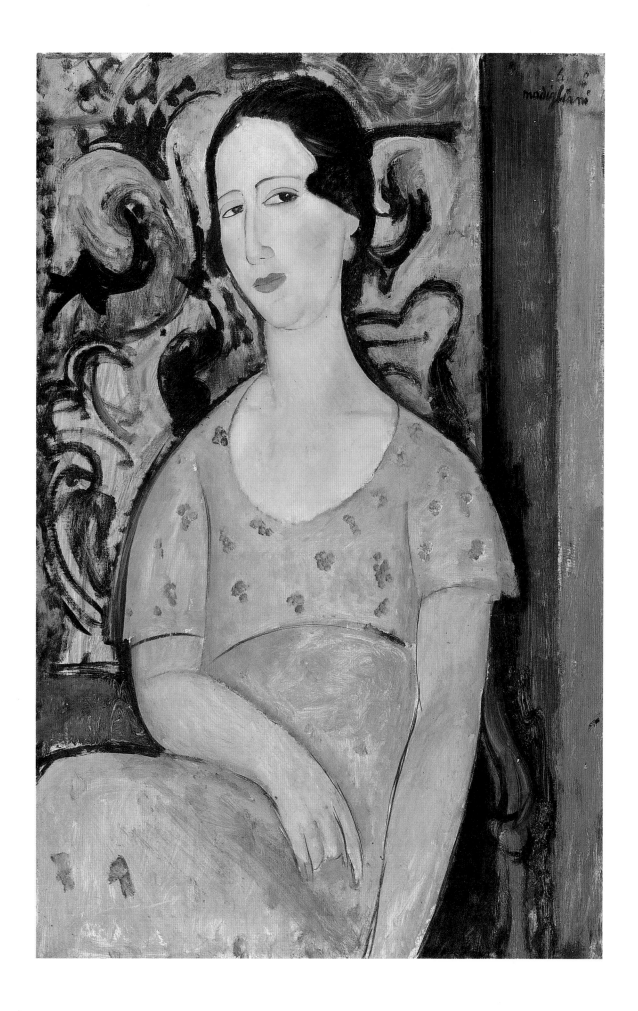

Marc Chagall

The Sacred Song of Painting

"An artist," Marc Chagall said, "is someone who is within the sphere of his mother, obsessed by her proximity in both a personal and a formal way.... The form of his art originates within him because of her presence and not from any academic teaching." Chagall's restless mother Feiga-Ita eventually supported his desire to become a painter after much pleading, and he honored her as a "Queen, in whom my talent was hidden and from whom I inherited everything except my spirit." Franz Meyer, Chagall's first biographer and son-in-law, emphasized that Chagall's images of the world and its people were rooted in a Hassidic joy of the senses and a pious acceptance of life. His view of "L'Eternel Féminin" must also be seen in that context. The philosopher Martin Buber (1878–1965) described Hassidism as the teaching of the omnipresence of a hidden God. He pours his love out upon all beings and things of the world as though it were bursting out of a barrel. The most important mission of the Hassidim is to awaken the divine spark of love in people and in things through his actions.[1]

Chagall's "Eternel Féminin" – that loving, embracing woman nestling in bouquets of flowers and floating weightlessly in pictorial space – is a mystically transfigured image of Woman, a kind of Song of Songs in painting (see plate 39). His autobiography *Ma Vie* (My Life), completed by the age of thirty-five, is also full of hymns in praise of Woman. In it he describes his first meeting with his future bride Bella Rosenfeld. "Her silence is mine. Her eyes, mine. It is as if she had known me for a long time, as if she knew everything about my childhood, my present, my future; as if she watched over me, fathomed me to my very soul although I was seeing her for the first time. I feel that she is my wife." When at nineteen he shocked his mother with a nude of Bella Rosenfeld, he quickly painted it over with an image of a procession. But Chagall's paintings and sketches themselves tell far more about his dream of "L'Eternel Féminin" than do any of his statements or recollections. In these, Woman appears as bride and lover, as sensuous nude and mother giving birth, as angel and apparition fading into a blueish, transcendental light (see plate 36). The pictures of the postwar period always resonate with remembrances of his wife Bella, whose sudden death in 1944 plunged him into a deep depression. Only after his marriage to Vava Brodsky in 1952 do his female motifs once more assume their melancholy serenity. He expressed his feelings in a poem to Vava:

> With you I am young,
> My years fall like leaves.
> Someone else paints my pictures
> In your presence they light up.

1 Martin Buber: *Die chassidische Botschaft* (Heidelberg, 1952)

32 Marc Chagall
Nude over Vitebsk, 1933
oil on canvas, 34 ³/₈ × 44 ¹/₂ in. (87 × 113 cm)
private collection

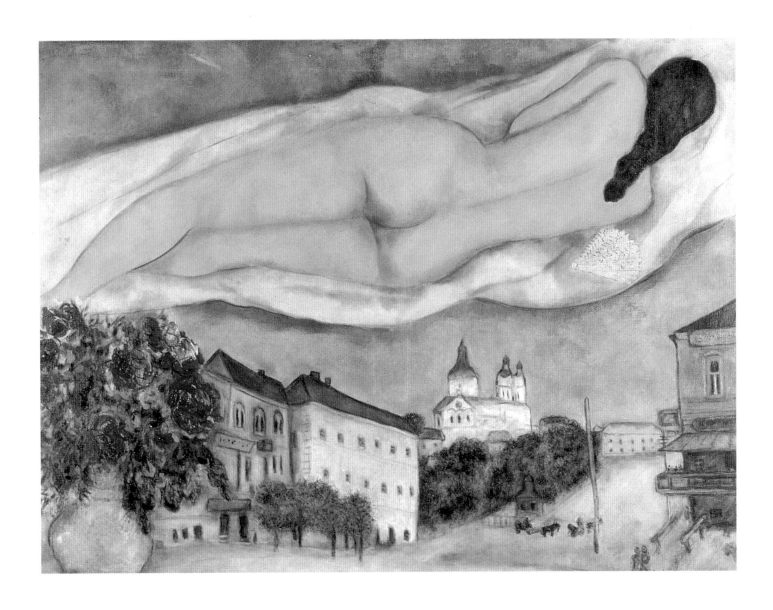

33 Marc Chagall
The Sled, 1943
gouache, 21 × 30 ¾ in. (51 × 78 cm)
private collection

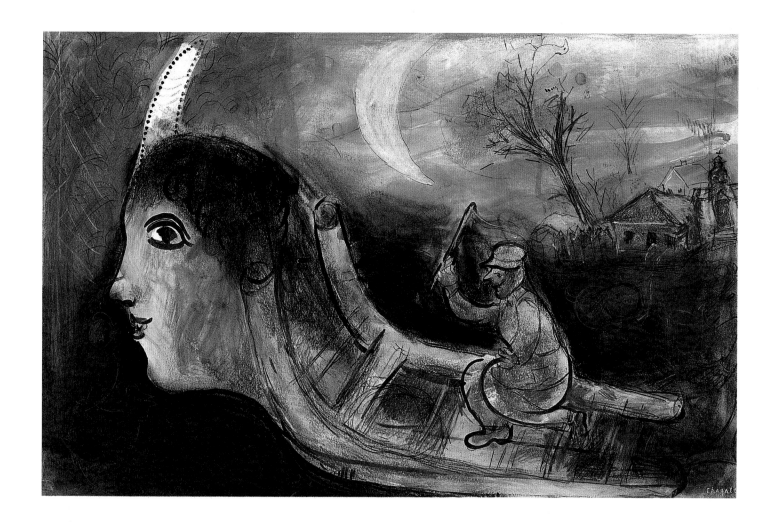

34 Marc Chagall
The Wedding, 1944
oil on canvas, 39 ⅜ × 29 ¼ in. (99.7 × 74 cm)
private collection

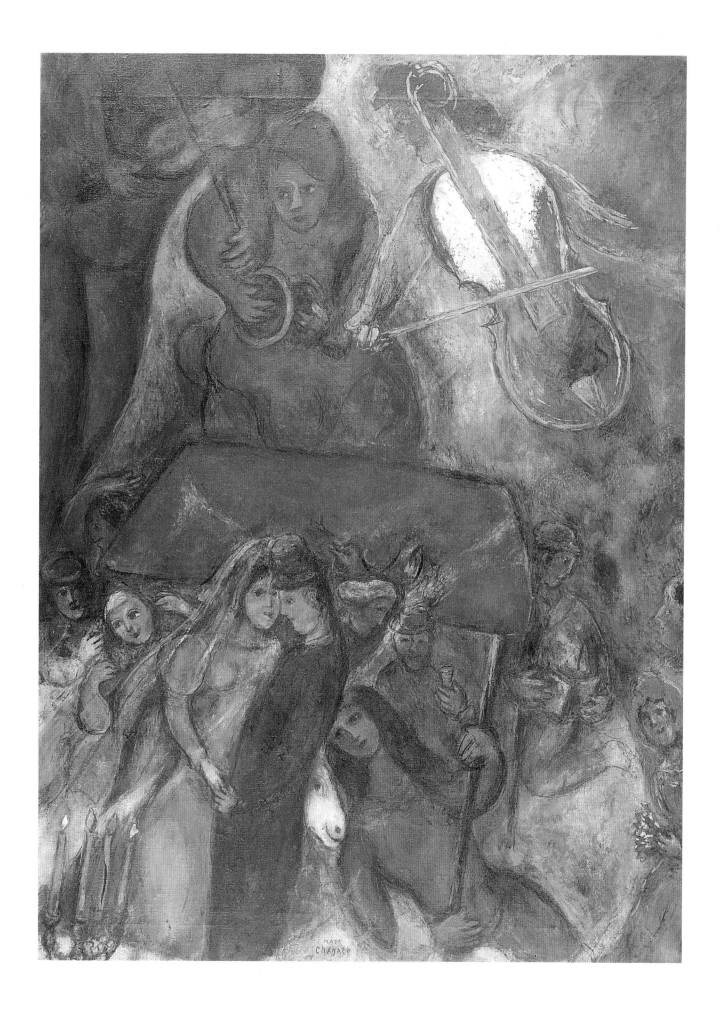

35 Marc Chagall
Sirens, 1949
gouache, 25 ⅝ × 19 ¾ in. (65 × 50 cm)
private collection

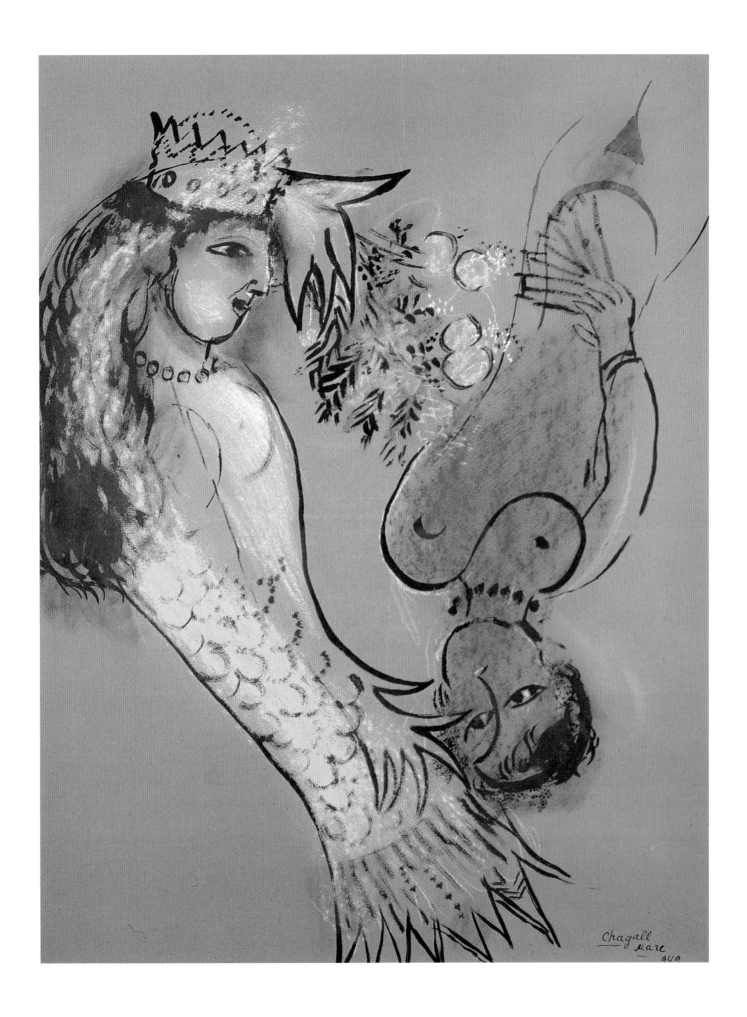

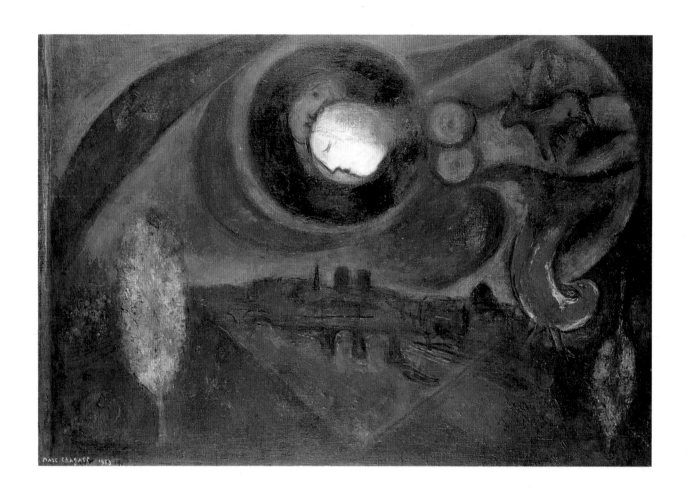

36 Marc Chagall
Le Quai de Bercy, 1953
oil on canvas, 25 ¼ × 36 ¾ in. (64 × 93.2 cm)
private collection

37 Marc Chagall
Village with Dark Sun, 1950
oil on canvas, 29 × 27 ⅜ in. (73.5 × 69.5 cm)
private collection

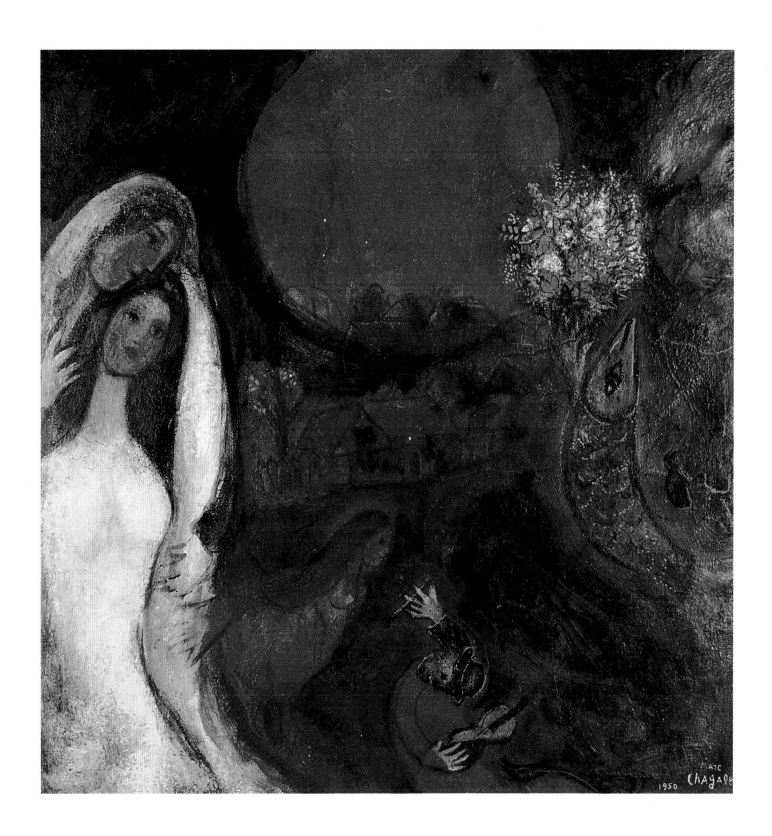

38 Marc Chagall
Blue Couple at the Water, 1954
gouache, 19 ⅜ × 26 ¾ in. (49 × 68 cm)
private collection

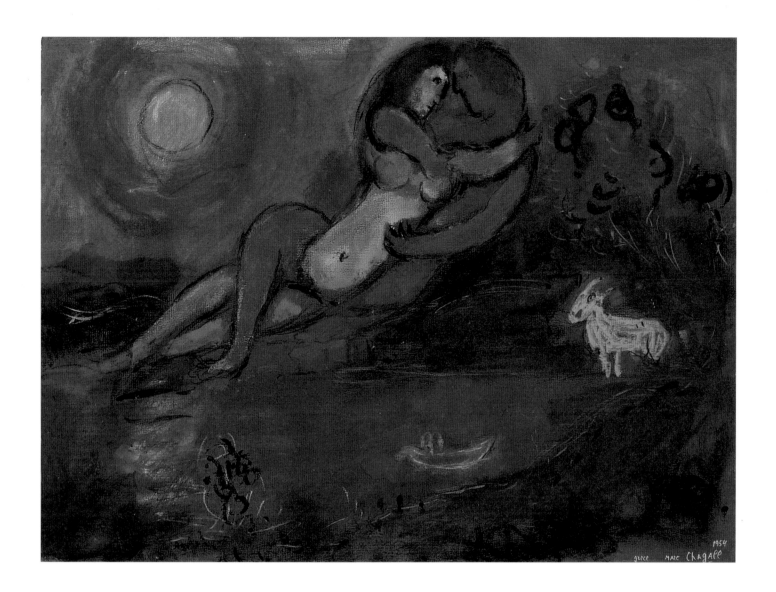

39 Marc Chagall
Bride over Paris, 1977
oil on canvas, 51 ¼ × 37 ¾ in. (130 × 96 cm)
private collection

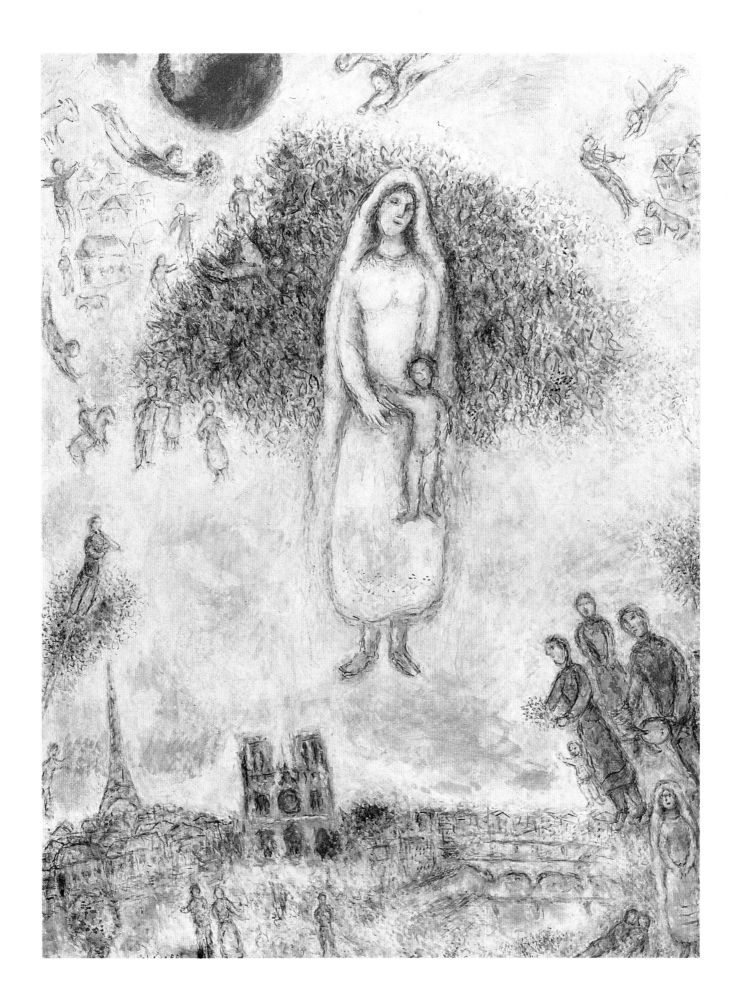

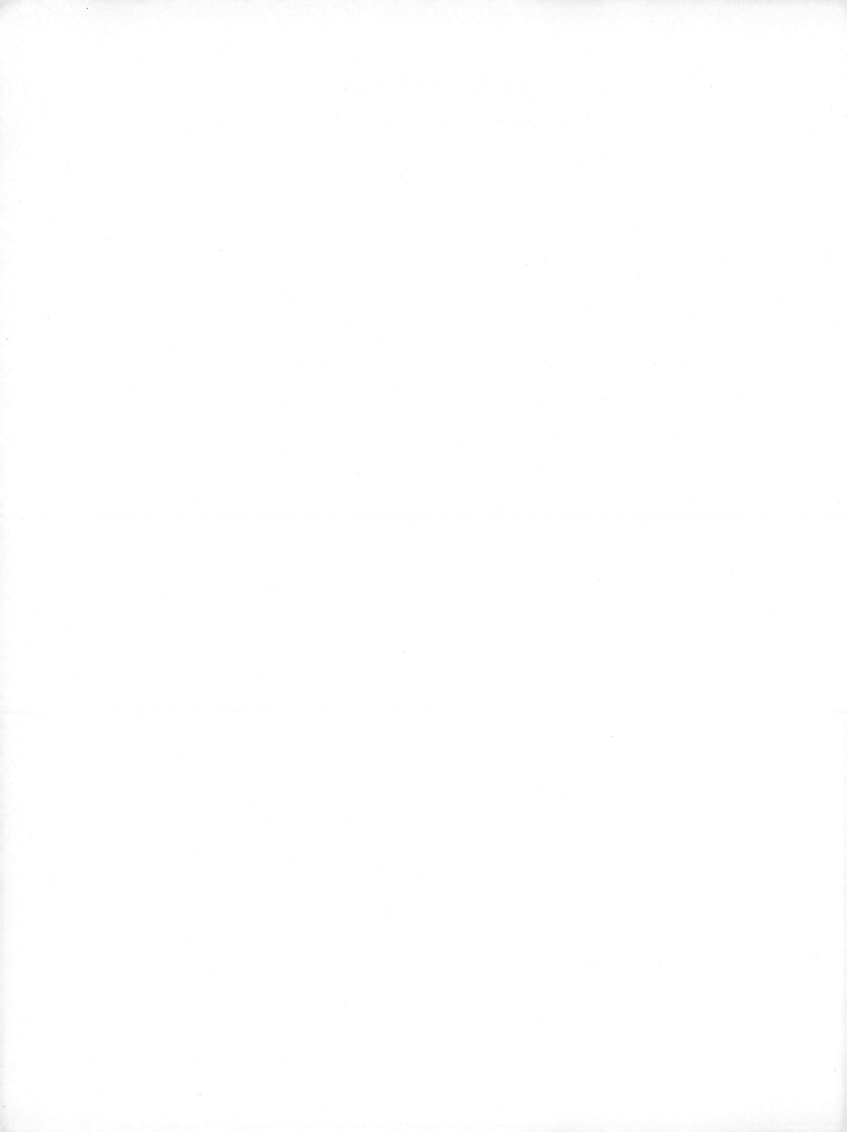

Fernand Léger

"L'Eternel Féminin" as "Contraste des Formes"

In contrast to the femle as understood by Henri Matisse (1869–1954), Fernand Léger had a "radical conception that saw the human figure only as an object" and allowed it no emotional or expressive value. Léger's image of the world and of woman was shaped by an immovable faith in a Socialist community where women would hold a position completely equal to that of men. For Léger a simple bolt had the same poetic force as a rose in bloom, a well-polished machine the same erotic radiance as a female nude. Michel Georges-Michel recounted an incident that proved the point: "Léger, casually dressed, appeared amid the turbines, cylinders and pumps, passed his hand over the polished steel of a scale, and said: 'Don't you find that beautiful?'

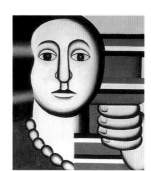

'Are those your models?'

Yes, but I render. I don't copy them."[1] The women in Léger's paintings are emotionless and lack eroticism. In their functional anonymity they are subordinated to the *Contraste des formes* of the picture. They inhabit a Utopian world of cool, dispassionate uniformity, where there is no place for love, death, or transitoriness.

Léger always had a good relationship with his mother, Marie-Adèle Daunou, who skeptically followed her son's career in Paris. "My mother," he later reminisced, "was a saint who spent many hours of her existence repairing the damage done by her husband and praying for him and for me."[2]

1 Michel Georges-Michel: *Künstler, die ich kannte* (Berlin, 1965), p. 23
2 Pierre Decargues: *Fernand Léger* (Paris, 1955), p. 7

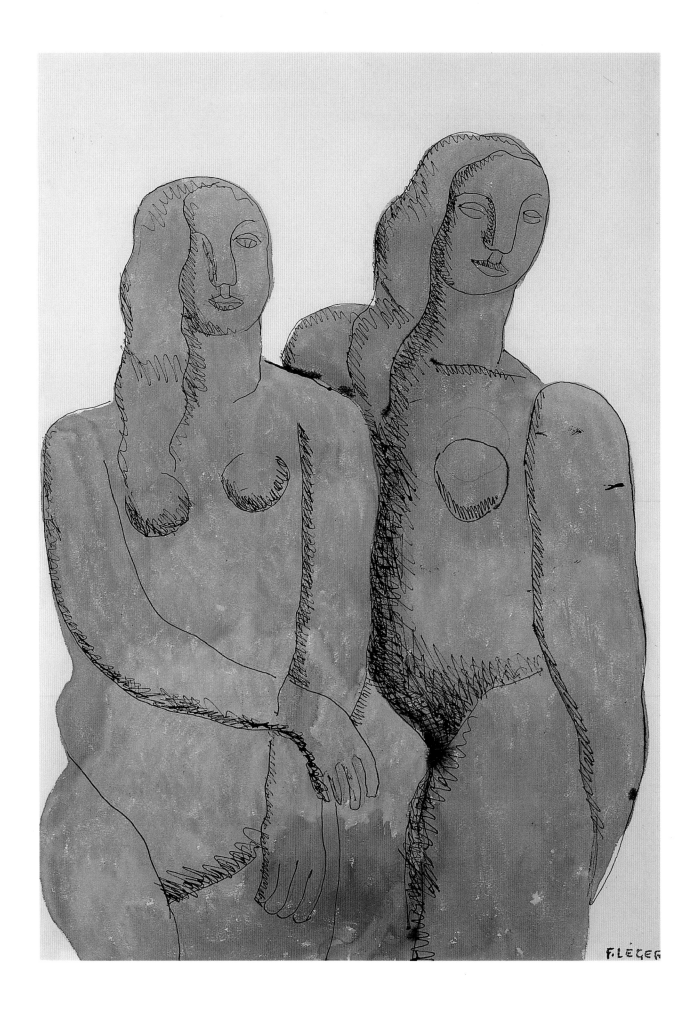

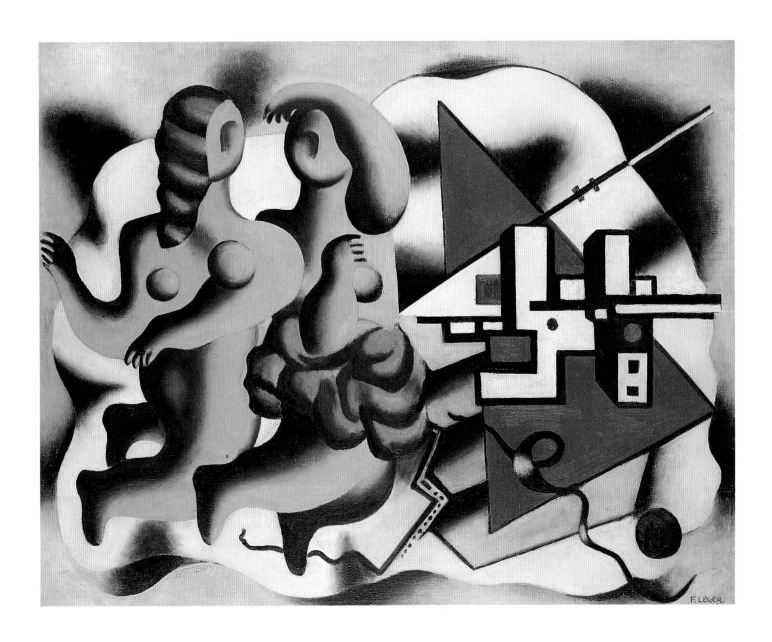

41 Fernand Léger
Dancers with Key (The Triangle), 1928
oil on canvas, 28 ⅝ × 36 ¼ in. (73 × 92 cm)
private collection

40 Fernand Léger
Two Women, 1939
watercolor, 25 ⅝ × 19 ¾ in. (65 × 50 cm)
private collection

42 Fernand Léger
Mother and Child, 1953–54
gouache, 23 ¼ × 19 ⅜ in. (59 × 49 cm)
private collection

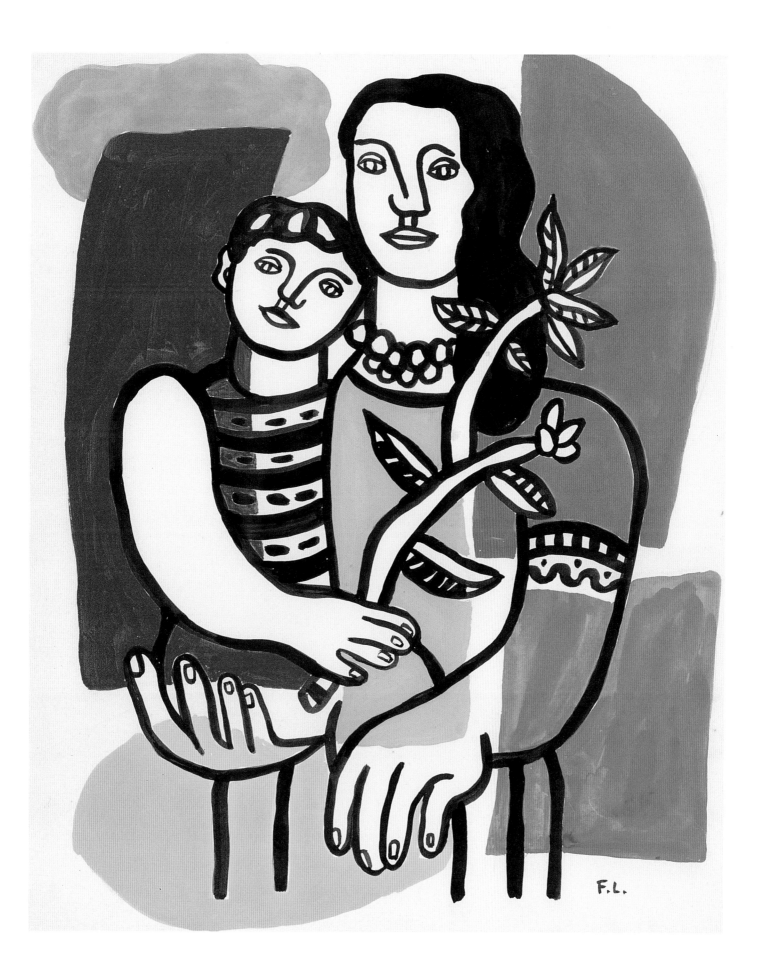

43 Fernand Léger
Female Torso, 1929
oil on canvas
private collection

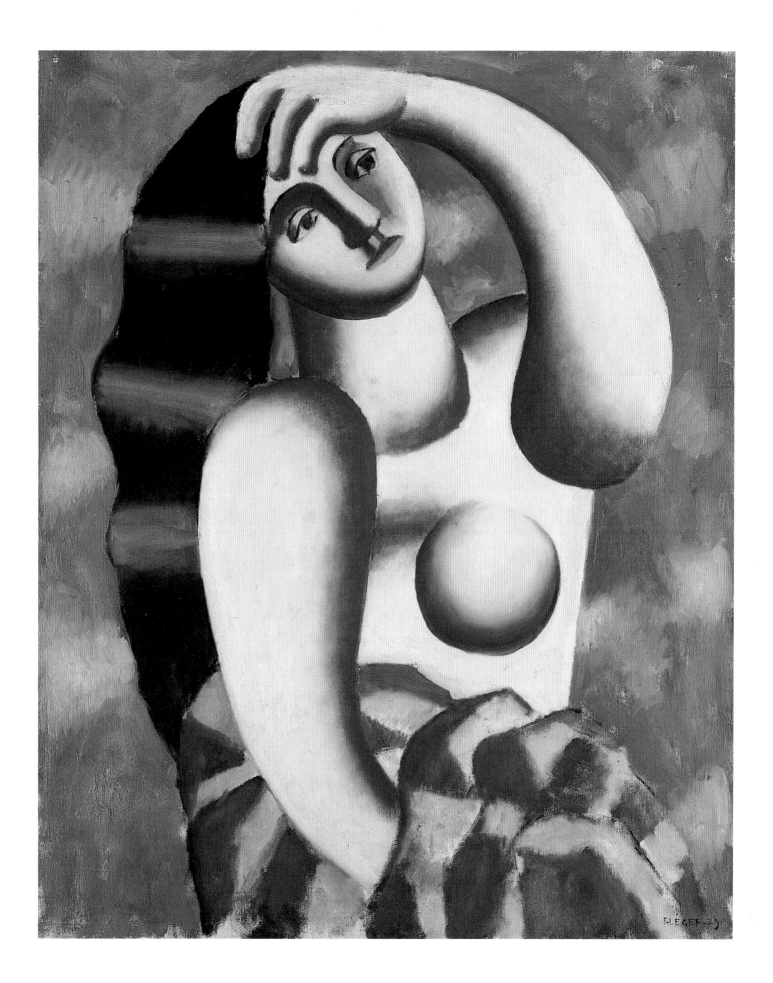

Joan Miró

The Eternal Female as Cosmic Principle

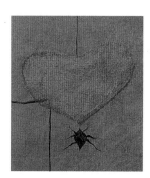

Joan Miró was very shy and had a solid and intensely bourgeois marriage with his wife Pilar. Despite this, the Catalonian artist's work shows an archaic picture of "L'Eternel Féminin" firmly rooted in Spanish mysticism, Surrealism, and his own life history. The early conflict between his father's expectations and the dreamy artistic tendencies supported by his mother lead to a nervous breakdown, from which Miró only slowly recovered while in the natural setting of the mountain village of Montroig. All his life he spoke of this key experience as a shaping force – indeed, as his rebirth. Montroig, Miró said, "was my religion." And this is the core of his deeply romantic art: a descent into deepest depression and then its being overcome through rebirth and metamorphosis supported by a deep faith in the forces of cosmos and nature. His art is pervaded by a pansexuality, by an all-encompassing sexuality repeatedly conjured up in his pictures through codes, symbols, and archaic signs. For Miró, creativity itself finally becomes an erotic act. In 1922 he wrote: "When I paint, I caress what I am doing, and the effort to give these things an expressive life wears me out terribly. Sometimes after a work session I fall into a chair, totally exhausted, as though I had just made love! Excuse me, dear friend, for this crudity of language I express myself with, but I can't find any other words."[1]

1 Margit Rowell, ed.: *Joan Miró – Selected Writings and Interviews* (London, 1986), p. 152

44 Joan Miró
Dancer II, 1925
oil on canvas, 45 1/2 × 34 7/8 in. (115.5 × 88.5 cm)
private collection, Switzerland

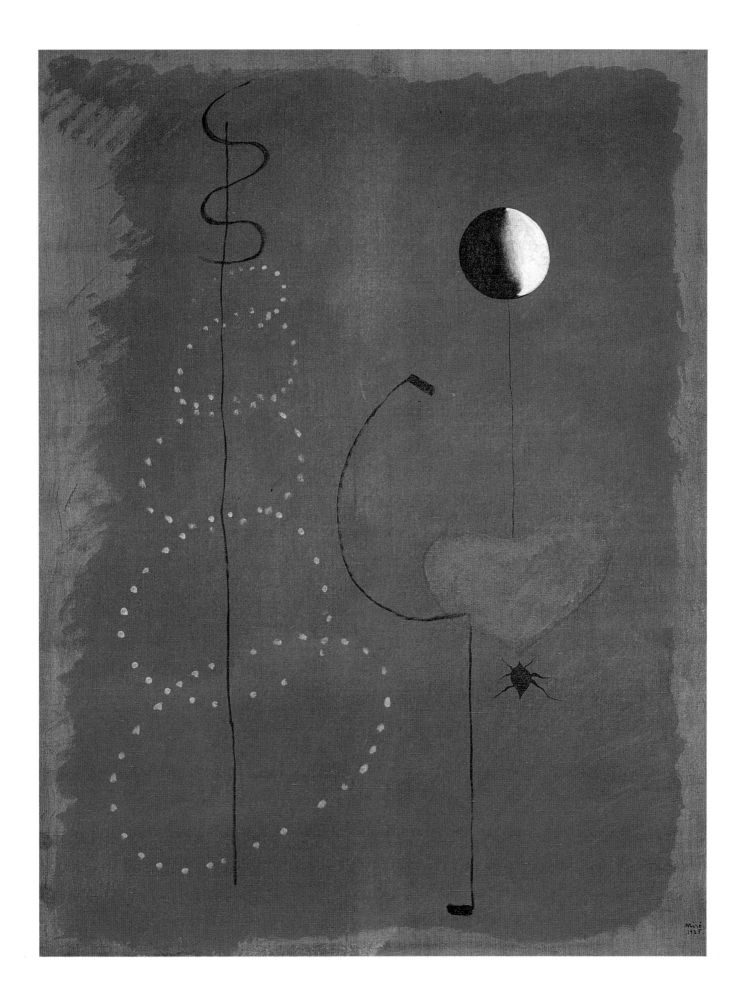

Pablo Picasso

Painter, Muse and Model

To Pablo Picasso the "Eternal Female" was the driving force behind artistic creation. No other painter thought about the theme of "painter and model" as much as he, and did so many variations on it. The roles that Picasso himself assumed in the process encompass all the high points and low points of his life: from the youthful, curious artist who seemed to only concentrate on the formal problems inherent in the painting of the nude, to the thoughtful classical sculptor, and finally to the lecherous old man who took on the role of the voyeur and grieved over the loss of his sexual potency. In his "private mythology" (Carl Einstein) Picasso took on the persona of the Minotaur, who can be witnessed in Dionysian scenes of seduction and rape, only to appear directly thereafter as a blind creature worthy of our pity, led about on the hand of a young girl. Lusts and desires are reflected in Picasso's pictures, as are his ever-present fears of death and separation.

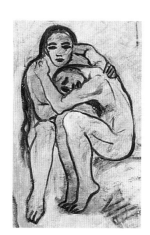

From his early, academic, and often religious pictures, in which genius is evident already at the age of fourteen, Picasso sought to win the recognition of his mother. Only with his move to Paris around the turn of the century did Picasso finally become acquainted with the enigmatic variants of the "L'Eternel Féminin" among the *bohème*. While living in the *Bateau-Lavoir*, an artist's colony on Montmartre, he met Fernande Olivier. At a time when he still spoke no French, she became the woman who cared for him – his protector and his model. Numerous separations and overlapping liaisons show that Picasso was unable to live or to work without the warmth of the "Eternel Féminin" near him. In 1918 he married Olga Koklova, whom he first met on a tour of the *Ballets Russes*. In 1935 he left her and went to live with Marie-Thérèse Walter, the mother of his daughter Maja. The relationship was followed by one with Dora Maar, and then in 1947 Françoise Gilot. He and Françoise had two children, a son Claude born in 1947 and a daughter Paloma born in 1949. In 1961 the octogenarian finally married the thirty-five-year-old Jacqueline. Picasso said this about himself: "I love or I hate. When I love a woman, everything is blown apart, especially my painting."[1]

1 Françoise Gilot and Carlton Lake: *Mein Leben mit Picasso* (Frankfurt am Main, 1967), p. 246

45 Pablo Picasso
Seated Nude Drying her Foot, 1921
pastel, 26 × 19 ¾ in. (66 × 50 cm)
Heinz Berggruen Collection, Berlin

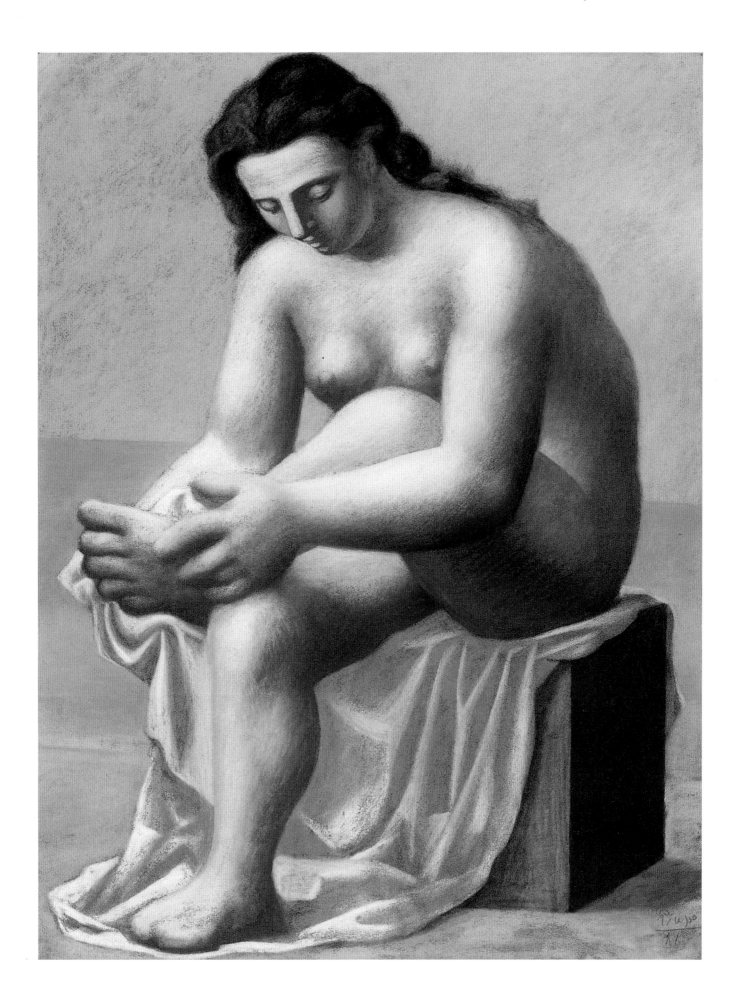

46 Pablo Picasso
Portrait of Nusch Eluard, 1938
oil on canvas, 21 ¾ × 18 ⅛ in. (55 × 46 cm)
private collection, Switzerland

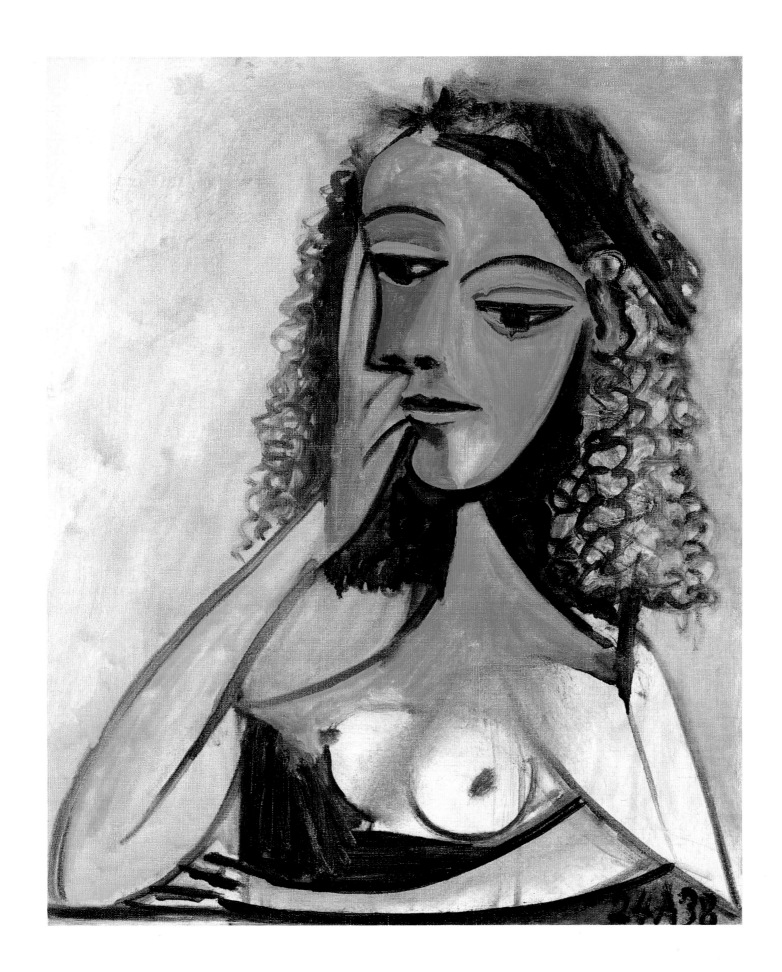

47 Pablo Picasso
Woman in a Straw Hat (Marie-Therèse), 1938
oil on canvas, 28 ¾ × 23 ⅝ in. (73 × 60 cm)
private collection, Switzerland

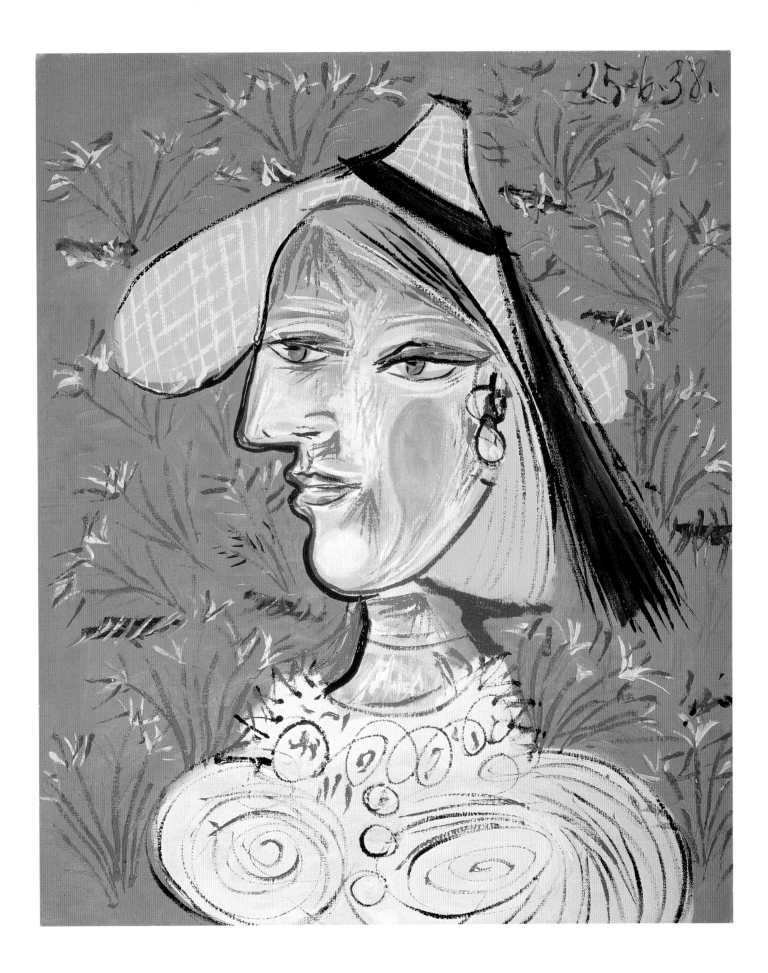

48 Pablo Picasso
Dora Maar, 1940
oil on canvas, 28 ³/₄ × 23 ⁵/₈ in. (73 × 60 cm)
Würth Collection

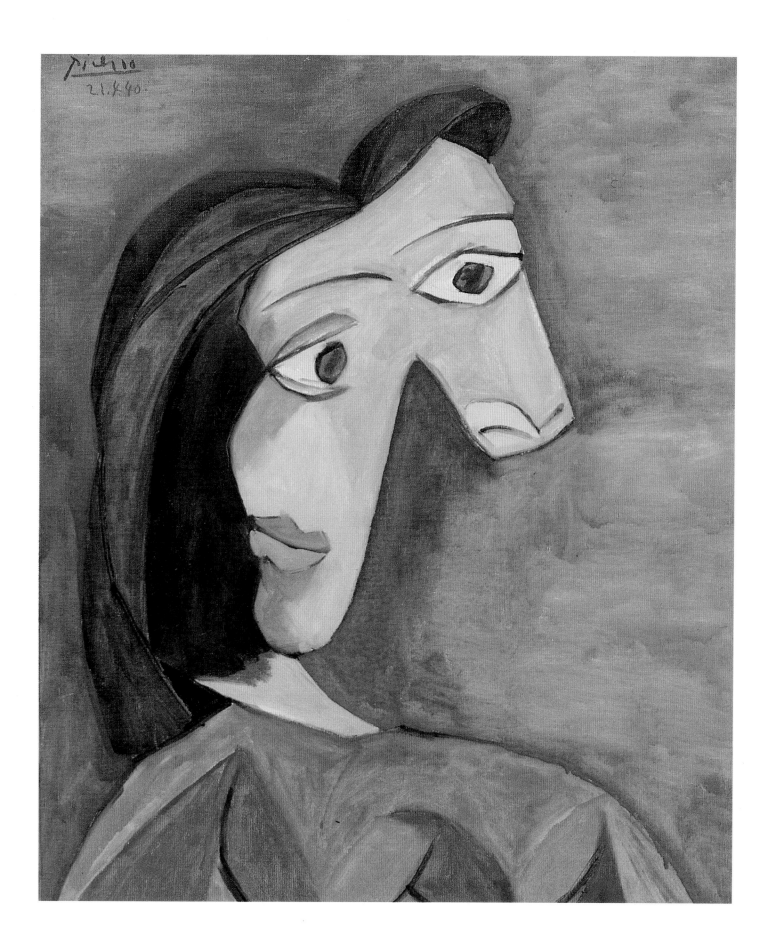

49 Pablo Picasso
Woman in an Armchair, 1941
oil on canvas, 39 3/8 × 32 in. (100 × 81 cm)
Würth Collection

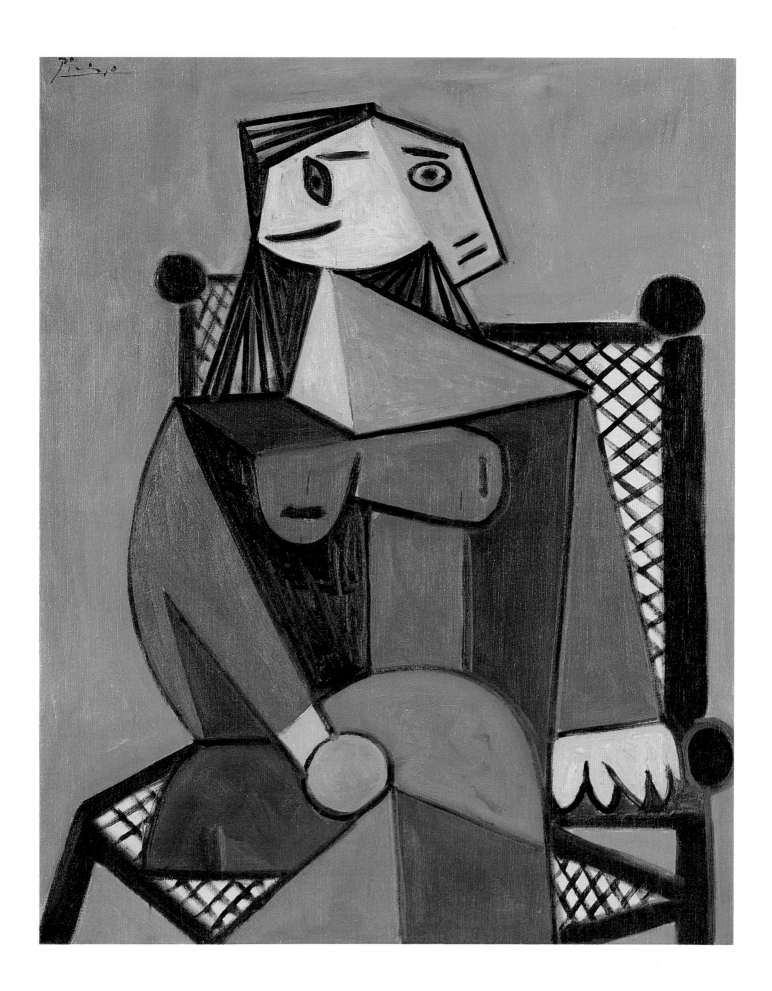

50 Pablo Picasso
Bust of a Woman (Dora Maar), 1943
oil on canvas, 28 3/4 × 23 5/8 in. (73 × 60 cm)
private collection

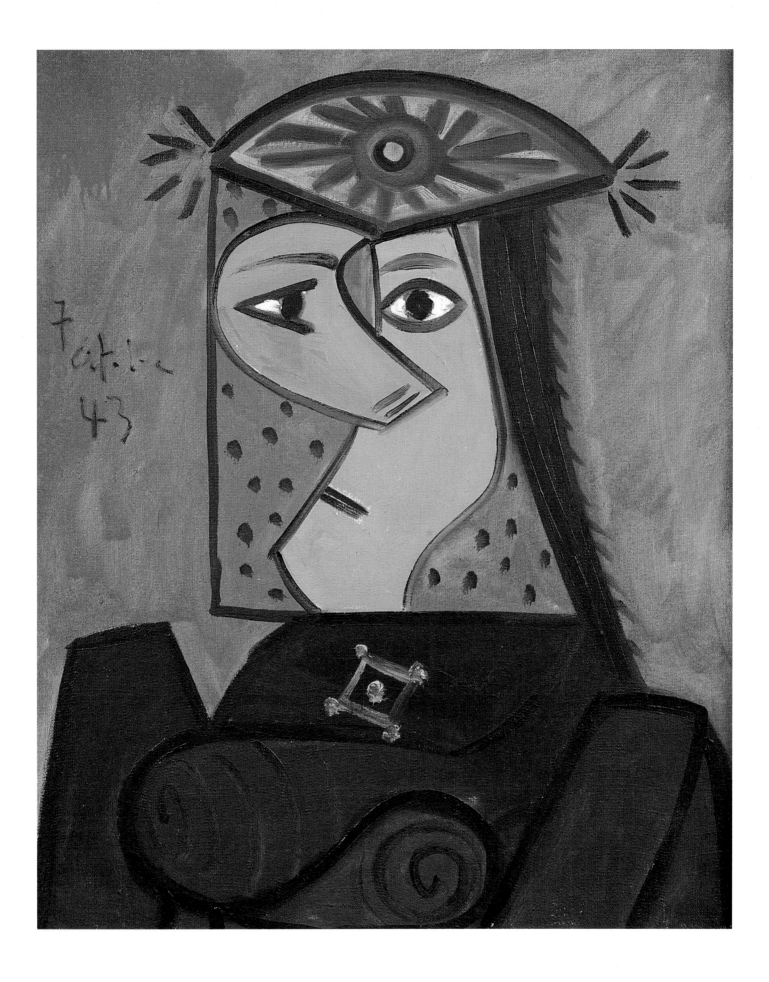

51 Pablo Picasso
Woman in a Blue Armchair, 1960
oil on canvas, 51 × 38 ¼ in. (129.5 × 97 cm)
private collection, Switzerland

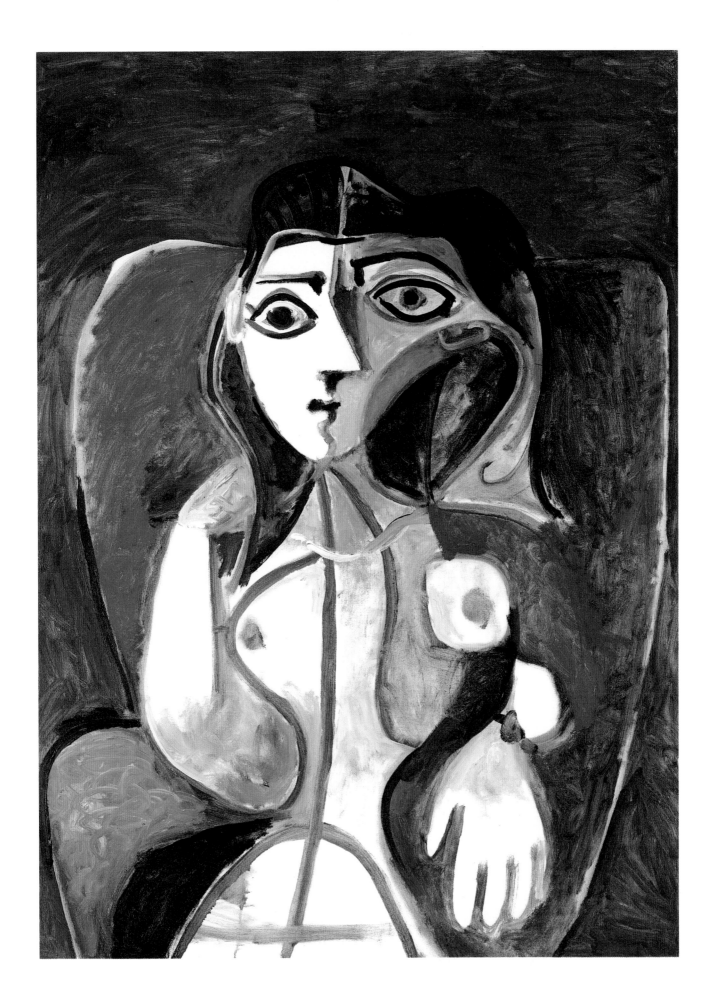

Picasso as Draftsman

The act of drawing is the basis for every one of Picasso's works. His drawing reflects his entire stylistic range and leads us directly to the very source of the creative process – to the genesis of a work. A drawing is the spontaneous record of an idea. It is the most direct and unmediated artistic statement and therefore carries great expressive force. This is borne out by the great number of his extremely expressive carnets, as Picasso's sketchbooks are called. The pastel *Woman with Shawl* (plate 53) is from the carnet of 24 drawings done in 1900. Drawn in the style of Henri de Toulouse-Lautrec (1864–1901), the piece was later used as a study for the cover of the first issue of *Arte Joven* (March 31,1901). This art magazine was published by Picasso together with a few friends – Picasso took the role of artistic director – but no adequate financial means could be secured and only three subsequent issues were published.

Two fundamentally different types of drawings typify the preliminary studies for the large, dramatic paintings of the Blue Period: clothed figures and pure nudes.

The drawing *The Absinthe Drinker* (plate 54) of 1901, at a time when Picasso was still signing his name *Ruiz* depicts the social alienation of the woman and is a prinicipal study for ten different paintings on the same theme. (It may be compared to *The Absinthe Drinker* of 1901 in the Hermitage Museum, St. Petersburg, also illustrated in this catalogue.) These drawings and paintings were influenced by Edgar Degas's *'L'Absinthe'* of 1876. In Picasso, as in Degas, the woman is seated in a somber café, in a forlorn and desolate atmosphere. The mood is evoked by the way she cups her head with her hand, the stark angular lines, a face bereft of expression, and a melancholy gaze into emptiness.

The drawing *The Two Sisters* of 1902 (plate 58) is certainly the most important and above all the best-preserved of proven studies for the painting of the same name, a key work of the Blue Period (illustrated in this catalogue). It leads us directly to the genesis of this period of work which was related to the subject of the Saint-Lazare prison in Paris. Picasso himself mentions this in a letter of July 13, 1902 to his friend Max Jacob:

My dear Max,
It has been a long time since I last wrote to you. Not that I could forget you, but I am working a great deal. That is why I never wrote. I show my work to the local artists, and they say it has too much soul and too little form. That is very funny. You know how to speak with such people; but they write very bad books and draw idiotic pictures. That is life. That is how it is.

Fontbona is making an inhuman effort, but he accomplishes nothing. I want to paint a picture from this drawing that I am sending you (The Two Sisters). [The painting is now in the Hermitage Museum in St. Petersburg.] It is a picture that I am working on, with a prostitute from Saint-Lazare and a nun (mother).

Send me something from what you wrote Pèl i Ploma. Good-bye, my friend. Write to me.
your friend Picasso
rue de la Merced 3, Barcelona, Spain

Anatoli Podokski gives an interpretation of this important work in the catalogue *Der junge Picasso: Frühwerk und Blaue Periode* (Kunstmuseum Bern, 1984): "The completed picture shows a celestial and sorrowful encounter between two symbolic 'sisters' as a universal, timeless event. Their contrast in substance (exalted and eternal; lowly and transitory) is expressed through color and drawing. The intense, deep and light blue tones of the mother figure correspond to her free-flowing (heavenly) sculptural modelling. The lifeless green-gray shadows (the color of raw clay) in the figure of the prostitute match her harshly drawn outline, the angular rhythms of her pose, and the sad sharp shadows in the folds of her robe."

The drawing *L'Offrande* (title in English: *The Gift*) of 1902 (plate 55) is the preliminary study to the oil painting of the same title also illustrated in this catalogue. In 1902 Picasso was just 21 years old. During that year he spent much of the time travelling between Paris and Barcelona. He lived a bohemian existence, residing in run-down hotels and suffering the greatest material want. At this time he was very much working in the style of his Blue Period, and his drawings were devoted mainly to symbolic and allegorical themes. The theme of the drawing *The Gift* is that of giving a gift as an eternal gesture. It is full of spirituality but maintains extreme formal rigor. The slim, upright forms and their garments inevitably recall the sacral figures of El Greco

(1541–1614). Politically, 1902 was the year in which mass strikes took place, and for Picasso himself it was the year of his greatest privation and material distress. In this context of personal despair, the warm cup of soup acquires a direct personal significance.

The watercolor *Woman Crouching* (plate 57) of 1903 is characteristic of the loneliness of the figures from the Blue Period. The woman's gaze is apathetic and passive, her physical presence greatly played down by her flowing, shroud-like dress. Her folded arms suggest withdrawal and fear of contact. Unapproachable, with little indication of human warmth, similar to the "figura sedens" of Albrecht Dürer (1471–1528) or of the "pensiero," and seemingly in an absurd world, the woman sits across from us. Her upraised shoulders and the coolness of the blue color create a chilly impression. The feeling of alienation that would later be the defining characteristic of Existentialism could hardly be shown visually with any greater effect.

Certainly the most important drawing in the present exhibition is *La Vie* (plate 59) of 1903. Formally and thematically, this is without a doubt the closest study for the oil painting of the same name also illustrated in this catalogue. The drawing is on the reverse of an invitation to a funeral, which explains the light crease through the middle. That fact alone should serve to indicate that the picture deals with nothing less than the central theme of life and death.

Picasso's features are recognizable in the drawing, but it is his friend Carlos Casagemas who is depicted in the oil painting. The index finger pointing to a representation of a kneeling couple has been interpreted as a quotation from Michelangelo's fresco in the Sistine Chapel in the Vatican, where God gives the breath of life to Adam through an extended finger. Picasso's complex work deals with the different stages of love at particular times in one's lifetime – from birth through periods of being in love, and ending with the old, crouching couple and the ultimate loneliness of human life. The pen-and-wash drawing *The Acrobats* (plate 61) of 1904 marks the transition from the Blue Period to the Rose Period. Picasso's financial situation improved dramatically towards the end of 1904. Important collectors became interested in his works. He began his relationship with the beautiful Fernande Olivier. The depressing mood of the blue pictures lessened and was replaced by a cheerful pink. Thematically, this signalled a shift from images of people with starved and forlorn existences to those of harlequins and travelling circus people. Furthermore, the figures were rendered less stiffly than those of the Blue Period: La Vie en rose. The Acrobats has a typically musical mood and a grand poetry characteristic of portrayals of travelling performers in general. The work was exhibited as early as 1920 at Herwarth Walden's Sturm-Galerie in Berlin.

The drawing of a *Female Nude* (plate 62) was done during the eventful period between spring 1906 and spring 1907, which has been called Picasso's "Iberian Period." Sculptures from the Iberian Bronze Age and African masks especially fascinated Picasso, and their archaic forms indirectly formed the basis for his work at this time. But Catalonian sculpture such as the twelfth-century Santa Maria de Castell de Gósol, an image of the Virgin, was also of primary importance. Picasso saw this wooden sculpture for the first time during his stay at Gósol in the Spanish Pyrenees, and for him it was tantamount to a revelation. The drawing reproduced here is itself to be understood in that context. The mask-like facial expression is presumably a preliminary study for the oil painting *Nude against a Red Background* in the Musée de l'Orangerie in Paris.

52 Pablo Picasso
Lola, the Artist's Sister, 1898
colored pencil, 15 ¾ × 14 ⅝ in. (40 × 37 cm)
private collection

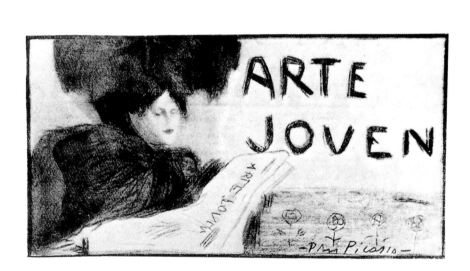

53 Pablo Picasso
Woman with Shawl, 1900
pastel, 4 ³/₄ × 8 ¹/₄ in. (12.1 × 21 cm)
private collection

This pastel was used as the
source for the title page to *Arte Joven*.

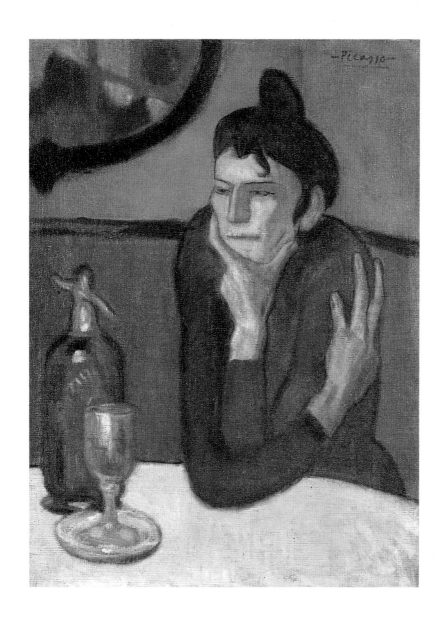

The Absinthe Drinker
oil on canvas, 28 ³/₄ × 21 ¹/₄ in. (73 × 54 cm)
Hermitage Museum, St. Petersburg

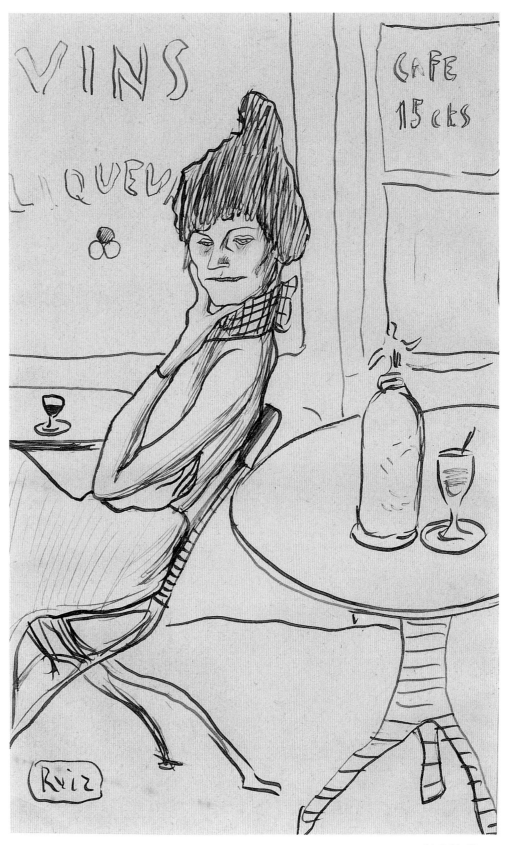

54 Pablo Picasso
The Absinthe Drinker, 1901
pen drawing,
11 ¾ × 5 ¼ in. (30 × 13 .5 cm)
private collection

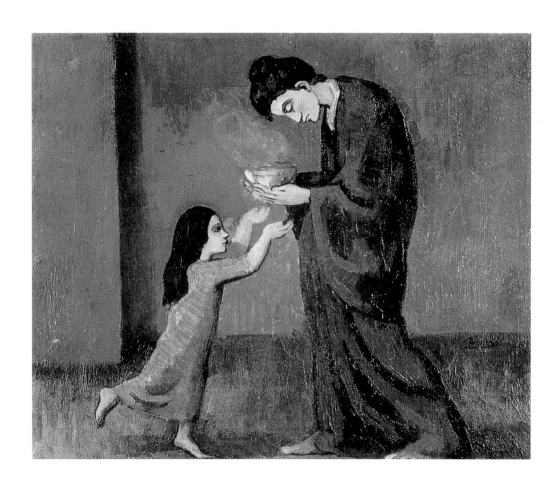

La Soupe (The Soup), 1903
oil on canvas, 14 ⅝ × 16 ⅞ in. (37 × 43 cm)
Art Gallery of Ontario, Toronto
Gift of Margaret Dunlap Crang, 1983

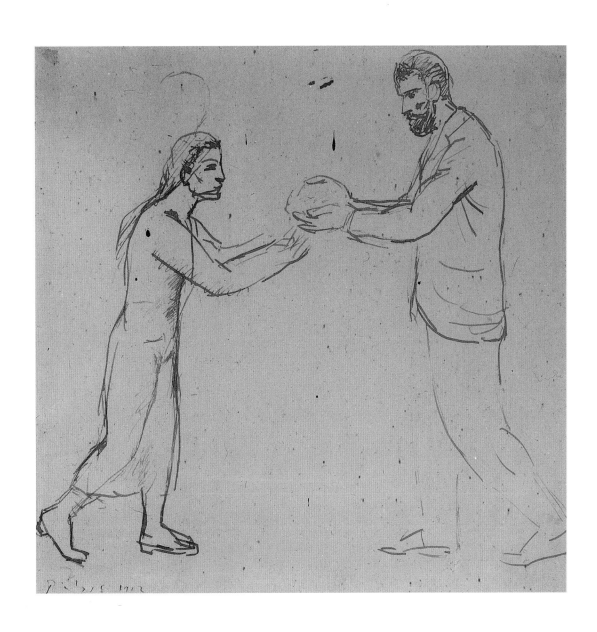

55 Pablo Picasso
L'Offrande (The Gift), 1902
ink drawing, 10 ¼ × 9 ⅞ in. (26 × 25 cm)
private collection

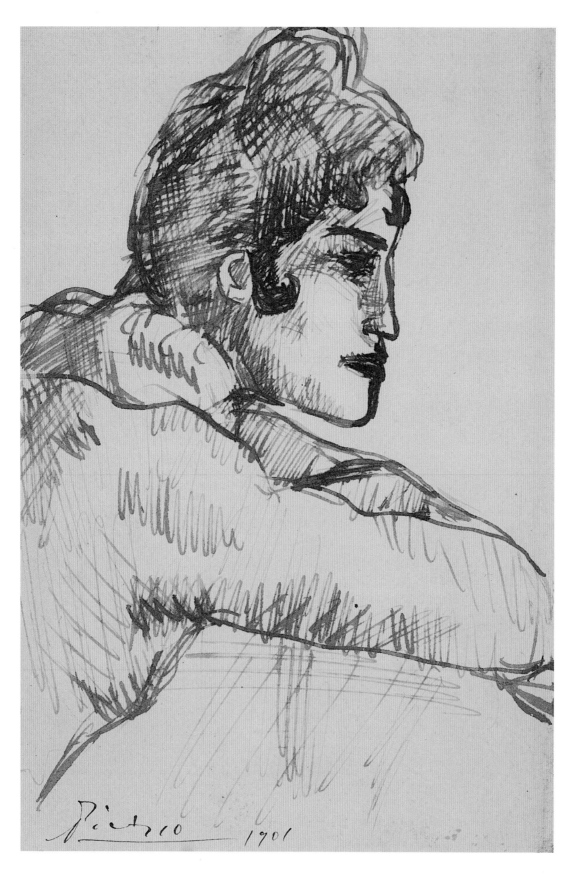

56 Pablo Picasso
Woman's Profile, Fernande, 1901
ink drawing, 6 ¼ × 4 ¼ in. (16 × 11 cm)
private collection

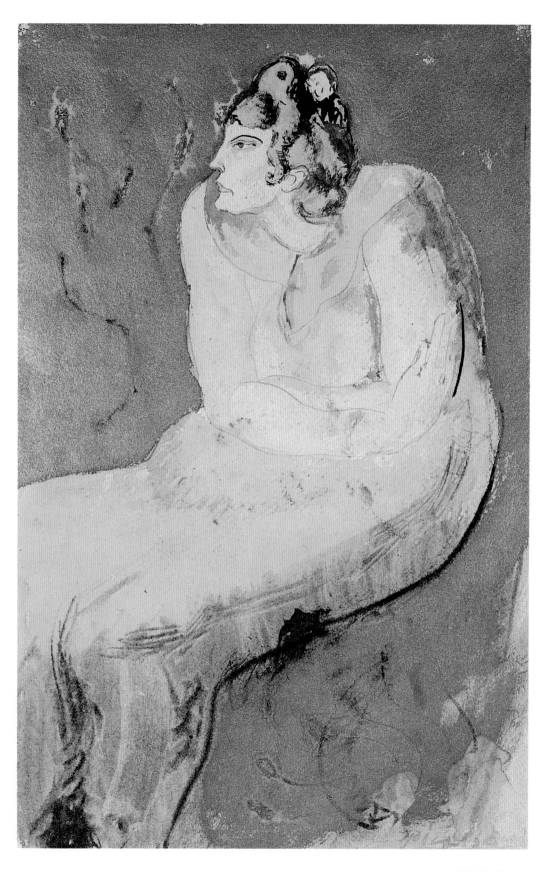

57 Pablo Picasso
Woman Crouching, 1903
ink and watercolor, 10 ¼ × 6 ⅝ in. (25.8 × 16.8 cm)
private collection

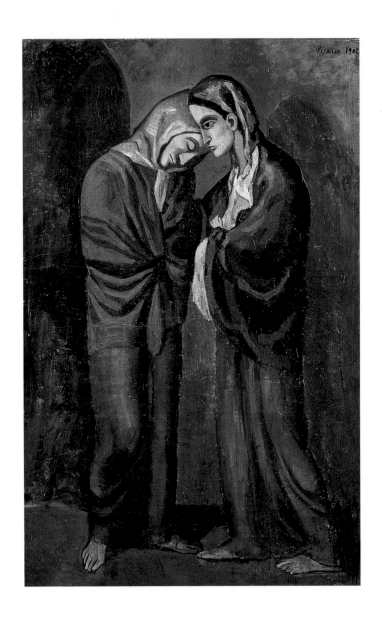

The Two Sisters, 1902
oil on canvas, 60 × 39 ³/₈ in. (152 × 100 cm)
Hermitage Museum, St. Petersburg

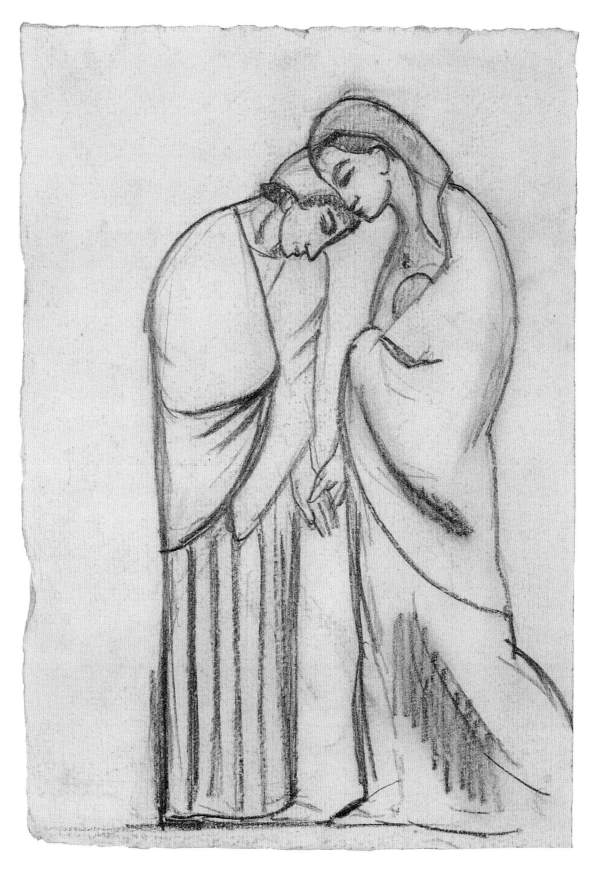

58 Pablo Picasso
The Two Sisters, 1902
pencil, 6 ¼ × 4 ¼ in. (16 × 11 cm)
private collection

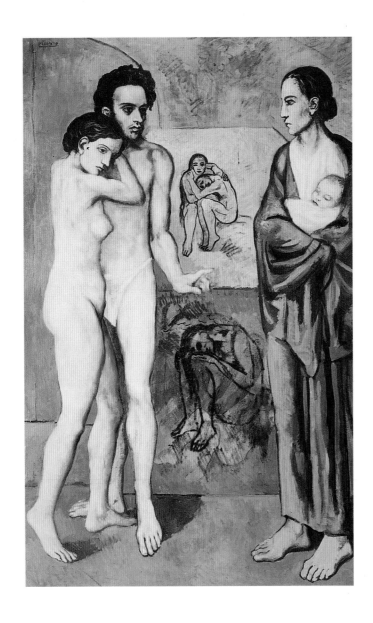

La Vie, 1903
oil on canvas, 77 ⁵⁄₈ × 50 ³⁄₈ in. (197 × 128 cm)
Cleveland Museum of Art, Cleveland, Ohio

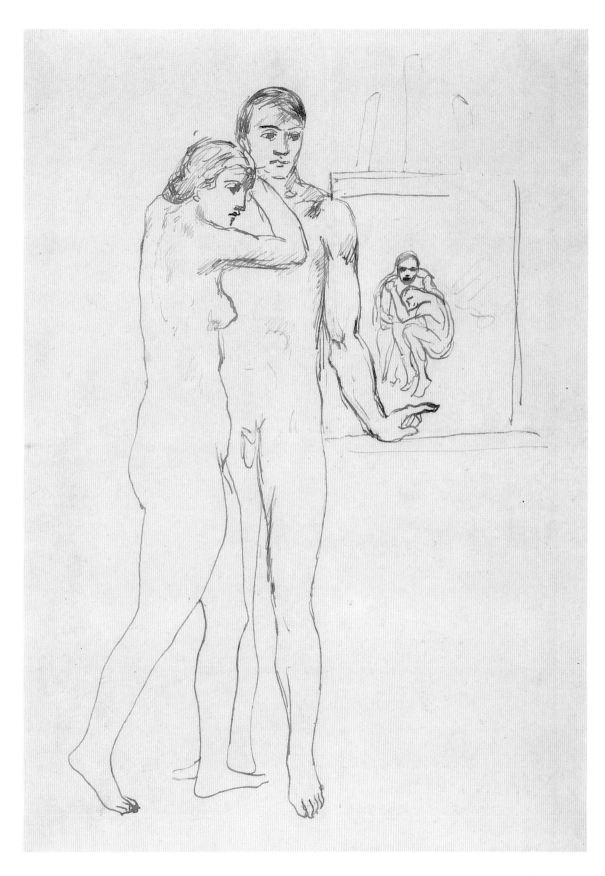

59 Pablo Picasso
La Vie, 1903
ink drawing, 10 ¼ × 7 ½ in. (26 × 19 cm)
private collection

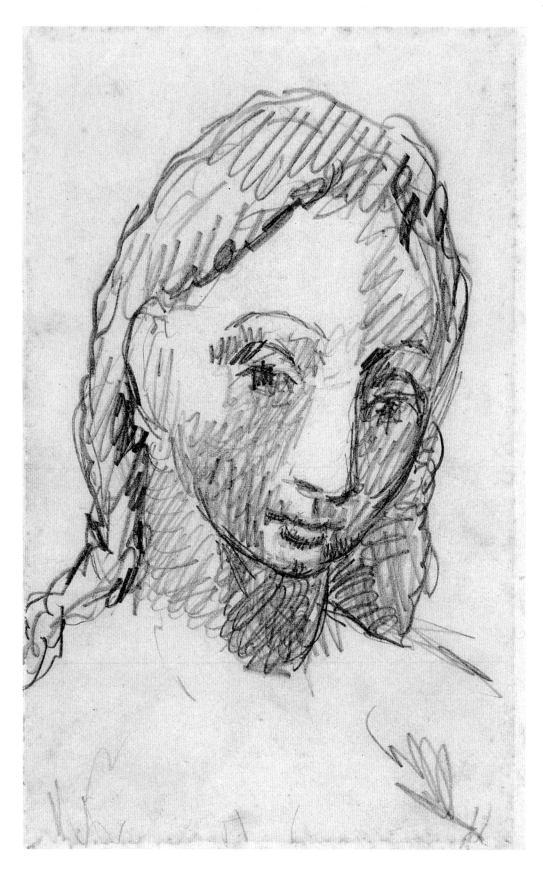

60 Pablo Picasso
Head of a Woman, 1906
pencil, 6 ³/₄ × 4 ¹/₈ in. (17 × 10.5 cm)
private collection

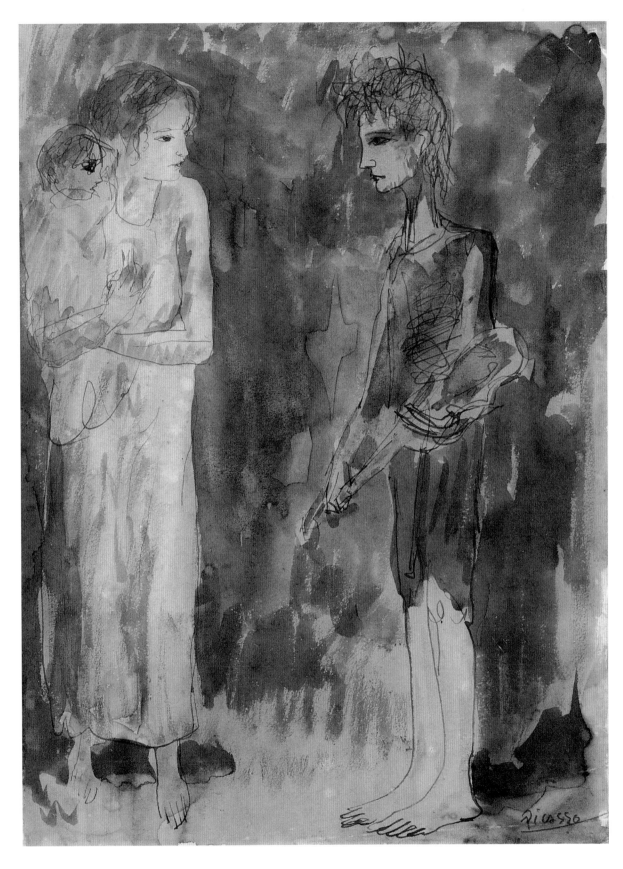

61 Pablo Picasso
The Acrobats, 1904
pen and wash, 14 ¹/₂ × 10 ³/₈ in. (36.7 × 26.5 cm)
private collection

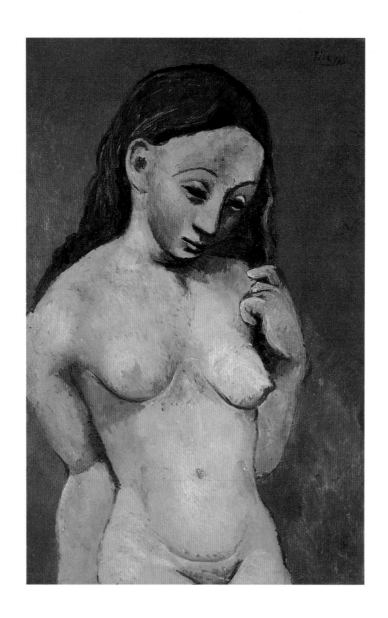

Nude against a Red Background, 1906
oil on canvas, 32 × 21 ¼ in. (81 × 54 cm)
Musée de l'Orangerie, Paris
Collection of Jean Walter-Paul Guillaume

62 Pablo Picasso
Female Nude, 1906
pencil, 6 ½ × 3 ⅞ in. (16.5 × 10 cm)
private collection

63 Pablo Picasso
Bathers, 1916
pencil, 11 × 27 ³⁄₈ in. (28 × 69.5 cm)
private collection

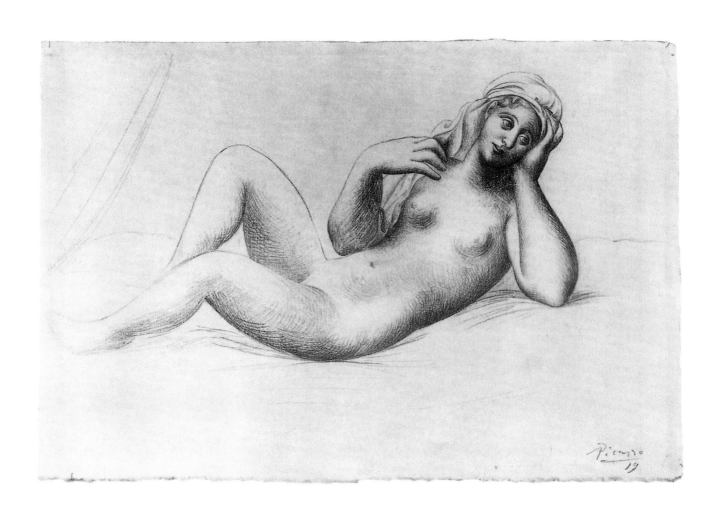

64 Pablo Picasso
Nude with a Turban, 1919
pencil, 8 ¾ × 13 in. (22 × 33 cm)
Collection of Dr. Klaus Hegewisch,
Hamburg

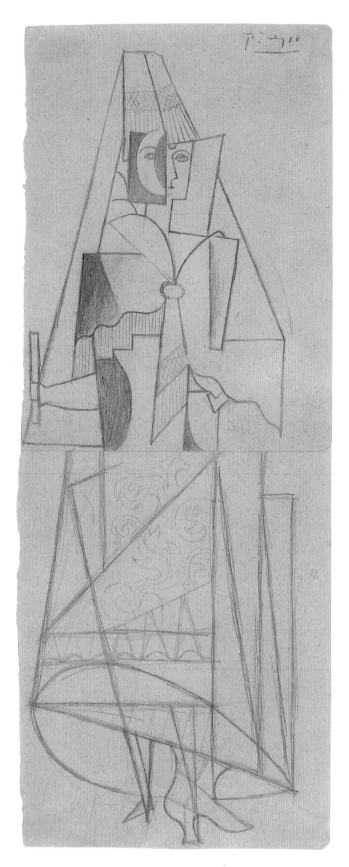

65 Pablo Picasso
Woman with Mantilla, 1917
pencil, 15 × 51 7/8 in. (38 × 15 cm)
private collection

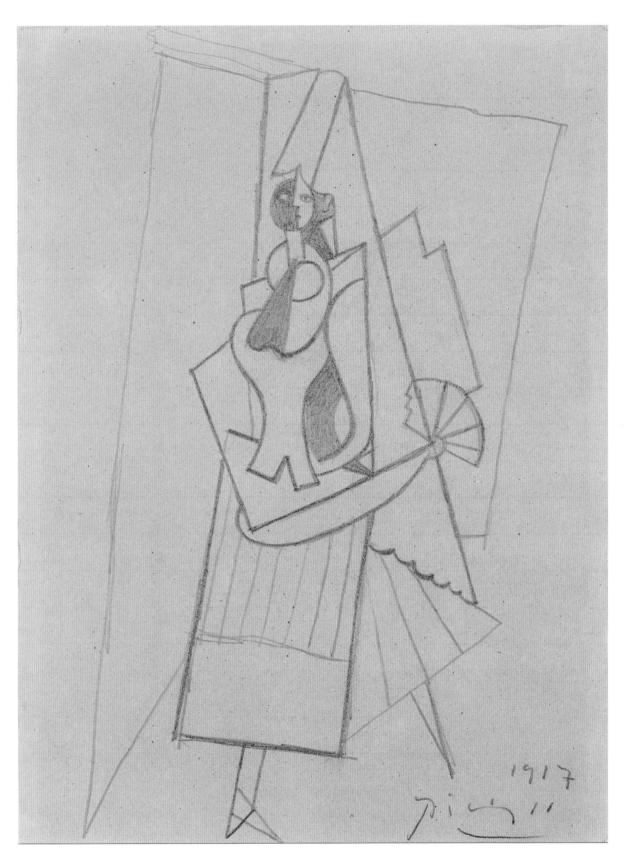

66 Pablo Picasso
Spanish Woman, 1917
pencil, 7 7/8 × 5 7/8 in. (20 × 15 cm)
private collection

67 Pablo Picasso
The Family of Napoleon III, 1919
pastel, 24 ³/₈ × 19 in. (62 × 48 cm)
private collection

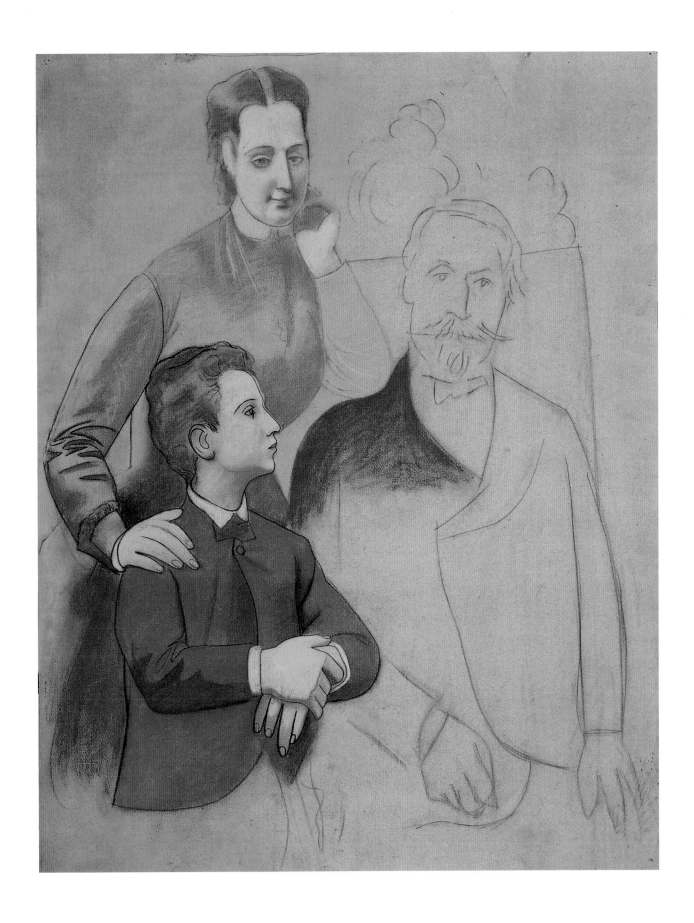

Picasso's inscription on reverse of *The Round Dance*

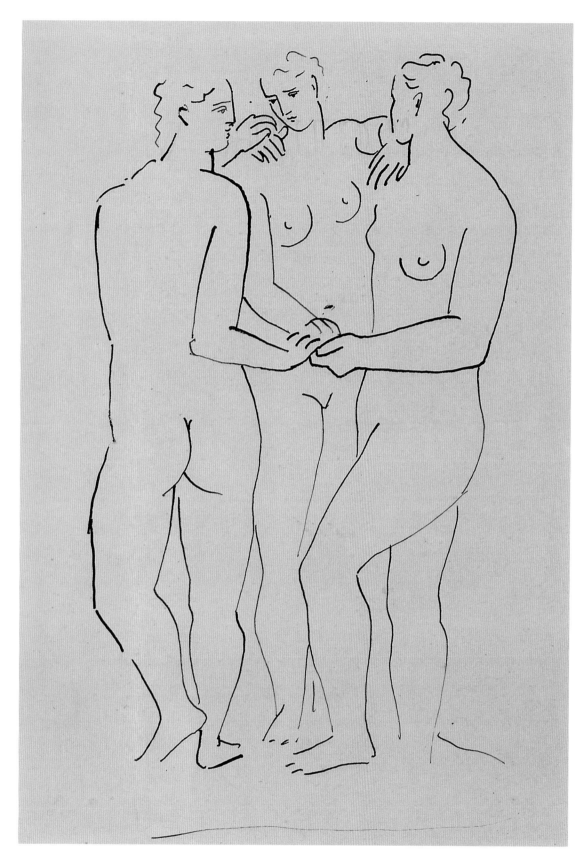

68 Pablo Picasso
The Round Dance, 1920
ink drawing, 7 ¼ × 5 in. (18.5 × 12.5 cm)
private collection

69 Pablo Picasso
Three Bathers, 1921
watercolor, 4 × 5 ¼ in. (10 × 13.5 cm)
private collection

Exposition Picasso

Galerie Paul Rosenberg, 21, rue La Boëtie, du 23 Mai au 11 Juin 1921

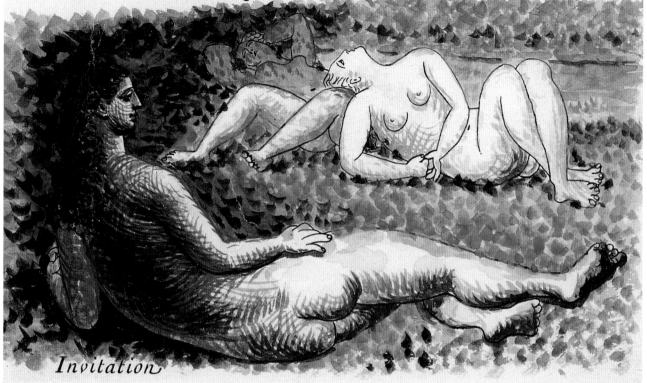

Invitation

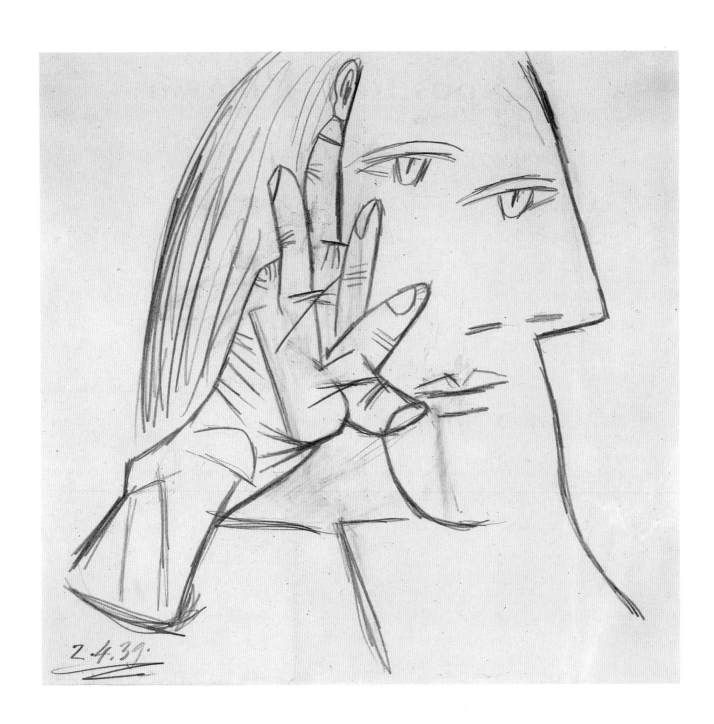

70 Pablo Picasso
Head of a Woman, 1939
pencil, 13 × 12 ½ in. (33 × 31.7 cm)
private collection

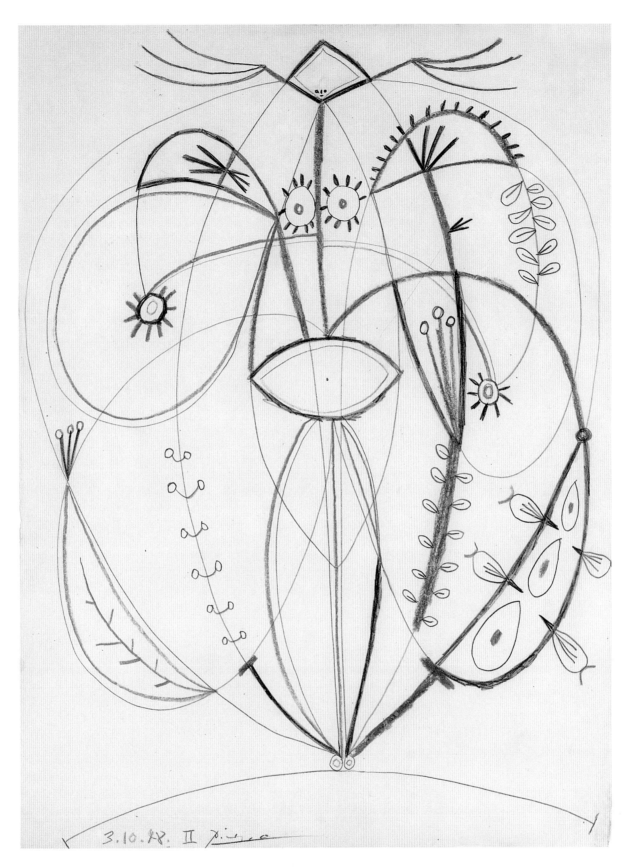

71 Pablo Picasso
Flower Woman, 1948
colored pencil, 26 × 19 ⅞ in. (66 × 50.5 cm)
Waddington Galleries, London

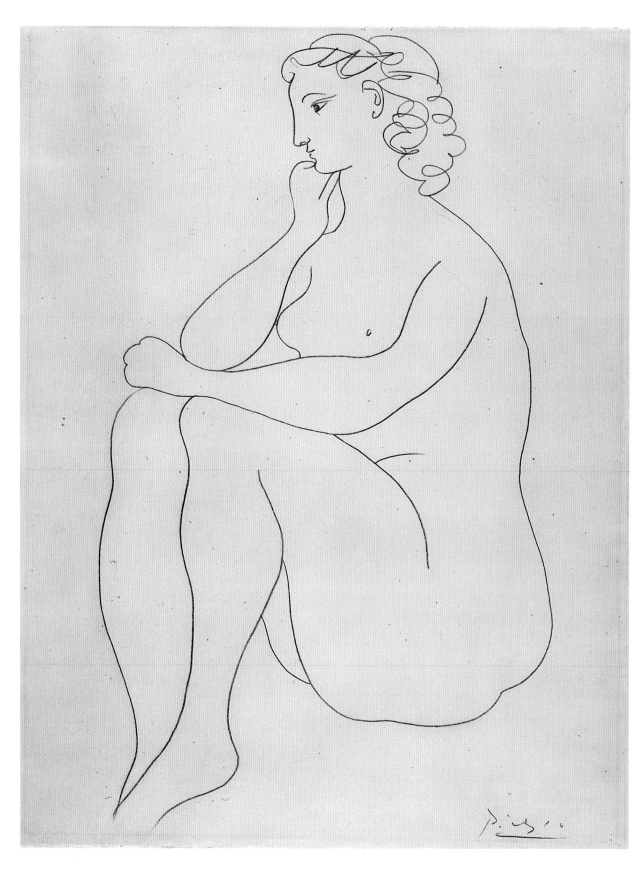

72 Pablo Picasso
Seated Nude, 1943
pencil, 26 × 19 ³⁄₄ in. (66 × 50 cm)
Würth Collection

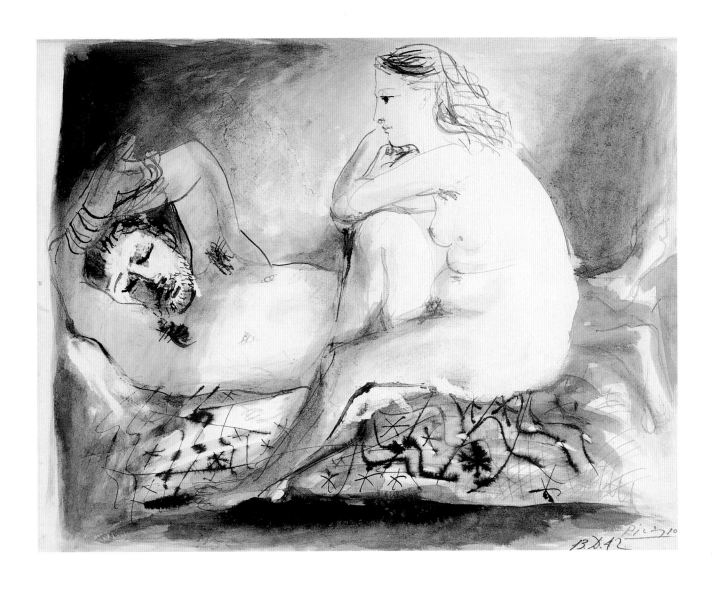

73 Pablo Picasso
Slumber, 1942
pen and wash, 19 ¾ × 25 ⅝ in. (50 × 65 cm)
Collection Heinz Berggruen,
at Stüler Bau, Berlin

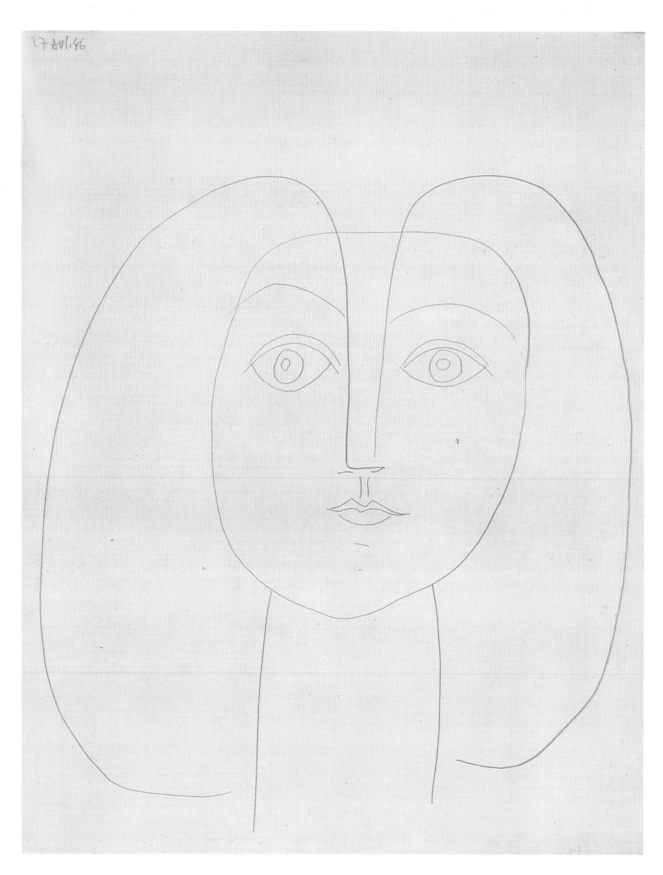

74 Pablo Picasso
Françoise Gilot, 1946
pencil, 26 × 19 ¾ in. (66 × 50 cm)
private collection

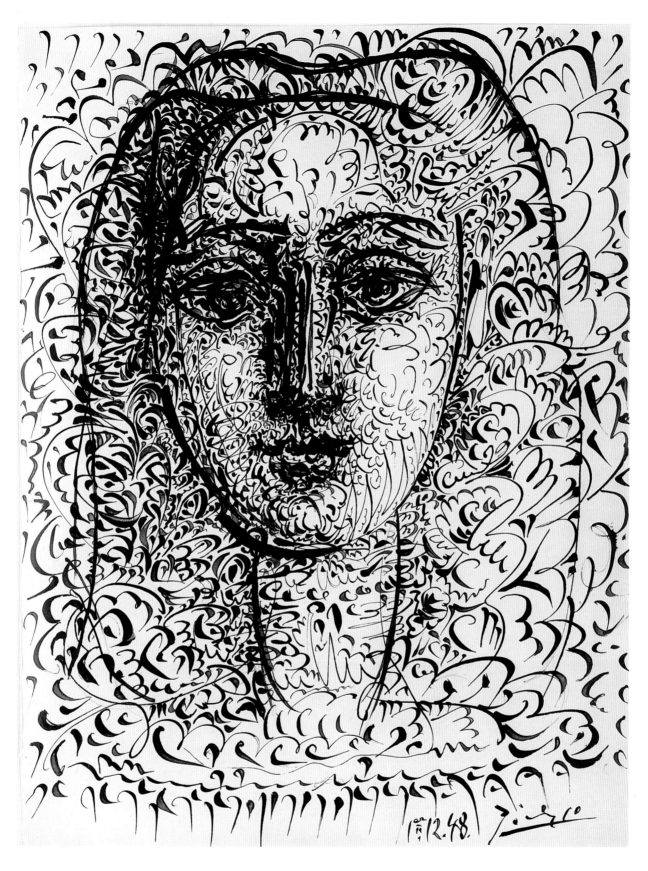

75 Pablo Picasso
Female Portrait (Françoise), 1948
pen drawing, 12 ⅝ × 9 ¾ in. (32 × 25 cm)
private collection, courtesy of Galerie Utermann, Dortmund

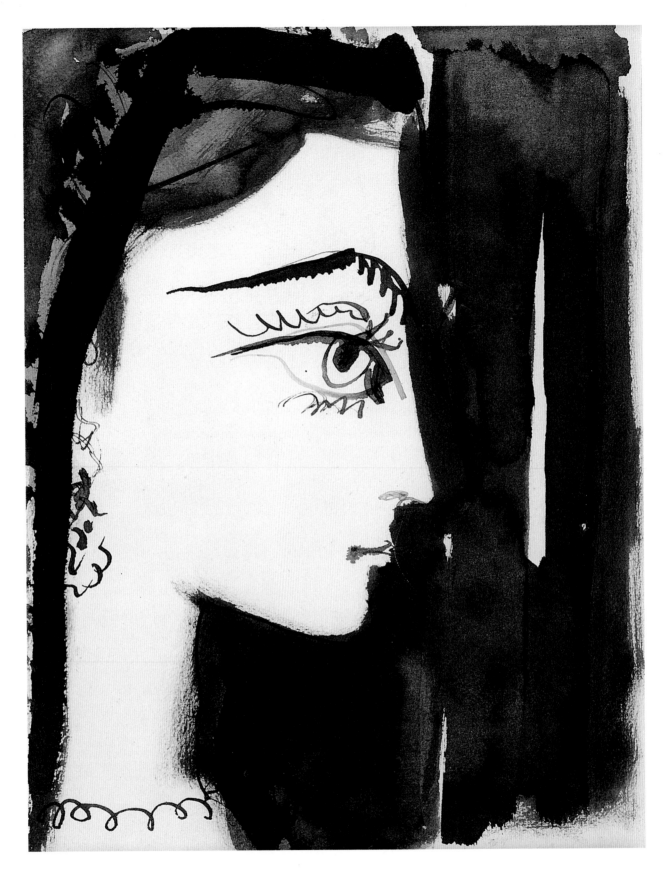

76 Pablo Picasso
Female Profile (Carmen), 1964
ink drawing, 12 ¹⁄₄ × 9 ³⁄₄ in. (31 × 25 cm)
Würth Collection

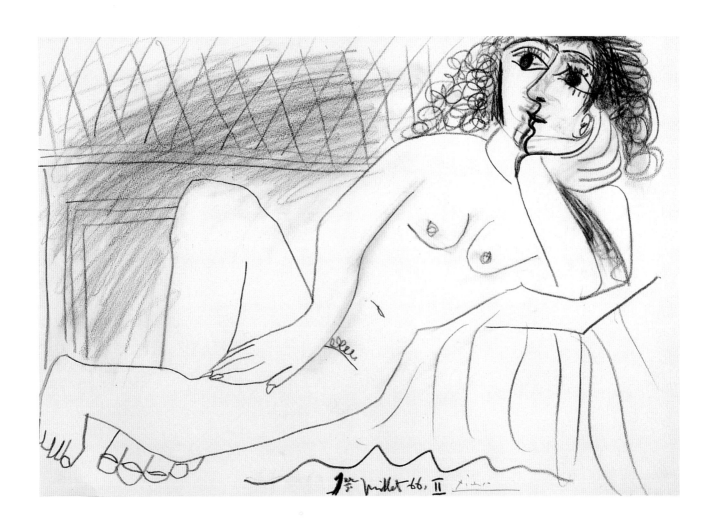

77 Pablo Picasso
Reclining Nude, 1966
drawing, 14 ⁵/₈ × 21 ¹/₄ in. (37 × 54 cm)
private collection

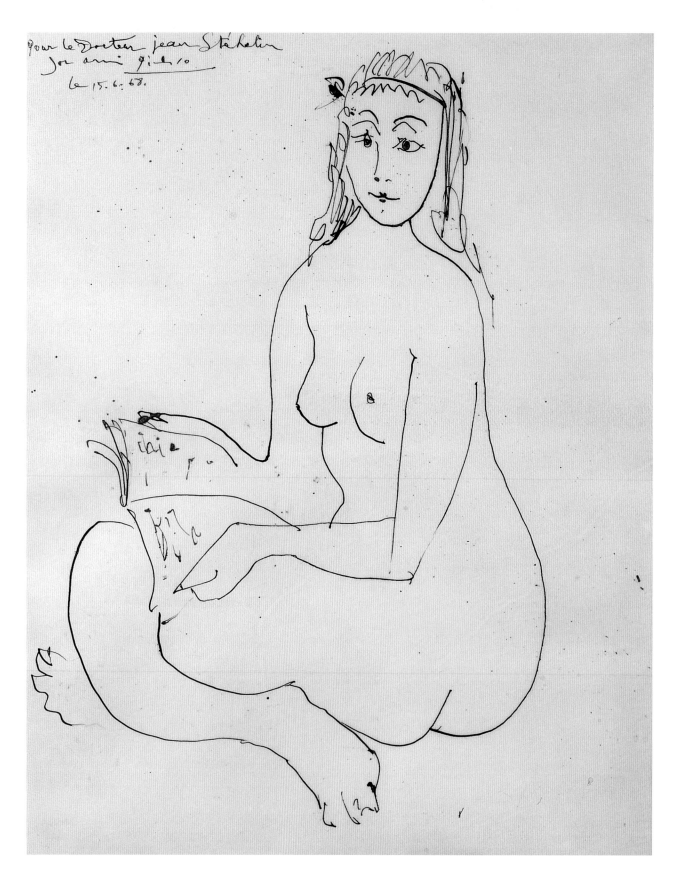

78 Pablo Picasso
Nude Reading, 1968
ink drawing, 19 $^{1}/_{8}$ × 15 in. (48.5 × 38 cm)
private collection

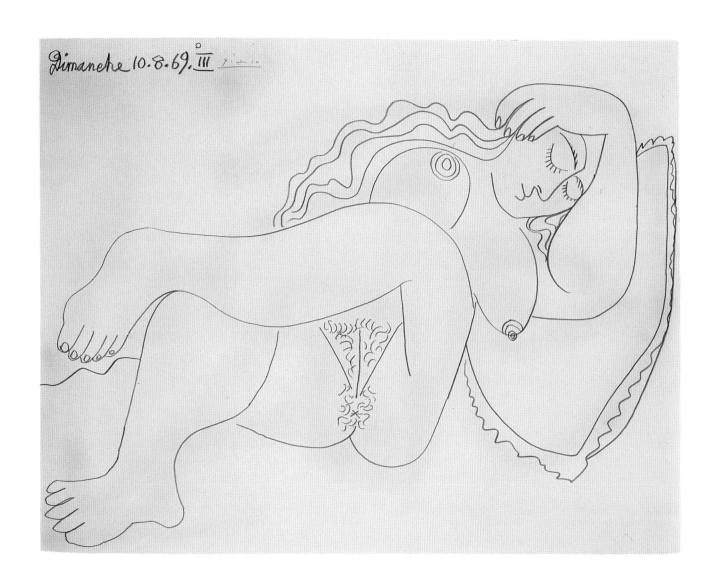

Dimanche 10.8.69. III

79 Pablo Picasso
Reclining Nude, 1969
pencil, 20 × 25 ¾ in. (50.8 × 25.7 cm)
private collection, Switzerland

Biographies

Pierre Bonnard

1867: Pierre Bonnard is born October 3 in Fontenay-aux-Roses. **1885:** Begins to study law in Paris. **1886:** Attends the Académie Julian, a private art school. Meets Paul Sérusier, Maurice Denis, and Paul Ranson, among others. **1888:** Takes his bar exams. Under the leadership of Sérusier, the art group the Nabis (the Enlightened Ones) is founded to advocate a flat, decorative style of painting in emulation of the work of Paul Gauguin. Bonnard joins the Nabis. **1889:** Is accepted at the Ecole des Beaux-Arts, where he meets Edouard Vuillard and Ker-Xavier Roussel. The Gauguin exhibition at the Café Volpini and a show of Japanese wood-cuts at the Ecole des Beaux-Arts leave lasting impressions. Begins working as a lawyer. Shares a studio with Denis and Vuillard. **1891:** Represented at the Salon des Indépendants with five paintings; shows there in subsequent years. Poster *France-Champagne* (designed 1889) meets with general acclaim. Makes acquaintance of Henri de Toulouse-Lautrec. Gives up legal career. Increasingly incorporates impressions of Japanese wood-cuts into his work. **1892:** Participates in the second Nabis exhibition. **1894:** Lithographs for *Revue blanche*. Friendship with the publisher Thadée Natanson. Meets Odilon Redon. **1896:** Studio in the Batignolles quarter. First solo show at the Galerie Durand-Ruel, as well as first participation in the Salon of *La Libre Esthétique* in Brussels. Stage designs and book illustrations. **1900:** Exhibits at Bernheim-Jeune together with the Nabis. From now on spends summer months in the country. Palette brightens. Illustrates a volume of poetry by Paul Verlaine. **From 1901:** Travels to Spain and Holland. **1902:** 156 lithographs for *Daphnis and Chloë*. **1903:** Participates in the founding of the Salon d'Automne in Paris. **1904:** Beginning of friendship with Henri Matisse. **1906:** Solo shows at Galerie Vollard and Bernheim-Jeune, where his works are shown regularly in subsequent years. **1908:** Travels to North Africa. **1909:** First extended stay in the south of France. **1913:** Experiences an artistic crisis. Searches for a new means of depiction; finally arrives at more clearly structured compositions through intensive drawing. **1915:** Saint-Germain-en-Laye. **1918:** Bonnard and Pierre-Auguste Renoir named honorary presidents of the group *Jeune Peinture Française.* **1921:** Major success with the large painting *The Terrace at Vernon* (1918) at the Salon d'Automne. **1924:** Retrospective at the Galerie Druet. **1926:** Buys a country retreat at Le Cannet

(southern France). Travels to USA as jury member for the Carnegie Prize. **1928:** First major solo show in New York. Participates in many more international exhibitions until his death. **1936:** Awarded the Carnegie Prize, Second Place. **1947:** Dies January 23 at Le Cannet. **1948:** Major retrospective at the Museum of Modern Art, New York.

Paul Cézanne

1839: Paul Cézanne is born January 19 in Aix-en-Provence. **1848:** Cézanne's father founds bank, *Cézanne & Cabasol*, in Aix. Cézanne sent to boarding school. **1852:** Meets and forms a close friendship with Emile Zola, who is one year younger, at the upper middle-class Collège Bourbon. **1857:** First drawing lessons. **1858:** Zola leaves Aix and moves to Paris. The two friends correspond regularly. Cézanne receives high-school degree on second attempt. **1859:** Begins to study law at Aix. His father purchases "Jas de Bouffan," a country estate. **1861:** Cézanne discontinues the study of law and moves to Paris to attend the Académie Suisse, a private art institute. Meets Camille Pissarro. **1862:** After a short stay in Aix, gives up work at his father's bank for ever, and applies for entry to the Ecole des Beaux-Arts in Paris. Is rejected. **1863:** Exhibits at the "Salon des Refusés" in Paris. **1864:** Salon jury again rejects his submission. **1867:** Together with a group of artists, shows one of his works for the first time in Marseille. Because of extremely negative public reaction, his painting is taken down ahead of schedule. **1868 and 1869:** Salon submissions again rejected. Meets his future wife, Hortense Fiquet. **1870:** Upon the outbreak of the Franco-Prussian War, Cézanne leaves Paris and moves with Hortense to L'Estaque, near Marseille. **1872:** Together with Pissarro, Pierre-Auguste Renoir, Claude Monet, and others, Cézanne lodges a protest against the arbitrariness of Salon jury selection. His pictures are again rejected. Becomes acquainted with the doctor and art collector Paul Gachet. Son Paul is born. **1874:** Exhibits three paintings in the first Impressionist exhibition, at the studio of the photographer Nadar in Paris. **1876:** Participates in an Impressionist exhibition at the galleries of the art dealer Paul Durand-Ruel. **1877:** Shows sixteen paintings in the third Impressionist exhibition, all of which meet with unanimous derision from the critics. **1878:** Withdraws to the south of France. Hortense

Fiquet lives in Marseille; Cézanne lives with his parents in Aix. His father cuts his monthly allowance after learning of the existence of Hortense and her son. Cézanne begs Zola for financial assistance. **1881:** Spends summer at Pissarro's in Pontoise and makes Paul Gauguin's acquaintance. **1882:** The Salon jury finally accepts a picture, which is promptly hung badly in a far corner of the exhibition hall. **1886:** Zola's novel *L'Oeuvre* is published in March. The story bears a strong resemblance to Cézanne's life. Cézanne recognizes himself in the character of the painter Claude Lantier, a brilliant but failed artist who finally kills himself. Cézanne is deeply upset, feels betrayed by his friend, and breaks contact with Zola forever. On April 28, marries Hortense in Aix in the presence of his parents. On October 23, his father dies at the age of eighty-eight, and Cézanne inherits 400,000 francs. **1889:** Dr. Gachet, an admirer of Cézanne's art, takes up his cause and arranges to have the painting *The House of the Hanged Man* shown at the Exposition Universelle in Paris. **1890:** Three of Cézanne's works are exhibited in Brussels. Spends the summer with his wife and son in Switzerland. First signs of diabetes. **1891:** Resides in Aix with his mother, while his wife and son live in Paris. **1894:** Three of his paintings fetch good prices at the auction of the Théodore Duret collection in March. Cézanne spends the fall at Monet's in Giverny. The astute businessman-art dealer Ambroise Vollard organizes Cézanne's first solo show, of over 150 works. Monet, Renoir, Pissarro and Edgar Degas are all enthused about the paintings. **1897:** Vollard buys out the stock from Cézanne's studio. **1900:** The art dealer Durand-Ruel sends twelve of Cézanne's paintings to his German colleague Paul Cassirer in Berlin. First show of Cézanne's work in Germany is organized, but no paintings are sold. Three works receive honorable mention at the Exposition Universelle in Paris. **1906:** Cézanne is represented at the Salon d'Automne with ten pictures. On October 15 he is caught in a thunderstorm while painting out-of-doors and dies October 22 of pneumonia in Aix. **1907:** Major memorial exhibition at the Salon d'Automne.

Marc Chagall

1887: Marc Chagall is born July 7 in Vitebsk, Russia, son of a simple Jewish family. **1906:** Finishes local school and begins studying with

Jehuda Pem, a Jewish painter who had studied at the academy in St. Petersburg. **1907:** Goes to St. Petersburg to study at the School of the Imperial Society for the Protection of Arts on a scholarship. **1908:** Studies several months at the Saidenberg and Svanseva schools under Léon Bakst. **1909:** Meets his future wife, Bella Rosenfeld. **1910:** Moves to Paris and into his first studio on Impasse du Maine. Meets Blaise Cendrars, Max Jacob, Guillaume Apollinaire, Fernand Léger, Amedeo Modigliani, and Roger de La Fresnaye. **1911:** Represented for the first time in the Salon des Indépendants and the Salon d'Automne. Moves to a larger studio in the artists' colony La Ruche. **1913:** Meets Herwarth Walden through Apollinaire. **1914:** First solo show, at Herwarth Walden's gallery Der Sturm in Berlin. Travels from Berlin to Russia. **1915:** Exhibition in Moscow. Marries Bella Rosenfeld on July 25 in Vitebsk. **1916:** Birth of daughter Ida. Major show in Moscow. **1917:** Returns to Vitebsk following the October Revolution; is named Commissar for Fine Arts in the government of Vitebsk. **1919:** Founds an art school in Vitebsk, becomes director, and hires El Lissitzky, Jean Pougny, and Kasimir Malevich as teachers. Conflict with Malevich. Chagall resigns. **1920:** Invited to Moscow by Abraham Efross and Alexey Granowsky. Creates wall-paintings, stage designs, and costumes for the Jewish Theater, Moscow. **1921:** Works as a drawing teacher at the war orphan's colony Malakovska, near Moscow. **1922:** Leaves Russia for good; returns to France via Berlin. In Berlin, Chagall fails to get back the paintings he left at Herwarth Walden's before the war. Begins etchings for his autobiography, *My Life*. **1923:** Arrives in Paris. Makes the acquaintance of Ambroise Vollard, who commissions him to do book illustrations for Nikolai Gogol's *Dead Souls*. **1924:** First retrospective in Paris at the Galerie Barbazanges-Hodebert. Meetings with Jean Paulhan, Jules Supervielle, André Malraux, and Marcel Arlan. **1926:** First exhibition in New York at the Reinhardt Galleries. **1927:** Commission from Vollard to do a circus portfolio. Produces the "Cirque Vollard" gouaches. **1928:** Does etchings for the *Fables* of Jean de la Fontaine. **1929:** French version of *My Life (Ma Vie)* completed, but not published until 1931. **1931:** Travels to Palestine in preparation for etchings on the Bible, which are completed 1931–39 and 1952–56. **1932:** Travels to Holland. **1933:** Major retrospective at the Kunsthalle Basel. **1934:** Travels to Spain. **1935:** Travels to Poland; dedicates a Jewish cultural institute in Vilna. **1937:** Travels to Italy; works with the motif of the cross as a symbol of the sufferings of his time. **1939:** Receives the Carnegie Prize in Pittsburgh. **1941:** Travels to the USA on the invitation of the Museum of Modern Art in New York. Chagall and his wife decide to settle there. Regular exhibitions at the Pierre Matisse Gallery. **1942:** Summer residence in Mexico. Stage designs and costumes for the ballet "Aleko," based on Tchaikovky's piano trio.

1944: Death of his wife Bella. **1945:** Stage designs and costumes for the ballet "The Firebird" by Igor Stravinsky, at the New York Metropolitan Opera. **1946:** Retrospective at the Museum of Modern Art, New York, and the Art Institute of Chicago. Color lithographs for "1001 Nights." **1947:** Returns to Paris. Traveling exhibition at the Musée National d'Art Moderne, Paris, the Stedelijk Museum, Amsterdam, and the Tate Gallery, London. First prize for graphic art at the 25th Venice Biennale. **1948:** Makes the acquaintance of Aimé Maeght, who becomes his art dealer. **1949:** Does murals for the Watergate Theatre, London. **1950:** Moves to Vence. Makes his first ceramic pieces. Traveling retrospective at the Kunsthaus Zürich and Kunsthalle Bern. **1951:** Second trip to Israel. Produces his first sculptures. **1952:** Marriage to Valentine (Vava) Brodsky. Travels to Greece in preparation for his lithographs for Maurice Ravel's "Daphnis et Cloë" for the Paris Opéra. The *Fables* of La Fontaine are published by Tériade. **1953:** Exhibition at the Palazzo Madama in Turin. Begins a series of Paris pictures. **1954:** Second trip to Greece. Begins work on the "Daphnis et Cloë" lithographs. **1955:** Exhibition at the Kestner-Gesellschaft in Hannover. **1956:** Exhibitions in Basel and Bern. "Circus" series of lithographs. **1957:** Exhibition in the baptistery of Notre-Dame de Toute Grâce on the plateau of Assy, Savoie. Opening of the Chagall House in Haifa. Exhibition of graphic works at the Bibliothèque Nationale in Paris. **1958:** Performance of Ravel's ballet "Daphnis et Cloë" at the Paris Opéra. Designs stained-glass windows for Metz Cathedral. Visits Chicago. **1959:** Receives an honorary doctorate from the University of Glasgow and honorary membership in the American Academy of Arts and Letters. Retrospectives in Paris, Munich, and Hamburg. Mural for the foyer of the Schauspielhaus, Frankfurt am Main. **1960:** Receives the Erasmus Prize, together with Oskar Kokoschka, in Copenhagen. Honorary Doctorate from Brandeis University, Waltham, Massachusetts. Does designs for twelve stained-glass windows for the synagogue of the Hadassah University Clinic, Jerusalem. **1962:** Dedication of the stained-glass windows, Jerusalem. **1963:** Trip to Washington, DC. Stained-glass windows for the northern transept of Metz Cathedral. **1964:** Travels to New York. Creates stained-glass windows for the United Nations building, and a first window for the Church of Pocantico Hills, Tarrytown, New York. Dedication of the ceiling painting at the Paris Opéra. **1965:** Honorary doctorate from the University of Notre Dame, Notre Dame, Indiana. Murals for the Metropolitan Opera, Lincoln Center, New York. Decoration and costume design for Mozart's "Magic Flute" in New York. Lithographs for "Exodus." **1966:** Mosaic walls and twelve murals for the new Israeli Knesset in Jerusalem. Three large Gobelins tapestries created in Paris for the same building. **1967:** Dedication of murals at the Metropolitan Opera, New York. Retrospectives

in Zurich, Cologne, and the Fondation Maeght in Saint-Paul-de-Vence to commemorate Chagall's eightieth birthday. The exhibitions "Message Biblique" at the Musée du Louvre, Paris, and "Chagall et le Théâtre" in Toulouse. **1968:** Travels to Washington, DC. Mosaic for the Université de Nice. **1969:** Cornerstone laid for the Fondation Message Biblique in Nice on February 4. Visits Israel for the dedication of the Gobelins tapestries in the new Knesset, Jerusalem. **1970:** Dedication of the glass windows in the choir of the Fraumünster, Zurich. The exhibition "Hommage à Chagall" in the Grand Palais, Paris. **1972:** Begins a major mosaic for the First National City Bank, Chicago. **1973:** Dedication of the Musée National du Message Biblique Marc Chagall in Nice on July 7. Preparations for stained-glass window designs for Reims Cathedral. **1974:** Dedication of the stained-glass windows, Reims Cathedral. First exhibition in the Musée Marc Chagall, Nice. **1975:** The exhibition "Works on Paper" at the Solomon R. Guggenheim Museum, New York. **1976:** Traveling exhibition in Tokyo, Kyoto, Kumamoto, and Nagoya, Japan. Exhibition of graphic work at the Kupferstichkabinett, East Berlin, and the Albertinum, Dresden. **1977:** Is awarded the Grand-croix de la Légion d'honneur by the president of France. Exhibition of original graphics for two books by Louis Aragon and André Malraux at the Fondation Maeght, Saint-Paul-de-Vence. **1978:** Exhibition at the Palazzo Pitti, Florence. Dedication of stained-glass windows at the Art Institute of Chicago. **1981:** Exhibition at the Galerie Maeght, Zurich. **1982:** Retrospective at the Moderna Museet, Stockholm. **1984:** Exhibition at the Musée National d'Art Moderne, Paris, the Musée National du Message Biblique, Nice, and the Fondation Maeght, Saint-Paul-de-Vence. **1985:** Dies March 28 in Saint-Paul-de-Vence. **1987:** Exhibition of gouaches and watercolors at the Stadthalle Balingen to commemorate the one-hundredth anniversary of Chagall's birth.

Edgar Degas

1834: Edgar-Hilaire-Germain de Gas is born July 19 in the upper-middle-class 9th *arrondissement* in Paris, eldest of four children in a banker's family. In keeping with modern practice, he later writes his surname as a single word. **1845:** Attends the boarding school Lycée Louis-le-Grand and becomes friends with Ludovic Halévy, Henri Rouart, and Paul Valpinçon. **1847:** Death of his mother. **1853:** In keeping with his father's wishes, begins to study law but stops the same year. **1855:** Studies art with the followers of Jean-Auguste-Dominique Ingres at the Ecole des Beaux-Arts. **Until 1859:** Travels around France and to Italy. Visits relatives in Naples and Florence. **1860–65:** First portraits, history paintings, and sketches of horses and riders. **1862:** Becomes friends with Edouard Manet and through him meets Emile Zola, Pierre-Auguste

Renoir, Claude Monet, and others. **1865:** Participates annually in the Paris Salon. **From 1868:** First depictions of the theater world. **1870–72:** First depictions of the opera and ballet. Serves in a Parisian barricade during the Franco-Prussian War. **1872–73:** Lives with relatives in New Orleans. **1874:** Death of his Father. Begins to participate regularly in the Impressionist exhibitions, continuing over the next twelve years. **From 1879:** Exhibits drawings, pastels, and graphic work with his paintings at the Impressionist shows. **1880:** Experiences first problems with his vision (cataracts). **1881:** Does wax sculpture of fourteen-year-old dancer Marie von Goethem. **From 1882:** Executes pastels of milliners and of female nudes at their toilet. **From 1885:** His cataracts become increasingly worse. From the mid-1880s, makes frequent, almost compulsive visits to the opera. **1889–90:** Travels to Spain and Morocco. Spends time working in Burgundy. **1892:** The Galerie Durand-Ruel organizes his first (and only) exhibition during his lifetime. Further work is endangered through his worsening vision. Devotes himself more and more to sculpting figures in wax and clay, and to his art collection. **1908:** Almost total blindness causes him to become increasingly antisocial and misanthropic, and forces him to give up drawing altogether. **1917:** Dies September 27 in Paris at the age of eighty-three.

Kees van Dongen

1877: Cornelis Theodorus Marie van Dongen ("Kees") born January 26 in Delfshaven, a suburb of Rotterdam, the second child of a wealthy family. Attends a public high school. **1892–1894/97:** Studies in Rotterdam at the Royal Academy of Fine Arts under J. Striening and J.C. Heyberg. Meets fellow art student Augusta (Guus) Preitinger, who later becomes his wife. **1897–98:** First stay in Paris (about half a year). Returns to Rotterdam and works as an illustrator for the newspaper *Rotterdamsche nieuwsblad.* Themes: scenes from everyday life and the red-light district by the harbor. Paints landscapes. **1889:** Moves to Paris permanently with Guus. She works as a retoucher. **1901:** Begins working regularly for papers with anarchist leanings such as *Gil Blas, Revue blanche,* and others. Participates in the wild life of the Montmartre district. Marries Guus. **1904:** Very successful debuts at the Salon des Indépendants (six paintings), the Salon d'Automne (two paintings), and the Galerie Vollard (105 paintings, and twenty drawings and watercolors). **1905:** Birth of his daughter Augusta (Dolly) in April. Spends the summer in Fleury-en-Bière. Called a *fauve* (wild beast) at the fall Salon, together with Henri Matisse, Maurice de Vlaminck, André Derain and others, because of his expressive paintings. **1906:** Moves with his young family into the legendary studio *Bateau-Lavoir* in Montmartre, center of the contemporary art scene in Paris.

Paints intensely colored pictures inspired by the circus and the world of the *demi-monde.* **From 1908:** Has a contract with Bernheim-Jeune. **From 1909:** Moves into increasingly spacious studios, where he and Guus host wild parties. Travels to Holland, Italy, Spain, and Morocco. **1912:** Holds courses at the Académie Vitti. **1914:** Guus and Dolly are detained in Holland by the outbreak of war and are at first unable to return to Paris. **1917:** Jasmy Jacob becomes his mistress (until 1927) and introduces him to high society in Paris. He becomes a much-celebrated portrait painter of the chic. Has glittering parties in their house in the Bois de Boulogne. Participates frequently in many exhibitions in France and abroad, and is well-received by the critics. **1921:** Divorces Guus. **1922:** Moves to a more luxurious house, where he holds a few exhibitions and chic receptions. **1928:** Travels to Egypt. Receives various State awards. **1929:** Becomes a French citizen. **1932:** Moves to Garches after Jasmy sells their villa. Despite his success, increasingly rejects the superficial *beaumonde* and gradually isolates himself. His biting mockery puts him on distant terms with high society as well as art critics. **1935:** Travels to the USA. **1938:** Meets Marie-Claire. **1940:** Has a son with Marie-Claire. Participates in exhibitions; numerous retrospectives of his work. His creative abilities remain undiminished. **1942:** Visits the sculptor Arno Breker in Berlin, for which he is subjected to vehement criticism after the war. **1946:** Death of Guus. **1949:** Marie-Claire and son Jean-Marie move to *Bateau-Lavoir,* a villa in Monaco, where van Dongen spends the winter months. **1950:** Death of Jasmy. **1953:** Marries Marie-Claire. **1959:** Moves to Monaco permanently. **1968:** Dies May 28 in Monaco at the age of ninety-one.

Paul Gauguin

1848: Paul Gauguin is born July 7 in Paris, the son of a Republican journalist. **1849:** The family moves to Peru. **1854:** Return to France. Paul attends boarding school in Orléans. **1865–71:** Becomes a trainee officer on ships. **1872:** Returns to France; takes a position with the prestigious Banque Bertin. Begins drawing. **1874:** Makes friends with his colleague Emile Schuffenecker, who also paints. **1876:** Represented at the Salon with one painting. Purchases Impressionist pictures. **1879:** Participates in the third Impressionist exhibition. Spends the summer painting with Camille Pissarro in Pontoise. **1883:** Decides to devote himself entirely to painting. **1884:** Lives briefly in Rouen, then in Copenhagen with his wife and five children. **1885:** Returns to Paris, alone. Extreme financial difficulties. **1886:** Stays in Pont-Aven, Brittany, where he meets Emile Bernard. Produces his first ceramic pieces. **1887:** Travels to Panama and Martinique with his fellow painter Charles Laval. **1888:** Paints in Pont-Aven and visits Vincent van Gogh in Arles that fall. Develops Synthetism, his flat painting

style with pronounced contours. **1889:** Organizes a show with Schuffenecker at Café Volpini to coincide with the Exposition Universelle in Paris. Represented in Brussels at an exhibition of *Les Vingt.* **1890–91:** Close contact with Symbolists in Paris around Albert Aurier, Charles Morice, Odilon Redon, and others. Plans to settle in the South Pacific and paint there, in a "tropical studio." **1891:** Arrives in Tahiti in June. **1893:** Returns to France. Has an exhibition at the Galerie Durand-Ruel; his paintings find little acceptance. **1895:** Returns to the South Pacific; lives there on various islands for the rest of his life. Begins to write. Experiences financial hardship. **1898:** Attempts suicide. **1900:** For the first time, is able to live entirely from his painting, owing to a contract with the Parisian art dealer Ambroise Vollard. **1901:** Dramatic worsening of his health (syphilis; alcohol). **1902:** Arrested because of anti-colonial leanings. **1903:** Dies May 8 on Hiva Oa (Marquesas).

Fernand Léger

1881: Fernand Léger is born February 4 in Argentan, son of a livestock farmer in Normandy. Attends a Catholic boarding school in Tinchebray. **1897:** Apprenticeship with an architect in Caen. **From 1900:** Works as an architectural draftsman in Paris. **1902:** Military service in an engineering corps. **1903–05:** Paints his first pictures, still influenced by Impressionism. Subsequently spends much time on Corsica recovering from a serious illness. **1907:** Attends the Cézanne memorial exhibition and is deeply impressed. After his return from Corsica, moves into a studio in the artists' colony La Ruche in Montparnasse. His neighbors are Amedeo Modigliani, Henri Laurens, Alexander Archipenko, Jacques Lipchitz, and Marc Chagall. **1909:** Moves away from Impressionism entirely. His own style is first seen in *Woman Sewing* (1909) and *Nudes in the Forest* (1909–1911; Rijksmuseum Kröller-Müller, Otterlo). Begins friendships with Robert Delaunay and Henri Rousseau. **1910:** Exhibition of his earlier paintings at the Galerie Kahnweiler, together with works by Georges Braque and Pablo Picasso. **1910–12:** Participates regularly in meetings of artists who later form the group "Section d'Or," including Robert Delaunay, Albert Gleizes, Francis Picabia, and Franz Kupka. **1911:** *Nudes in the Forest* is the sensation of the Salon des Indépendants. **1913:** Enters into an exclusive contract with Daniel-Henry Kahnweiler. **1914:** Drafted into war service. **1916:** Seriously wounded in a gas attack on the front. **1917:** Adopts sculptural forms in the painting *The Card Game.* **1920:** Meets the architect, urban planner, and painter Le Corbusier. **1921:** Beginning of his monumental phase that includes compositions such as *The Luncheon.* Works with Blaise Cendrars on Abel Gance's film *La Roue.* **1923:** Publishes an essay on "Machine Aesthetics," explaining the fundamentals of his approach. **1924:** Moves into a

studio with Amédée Ozenfant. Teaches there with Marie Laurencin and the Russian Alexandra Exter. In the same year, designed, realized and produced his first film, *Ballet mécanique.* **1925:** Decorates Le Corbusier's L'Esprit Nouveau pavilion with murals. **1930:** Meets the American painter and sculptor Alexander Calder. **1931:** First journey to the USA; exhibits at the Durand-Ruel Galleries and elsewhere in New York. **1933:** Travels to Greece with Le Corbusier. **1934:** Lectures at the Sorbonne, Paris, on "From the Acropolis to the Eiffel Tower." **1935:** Travels to the USA with Le Corbusier; has exhibitions at the Museum of Modern Art, New York, and the Art Institute of Chicago. **1938:** Travels again to the USA and is commissioned to decorate the apartments of Nelson Rockefeller in New York. Gives a lecture at Yale University on "Color in Architecture." **1940:** Travels to the USA by ship with Jacqueline Rey. **1945:** Returns to Paris in December. **1949:** Makes his first ceramic pieces. Has a retrospective at the Musée National d'Art Moderne, Paris. **1950:** His wife Jeanne Lohy dies after thirty years of marriage. **1951:** Designs glass-paintings and tapestries for the church in Audincourt (Doubs). **1952:** Marries Nadia Khodossevich. Designs a mural for the large auditorium of the United Nations in New York. **1954:** Paints the final version of *The Big Parade.* **1955:** Dies on August 17 in Gif-sur-Yvette.

Henri Matisse

1869: Henri Matisse is born December 31 in Le Cateau-Cambrésis, northern France. **1887–88:** Studies law in Paris. **1889:** Works as clerk in a law office in Saint-Quentin. Takes drawing lessons. **1890:** Spends a year confined to bed due to illness. Begins to paint. **1891–92:** Registers at the Académie Julian in Paris under William Bouguereau. Gustave Moreau accepts him in his atelier at the Ecole des Beaux-Arts. Matisse copies works at the Musée du Louvre and attends night courses at the Ecole des Arts Décoratifs, where he becomes friends with Albert Marquet. **1895:** Begins to paint *en plein air.* Travels to Brittany. **1896:** Exhibits four paintings in the Salon of the Société Nationale des Beaux-Arts, to which he is named member ex officio. **1897:** Discovers the work of the Impressionists, including that of Claude Monet, at the Musée du Luxembourg. **1898:** Studies the works of J.M.W. Turner in London. Travels to southern France. **1899:** After Moreau's death, leaves the Ecole des Beaux-Arts and attends the Académie Carrière. Meets André Derain and Jean Puy. Takes evening courses in sculpture. Acquires paintings from Paul Cézanne, Paul Gauguin, Auguste Rodin and Vincent van Gogh. **1901:** Makes acquaintance with Maurice de Vlaminck. **1903:** The Salon d'Automne is founded. Exhibits there with his painter friends. Produces his first etchings. **1904:** Has a solo show at the Galerie Vollard. Meets Paul Signac in St Tropez. **1905:** Exhibits at the Salon d'Automne with

Derain, Marquet, Vlaminck, Georges Rouault, and others. The group causes a scandal and is named Les Fauves (the wild beasts). **1906:** Travels to Algeria. Develops an interest in African art. Meets Pablo Picasso. Does lithographs and wood-cuts. **1909:** Has a contract with Bernheim-Jeune in Paris. **1910–11:** Deeply impressed by an exhibit of Islamic art in Munich. Has a large retrospective at Bernheim-Jeune. Participates in the exhibition "Manet and the Post-Impressionists" in London. **1912:** Travels to Morocco. The beginning of his participation in many international exhibitions. Executes murals, stage designs, tapestries, book illustrations, and sculptures. **1948:** First large *gouaches découpées* (paper cut-outs). **1951:** Completes his last major commission: murals, mosaics, and liturgical vestments for the Chapelle du Rosaire, Vence. **1954:** Dies on November 3 in Nice.

Joan Miró

1893: Joan Miró is born April 20 in Barcelona, son of a goldsmith. **1905:** Produces his first sketchbooks while vacationing in Curnudella and Palma de Mallorca. **1907:** Attends business school in Barcelona. Also enrolls at the art academy La Lonja in Barcelona. **1910:** Completes his business education. **1911:** Resistance to a business career causes him to become ill. Recovers in Montroig. Henceforth, determines to devote himself exclusively to painting. **1912:** Returns to Barcelona and registers at Francesc Galí's art school. **1914:** Rents his first studio at Carrer Sant Pere Més Baix 15, near Barcelona Cathedral, together with E.C. Ricart. **1917:** At the Galería Dalmau meets Francis Picabia, then publisher of the Dada magazine *391.* Becomes friends with the poet Salvat Papasseit and designs a cover for his periodical, *Arc-voltaic.* **1918:** Joins drawing classes at the Sant Lluch Circle. **1920:** Travels to Paris. **1921:** Second trip to Paris. André Masson is his neighbor at rue Blomet, where artists and writers meet. Through Masson, meets Paul Klee. Through Picasso, meets the art dealers Paul Rosenberg and Daniel-Henry Kahnweiler. First exhibition, in April at the Galerie La Licorne, is a failure. **1922–23:** Spends half of each year in Paris, half in Montroig. Becomes part of the group around the magazine *Littérature.* **1924:** Joins the Surrealists during his stay in Paris between March and June. Reads the works of Alfred Jarry and the Comte de Lautréamont. Paints his first pictures showing object-symbols on almost monochromatic backgrounds. **1925:** Solo show at the Galerie Pierre, of thirteen paintings and fifteen drawings, is a major success. **1926:** First collaboration with Sergei Diaghilev's *Les Ballets Russes.* Death of his father in Montroig. Participates in an international exhibition in Brooklyn, New York. **1927:** Moves into his new studio in Montmartre. **1928:** Travels through Holland and visits important museums. Makes his first visit to the Museo del Prado in Madrid. Large and successful exhibition of forty-one

works at Bernheim-Jeune, Paris. **1930:** First solo show in the USA at the Valentine Gallery, New York. Exhibits in Paris with Masson, Man Ray, and Max Ernst to accompany the premiere of the film *L'Age d'Or* by Luis Buñuel and Salvador Dalí. Birth of his daughter Maria Dolores in Barcelona. **1932:** First exhibition at the Pierre Matisse Gallery, New York, which shows his works regularly from then on. **1934:** Solo show at the Kunsthaus Zürich. The violent phase of his work that now begins foreshadows the impending Spanish Civil War. **1936:** Leaves Spain at the outbreak of the Civil War and settles in Paris. The architects Josep Lluís Sert and Lluís La Casa commission him to do a mural for the Spanish pavilion at the 1937 World's Fair in Paris. **1938:** Spends the summer at Varengeville-sur-Mer in Normandy. **1939:** General Franco defeats the Republicans; Spanish dictatorship established. Miró rents a house in Varengeville-sur-Mer. **1940:** Travels with his family to Palma de Mallorca and takes shelter with his sister. **1942–43:** Returns to Barcelona. Creates many works on the theme of "Woman, Bird, Star" there and in Montroig, where he spends the summer months. **1944:** Death of his mother on May 27. Begins his ceramic work in the studio of his friend Llorens Artigas in Barcelona. **1947:** First extended stay in New York. First film on Miró, by Thomas Bouard. **1948:** Returns to Paris. Meets Aimé Maeght, who subsequently exhibits Miró regularly at his gallery. **1949–51:** Retrospective at the Kunsthalle Bern. **1956:** Receives a commission to create two large ceramic wall-pieces for the new UNESCO building in Paris. Settles permanently in Mallorca. **1959:** Second extended trip to New York, where he has a retrospective at the Museum of Modern Art. **1961:** Third trip to the USA. **1962–63:** Retrospective at the Musée National d'Art Moderne in Paris. **1964–65:** Completes thirteen monumental sculptures at the Fondation Maeght in Saint-Paul-de-Vence. **1966:** First trip to Japan; attends his retrospective in Tokyo. **1970:** Does a monumental ceramic wall for the facade of the terminal at Barcelona airport. **1972:** Major exhibition at the Solomon R. Guggenheim Museum, New York. **1974:** Major exhibition at the Grand Palais, Paris. **1975:** The Fundació Joan Miró opens in Barcelona. **1976:** Designs stained-glass windows for a chapel in Saint-Frambourg, Senlis. **1977:** Designs two curtains and large marionettes for the theater-piece *Mori el Merma.* **1978–82:** Has numerous highly successful exhibitions and retrospectives. Works are increasingly integrated into architecture, such as the ceramic mural for the Palace of Congresses and Exhibitions, Madrid; also does large sculptures such as *Woman with Bird* in Barcelona. **1983:** Dies December 25 in Palma de Mallorca.

Amedeo Modigliani

1884: Amedeo Modigliani is born July 12 in Livorno, fourth and youngest child of the banker Flaminio Modigliani. His mother, Eugenia Garsin, had had a literary education. **1897:** Begins drawing lessons. **1898:** Enrolls in the art academy in Livorno in same class as Guglielmo Micheli. **1901–02:** Travels through central and southern Italy. **1902:** Enrolls in the Scuola Libera di Nudo in Florence. Visits the galleries of old-master paintings and the quarries of Carrara and Pietrasanta. Decides to become a sculptor. **1903:** Enters the Reale Istituto di Belle Arti in March. Meets Umberto Boccioni and Ardengo Soffici, who would soon become Futurists. **1906:** Moves to Paris in the winter. Takes a studio in Montmartre. Attends the Académie Colarossi. Works in the style of Henri de Toulouse-Lautrec and Paul Cézanne. **1907:** Becomes acquainted with Paul Alexandre, a doctor. Has membership in Societé des Artistes Indépendants. Exhibits at the Salon d'Automne and at the studio of the sculptor Amadeu de Souza-Cardoso. **1908:** Exhibits six pieces at the Salon des Indépendants. **1909:** Meets Constantin Brancusi; begins working as a sculptor, and moves to Montparnasse; travels to Livorno. **1910:** Exhibits six works at the Salon des Indépendants. **1911:** Exhibits at the studio of Amadeu de Souza-Cardoso. **1912:** Exhibits sculpted busts at the Salon d'Automne. **1913:** Travels to Carrara and Livorno. **1914:** His works are shown in the "Twentieth Century Art" exhibition at the Whitechapel Art Gallery, London. **1914–15:** Abandons sculpture and resumes painting, now in a Divisionist-Pointillist style. Meets the British writer Beatrice Hastings. Signs a contract with the art dealer Paul Guillaume. **1916:** Leaves Guillaume for the art dealer Leopold Zborowski. Creates portraits in a cubic-geometric style with psychological content. **1917:** Returns to painting the nude figure. Sitters in his portraits begin to assume elongated faces and walnut-shaped eyes. Lives with Jeanne Hébuterne, a student at the Academy. Has his only solo show at the Galerie Berthe Weill. **1918:** Moves to southern France to help relieve his tuberculosis. Paints portraits of the local people and a few landscapes. Birth of his daughter on November 29. Guillaume includes works by Modigliani in an exhibition in Paris. **1919:** Modigliani returns to Paris for good in May. Jeanne and their daughter accompany him. Participates in various exhibitions, in London and at the Salon d'Automne in Paris. **1920:** Dies at the age of thirty-five on January 24 in the Hôpital de la Charité, Paris. The next day, Jeanne commits suicide.

Pablo Picasso

1881: Pablo Ruiz Picasso is born October 25 in Málaga, son of the painter and drawing teacher Don José Ruiz Blasco. **1889:** Paints earliest surviving picture, *Picador*. **1892:** Enters art school in La Coruña. **1895:** Accepted to the advanced course at the art academy La Lonja, Barcelona, where his father has just begun to teach. **1900:** His painting *Last Moments* represents Spain at the Exposition Universelle in Paris. Travels to Paris for the first time. **1901:** His friend Carlos Casagamas commits suicide. Has exhibition at the Galerie Vollard and again visits Paris. Beginning of his Blue Period. **1902–04:** Has exhibition in Barcelona. **1904:** Moves into the studio in the *Bateau-Lavoir* artists' colony in Montmartre, Paris. **1904–06:** Meets the poets Max Jacob, Guillaume Apollinaire, and André Salmon, as well as Gertrude and Leo Stein, André Derain, and Henri Matisse. Fernande Olivier becomes his model and mistress. **1906:** Stays with Fernande in Gosól, in the Catalonian highlands. Here he discovers a simplified, primitivist painting that later inspires him to Cubism. **1907:** Paints *Les Demoiselles d'Avignon*. **1908:** Paints his first Cubist still-lifes and landscapes with Georges Braque. **1912:** Executes his first collages and assembles his first *gitarre*. Separates from Fernande and lives with Eva Marcelle Humbert. **1914:** The war causes a separation from all of his friends except Matisse and Max Jacob. **1915:** Death of Eva on December 14. **1916:** Through the efforts of Jean Cocteau, designs decorations for "Parade," a ballet by Sergei Diaghilev. First exhibition of *Les Demoiselles d'Avignon* through Salmon raises little notice. **1917:** "Parade" causes a scandal. **1918:** Marries Olga Koklova. Death of Apollinaire. **1921:** Birth of son Paulo. Simultaneously paints *Three Women at the Spring* in a classical style and *Three Musicians* in a Cubist style. **1923:** Meets André Breton at Cap d'Antibes in the summer. Breton convinces Jacques Doucet to buy *Les Demoiselles d'Avignon*. Picasso paints harlequins in a neo-classical style and abstract still-lifes. **1924:** *The Three Dancers* and *The Kiss* unleash the strain of violence in his art. Participates in the Surrealist exhibition in Paris. **1927:** Meets Marie-Thérèse Walter. The liaison remains secret, but is alluded to in his paintings. **1928:** Makes first sculptures in iron with Julio Gonzáles. His design proposals for a monument to Apollinaire are rejected. **1930:** Does etchings for Ovid's "Metamorphosis," published in 1931 by Skira. **1931–33:** Period of monumental sculptures begins. Marie-Thérèse becomes his favorite subject for paintings and etchings. Has first retrospective at the Galerie Georges Petit, which then travels to the Kunsthaus Zürich. Designs the cover for the revue *Minotaure*. **1935:** Birth of Maya, his daughter with Marie-Thérèse. Dramatic separation from Olga. Stops painting for several months and writes poems, which Breton publishes. **1936:** Outbreak of the Spanish Civil War. Begins a love affair with the photographer Dora Maar. Becomes friends with Paul Eluard. **1937:** Paints *Guernica*. **1939:** Upon the outbreak of war, Picasso, Dora Maar, and Jean Sabartès flee to Royan, where Marie-Thérèse and Maya are already living. **1940:** His invitation to the USA is rejected, and he must return to occupied Paris with Dora Maar. **1943:** German soldiers in Paris melt down bronze sculptures in the public squares of the city. In response, Picasso creates the sculpture *Man with a Sheep*. Meets the young artist Françoise Gilot. **1944:** Joins the Communist Party in September. Lives with Françoise. **1945:** Paints the anti-war work *The Charnel House*, a complement to *Guernica*. Begins cooperating with Fernand Mourlot. Produces more than 400 lithographs over the next twenty years. **1947:** Birth of Claude, his son with Françoise Gilot. **1948:** Takes part in the Congress of Intellectuals for Peace in Breslau; visits Auschwitz. **1949:** His lithograph *Dove* is adopted as the emblem of the Peace Conference in Paris. Birth of his daughter Paloma (the Dove). Makes ceramics in Vallauris. **1951:** Paints *Massacre in Korea*, a reaction to the American invasion. **1952:** Paul Eluard dies. **1953:** His portrait of Stalin causes a scandal. Françoise Gilot leaves him. **1954:** Meets Jacqueline Roque. **1955:** Moves into the Villa La Californie in Cannes. Does designs for the film *Le Mystère Picasso* with Henri-Georges Clouzot in Nice. **1956:** Reacting to the Soviet invasion of Hungary, Picasso, Hélène Parmelin, Edouard Pignon, and other Communist intellectuals call for a special Congress of the Communist Party. **1959:** Picasso purchases and moves into a château at Vauvenargues. Marries Jacqueline on March 2. Moves with Jacqueline to the villa Notre-Dame-de-Vie in Mougins. **1965:** Undergoes surgery for an ulcer at the American Hospital in Neuilly (Paris). **1966:** Has retrospective in Paris, where he shows over 500 works never before exhibited, including his sculptures. **1968:** Sabartès dies. Exhibition of 347 etchings at the Galerie Louise Leiris. **1970:** Exhibition of 167 paintings from 1969 to 1970 in Avignon. **1972:** Paints his last work. **1973:** Exhibition of 156 drawings from 1970 to 1972 at the Galerie Louise Leiris. Dies on April 8 in Mougins and is buried at Vauvenargues. Posthumous exhibition of 201 paintings from 1970 to 1972 in Avignon. **1975:** Death of his son Paulo. **1979:** Exhibition of his works confiscated by the French State to pay off his inheritance tax. **1980:** Retrospective of his work at the Museum of Modern Art, New York. **1985:** Opening of the Musée Picasso in the Hôtel Salé, in the picturesque Marais quarter of Paris. Death of Jacqueline, who is also buried at Vauvenargues.

Pierre-Auguste Renoir

1841: Pierre-Auguste Renoir is born February 25 in Limoges. **1844:** His family moves to Paris. **1854–58:** Apprenticeship as a porcelain painter; takes drawing courses. **1859:** Paints designs for theater curtains. **1861–62:** Studies in the studio of Charles Gleyre. **1862:** Accepted to the Ecole des Beaux-Arts; meets Claude Monet, Alfred Sisley, and Frédéric Bazille. Narcisse Diaz de la Peña introduces him to the Barbizon School. Under Diaz's influence, begins to paint *en plein air*. Works with Monet and Gustave Courbet in

the forest of Barbizon near Fontainebleau. **1864:** Represented in the Paris Salon for first time. **1866–67:** Salon submissions rejected. **1868:** Moves into an apartment with Bazille in the Batignolles quarter in Paris; meets artists in the circle of Edouard Manet. Again represented at the Salon. **1869:** Paints with Monet, and his palette brightens under Monet's influence. **1870–71:** Serves in the Franco-Prussian War. **1872:** Paul Durand-Ruel helps him to sell his first works. After rejection by the Salon jury, Renoir signs demands for a "Salon des Refusés," together with Manet, Henri Fantin-Latour, Camille Pissarro, Paul Cézanne, Johan Barthold Jongkind, and others. Durand-Ruel exhibits a painting by Renoir in London. **1873:** Meets the critic Théodore Duret at Edgar Degas's studio. Paints together with Monet that summer at Argenteuil. **1874–77:** Takes part in the Impressionist exhibitions. **1875:** With Monet, Sisley, and Berthe Morisot, organizes an auction of their pictures at the Hôtel Drouot. **1877:** With his encouragement, *L'Impressionist* is published as a counterbalance to critical rejection. **1878–81:** Exhibits paintings at the Salon. **1881:** Travels to Italy; studies the work of Raphael and the frescoes of Pompeii. **1882:** Participates in the seventh Impressionist exhibition. **1883:** Makes a study trip to the Riviera with Monet. **1884:** Has a successful retrospective at the Ecole des Beaux-Arts. **1886:** Durand-Ruel exhibits his paintings in New York. **1889:** Refuses to take part in the Exposition Universelle in Paris. **1890:** Participates in the Salon for the last time. **1892:** First purchase of a work by the French government. **1894:** Takes part in an exhibition of *La Libre Esthéthique* in Brussels. **1899:** Moves to southern France. **From 1902:** Constant deterioration of his health; nerve damage in his left eye. **1904:** Represented at the Salon d'Automne in Paris. **1910:** Retrospective at the ninth Biennale in Venice. **1913:** Completes his first sculptures under the guidance of Richard Guino (a student of Aristide Maillol). **1918:** Named joint honorary president of *Jeune Peinture*

Française with Pierre Bonnard. **1919:** One of his portraits is shown at the Musée du Louvre. Dies on December 3 in Cagnes-sur-Mer.

Portraits of the artists

Page 17: Pablo Picasso, *Renoir,* 1919
charcoal and pencil, private collection
Page 19: Edgar Degas, *Self-portrait,* 1857
etching, third version, Museum of Fine Arts, Boston
Page 21: Paul Cézanne, *Self-portrait with Turquoise-Green Background,* ca. 1885
oil on canvas, The Carnegie Museum of Art, Pittsburgh, Pennsylvania
Page 23: Paul Gauguin, *Self-portrait "Les Miserables",* 1888
oil on canvas, Rijksmuseum Vincent van Gogh, Amsterdam
Page 26: Pierre Bonnard, *Self-portrait,* 1924
etching, Metropolitan Museum of Art, New York, Harris Brisbane Dick Fund
Page 30: Henri Matisse, *Self-portrait,* 1900
oil on canvas, private collection
Page 35: Photograph of Kees van Dongen, ca. 1897
Page 40: Amedeo Modigliani, *Self-portrait ,* 1919
oil on canvas, Museu de Arte de São Paulo
Page 45: Marc Chagall, *Self-portrait,* 1910
ink drawing, Musée National d'Art Moderne, Centre Georges Pompidou, Paris
Page 48: Fernand Léger, *Self-portrait,* 1914
pencil drawing, private collection
Page 50: Photograph of Joan Miró between the canvases of his triptych *Red, Green, Orange,* 1963
Photo: Català-Roca, Barcelona
Page 52: Pablo Picasso, *Self-portrait,* 1907
oil on canvas, National Gallery, Prague

Details

Page 61: Auguste Renoir, *Reclining Nude, Rear View,* 1909
oil on canvas, Musée d'Orsay, Paris
Gift of Dr. and Mrs. Albert Charpentier

Page 77: Edgar Degas, *The Green Singer,* ca. 1885
pastel on paper, Metropolitan Museum of Art, New York, Bequest of Stephen C. Clark
Page 83: Paul Cézanne, *The Bathers,* 1879–82
oil on canvas
private collection, Japan
Page 87: Paul Gauguin, *Pastorales Tahitiennes,* 1893
oil on canvas
Hermitage Museum, St. Petersburg
Page 91: Pierre Bonnard, *Café in the Woods,* 1896
oil on canvas
Mr. and Mrs. Spencer Hays Collection
Page 109: Henri Matisse, *Blue Nude I,* 1952
gouache cut-out
Collection of Ernst Beyeler, Basel
(complete view)
Page 117: Kees van Dongen, *Torso,* 1905
oil on canvas, private collection
Page 131: Amedeo Modigliani, *Nude with Necklace,* 1917
oil on canvas
Solomon R. Guggenheim Museum, New York
Page 137: Marc Chagall, *Blue Couple at the Water,* 1954
gouache, private collection
Page 153: Fernand Léger, *Woman with Vase,* 1924–27
oil on canvas, Öffentliche Kunstsammlungen Basel, Kunstmuseum
Page 161: Joan Miró, *Dancer II,* 1925
oil on canvas, private collection, Switzerland
Page 165: Pablo Picasso, *La Vie,* 1903
oil on canvas, Cleveland Museum of Art, Cleveland, Ohio
Page 180: Pablo Picasso, *Man wearing Mask, Woman with a Child in her Arms,* 1936
pen, India ink, tinted wash, Musée Picasso, Paris

For technical reasons it has been impossible to amend the reproduction of Matisse's *Woman before a Mirror* (plate 22), which appears here as a mirror image of the original painting.